FASHION
& lifestyle
PHOTOGRAPHY

ilex

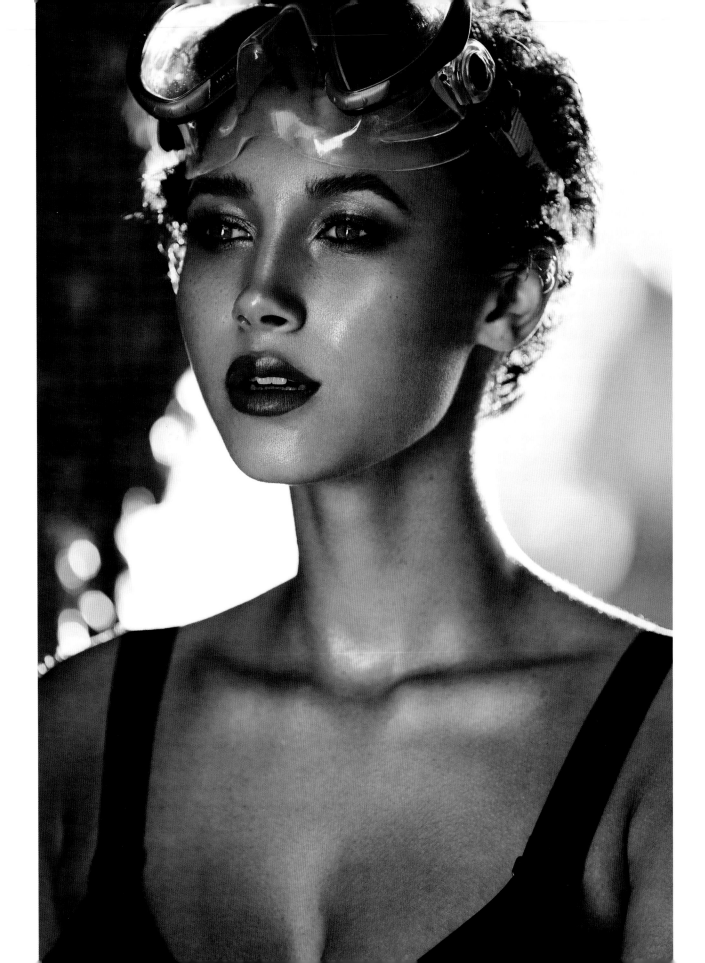

FASHION
& lifestyle
PHOTOGRAPHY

Succeed in the
commercial world and
become a stand-out
photographer

DIXIE DIXON

ilex

An Hachette UK Company
www.hachette.co.uk

First published in Great Britain
in 2017 by ILEX, a division of
Octopus Publishing Group Ltd
Carmelite House
50 Victoria Embankment
London, EC4Y 0DZ
www.octopusbooks.co.uk

Distributed in the US by
Hachette Book Group
1290 Avenue of the Americas
4th and 5th Floors
New York, NY 10104

Distributed in Canada by
Canadian Manda Group
664 Annette St.
Toronto, Ontario, Canada M6S 2C8

Publisher: Roly Allen
Publisher, photography: Adam Juniper
Specialist Managing Editor: Frank Gallaugher
Project Editor: Ellie Wilson
Art Director: Julie Weir
Design: JC Lanaway
Production Controller: Meskerem Berhane

ISBN 978-1-78157-422-5

A CIP catalogue record for this book is available
from the British Library

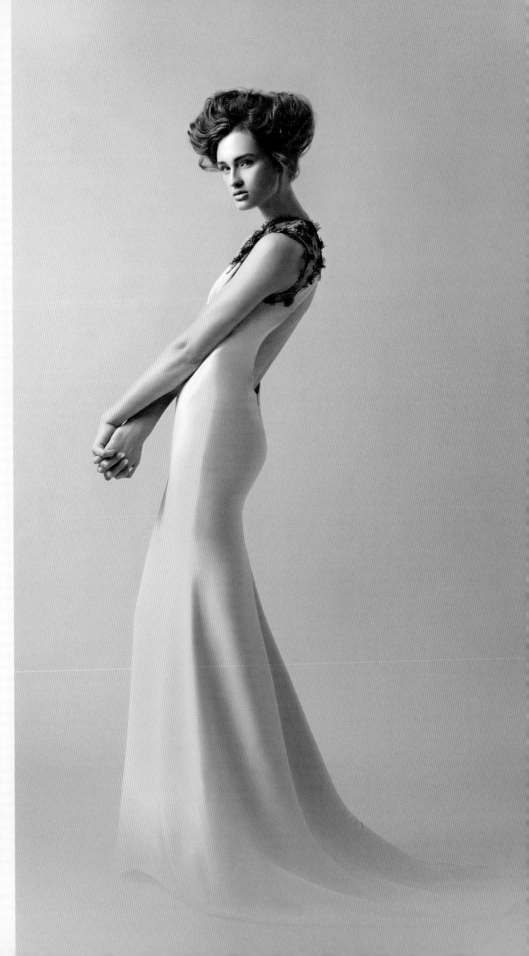

CONTENTS

Foreword 6

● INTRODUCTION 10

A Note to Readers
My Journey
Case Study: My Big Break

❶ COMMUNICATING YOUR ARTISTIC VISION 20

Finding Your Style
Find What You Love
Your Visual Vocabulary

❷ GEAR 28

Gear Basics
My Camera Bag
Lenses
My Lenses
Traveling with Gear

❸ TECHNIQUE 42

Camera Settings
Focus Modes
Composition
The Importance of Color in Photography
Case Study: Shooting with Color

❹ LIGHTING 60

Lighting Basics
The Principles of Lighting
Choosing Your Lighting
Different Types of Light
Natural Light
Using Reflectors
Constant Light
Compact Constant Light Sources
Strobe Lighting
Light Shapers
Lighting Setups
Special Effects

❺ THE FASHION PHOTOGRAPHY INDUSTRY 100

Genres of Commercial Photography
Fashion in Focus
Beauty in Focus
Lifestyle in Focus
Editorial in Focus
Swimwear in Focus
Lingerie in Focus
An Extraordinary Client

❻ BUILDING YOUR CAREER 128

Your Commercial Photography Team
Team Members
How to Choose Your Team
How to Build Your Dream Team
Working with Models

❼ THE COMMERCIAL PHOTO SHOOT
FROM START TO FINISH 148

The Job
The Estimate
Mood Boards
Pre-Production
Location
Case Study: Poopouri Campaign
Casting
Shoot Day
Case Study: A Magical Shoot
Case Study: Eurostorm
Concluding the Shoot
Post-Production

❽ BUILDING YOUR BRAND 176

Word of Mouth
Create a Cohesive Brand
Behind-the-Scenes Videos
Social Media

Index 190
Acknowledgments 192

FOREWORD

One of Dixie's greatest gifts is being a brilliant communicator, especially on the topic of fashion and lifestyle photography. Many of Dixie's creative speaking events are titled "The Soul of Fashion Photography," and it's those dynamic talks that have inspired this beautiful book.

Fashion and Lifestyle Photography is a journey that shares images and captures the art, heart, passion, and, indeed, the *soul* of fashion.

Whether on the runways of New York, Milan, and Paris, or the covers of *Vogue* or *Sports Illustrated*, only genius photographers offer the ability to make fashion democratic. In an era of web-based obsession and declining magazine sales, the one art element in fashion that always fascinates is a compelling photograph. How do those images happen? Who are the inspired and inspiring authors of visual novels whose stories are told in the time length of a blink of an eye, and a single frame?

Dixie Dixon belongs in the parthenon of photographers of that overused word . . . iconic. In my fashion career, the people who captured images—and made this then insecure child-woman appear to be a credible cover model in the world of fashion—included Francesco Scavullo, Herb Ritts, Bruce Weber, Richard Avedon, Peter Lindbergh, Tracey Morris, Jonathan Exley, Arthur Elgort, and Alberto Tolot. All photographers whose work is treasured and collected by those of us who love fashion.

The best auteurs create an indescribable, safe, intimate rapport with the person being photographed, while they're actually performing their own amazing art. Dixie is one of the finest auteurs in the millennium. You will become a participant in each experience in Dixie's beautiful, compelling book.

The experience with Dixie was completely individual and unique. Pure. Soulful. Emotional. Brilliant. Beautiful. We laughed . . . we cried . . . We became sisters in the art form. We made, with the support of a glorious team—including my forever Global Creative Director, Jon Carrasco—images that matter.

Something wonderful happened during each shoot in this book. The "soul of fashion," when captured in a photoshoot, is the responsibility of the photographer. I am unaware of a photographer who has greater gifts than Dixie Dixon and her gleaming Nikon cameras.

The day we worked together, Dixie was inspired by Bert Stern's Marilyn Monroes, George Hurrell's Greta Garbos, and a beloved member of my family, Elizabeth Taylor, who—as the most photographed woman of the twentieth century—made far too many photographers famous to credit one.

The secret lesson to *Fashion and Lifestyle Photography*, is that we, the viewers and readers, must realize that when the person behind the camera is Dixie Dixon, she is more than an equal part of the image's soul and beauty. May this very special book arrive into the world and be received with the same love that the miraculous Dixie imbues to all, whenever she steps behind her Nikon.

Kathy Ireland
Model, Actress, Author & Entrepenur

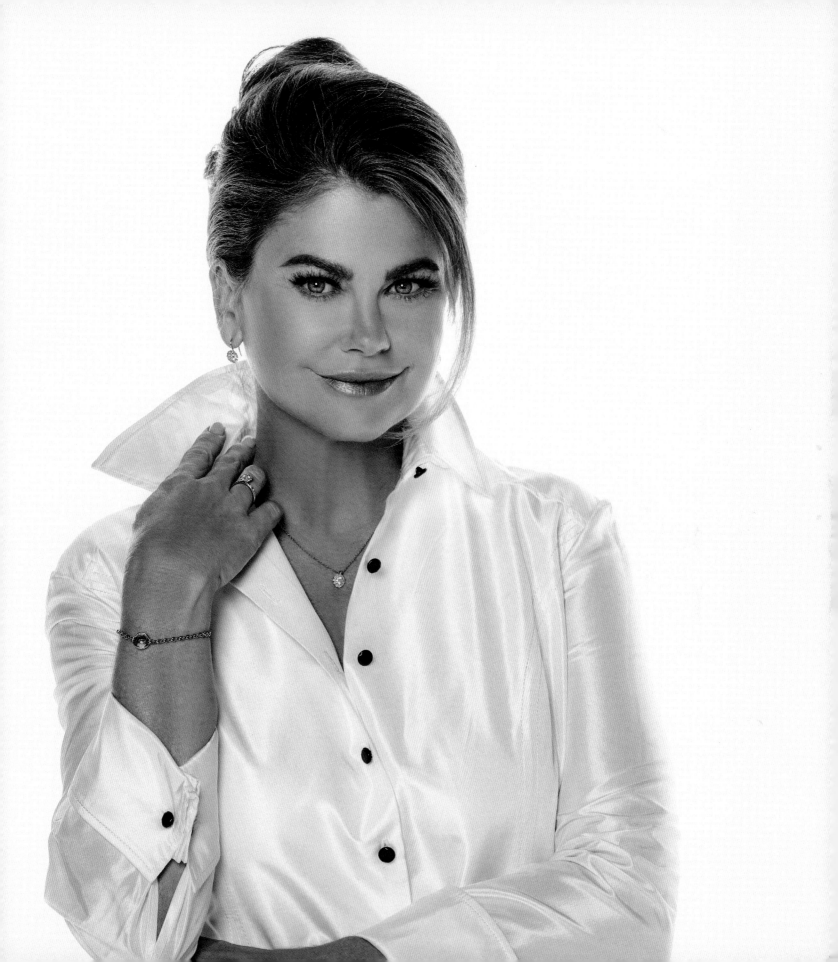

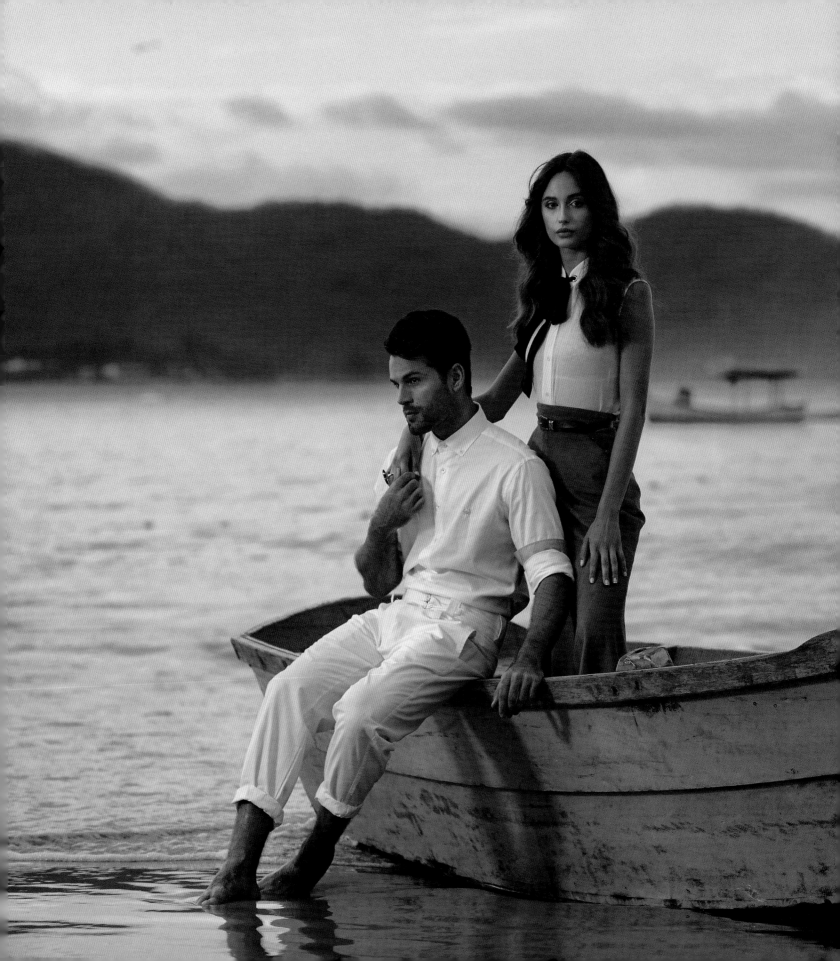

A NOTE TO READERS

Photography is one big insane adventure, and in writing this book, it is my goal to say to anyone who has the dream of being a commercial photographer, or any kind of photographer for that matter—you can do this!

I began with only the dream in mind; I had no connections, no experience, and no idea how I was going to make this dream happen—it has all primarily been trial and error. The truth is, there is no set path to success in photography—that fact alone should liberate you. You need no degree, formal training, or certificate to become a photographer. The most important decision you have to make is to define what success looks like to you, then keep that laser-sharp focus in the back of your mind throughout your photography journey.

If your goal is to make a million bucks the easiest way possible, I can guarantee, there are much easier ways to do that than in photography. Being a photographer requires crazy passion. The kind of intense passion that gets you up in the morning to create, to express yourself, and to define your vision. And it is also the kind of passion that allows you to keep your wits about you while grinding out all of the laborious, mundane business tasks that are part of the job. Photography is labor-intensive, idea-intensive, and business-intensive.

You have to wear many hats as a photographer. Photographers have to learn to excel in many areas in addition to photography: business/entrepreneurship, marketing, communication, sales, accounting, and delegating, all of which can be learned. The reason why defining what success looks like to you is so important is that there are many routes you can embark on to succeed; the trick is to figure out which path suits your goals best.

It has always been my goal to make my living in commercial photography, not in teaching. I do love both, but my ultimate passion lies in the act of shooting what I love for rad clients, working with a dream team, and creating something bigger than we each could have created alone. This collaborative effort is what drives my work.

This book is my way of giving back to the industry, a labor of love in other words, to demystify what it is to be a commercial photographer today, and to give away all of the tools and "secrets" I have learned thus far in my photography journey. I am forever grateful to all of the amazing mentors I have had who have taken their time to help me.

When I was starting out in this industry, there were very few resources for commercial photographers. The commercial world has always been this elusive yet glamorous genre of photography that nobody talks about, and it is my hope that this book gives you a behind-the-scenes look into commercial photography.

There is a quote by the entrepreneur Gary Vaynerchuck that I love, and I think it best expresses the kind of passion you need to possess in order to be successful in this photography game. Applied to the craft of photography, it reads:

"A real photographer is in it because she or he has no choice. They are dragged by their heart to dream up imagery and execute them. They aren't driven by the money or the current coolness of it. They do it because they have no choice, not because it's 'hot' right now."

ADAPTED FROM GARYVEE

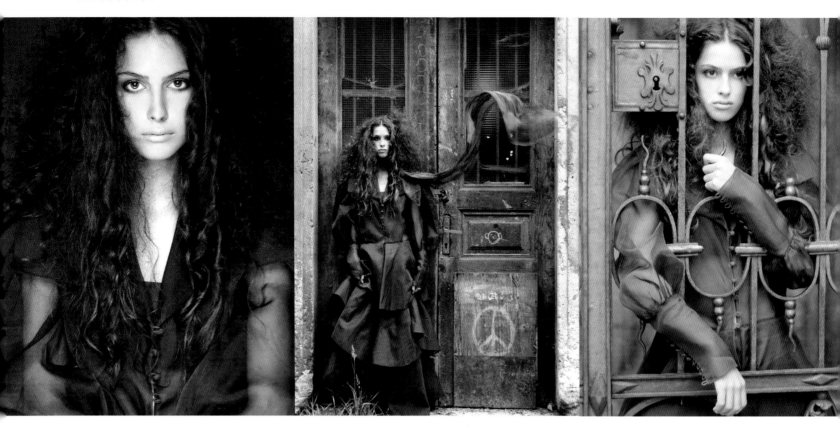

MY JOURNEY

As a kiddo, I would return home from trips with over twenty rolls of film—boy did that get expensive quickly. I can still remember the feeling of holding my first real camera, the Nikon FG 35mm film camera, and knowing that this was going to be a lifelong love affair.

During high school, I worked at a local photography business shooting the local sports teams every weekend, starting before sunrise and ending after sundown. Before my junior year, I enrolled in a summer photography course (mostly to get out of band camp). I was a first chair saxophone and absolutely loved it, however, I was horrible at playing in the marching band. One afternoon my band director scolded me at practice and left me in tears. As embarrassing as that was, it was one of those serendipitous events that pushed me to join the yearbook staff, as it was the only way I could get out of marching and still play in the concert band. It was the best decision I ever made, as it meant I had to take a darkroom photography course.

That is when I fell in love; everything about photography spoke to my soul. Not to mention I got into every party, every game, every social event . . . anything fun that was going on at my school, I was there, and I had a reason to be. It felt a little rebellious, the good kind of rebellion. My camera was my sidekick in exploring the world, and a

ABOVE **Fashion first**
The three images above were some of my first fashion images, shot with the Nikon D70 and a 50mm prime lens.

"I fell in love; everything about photography spoke to my soul."

reason to be there despite my rather introverted personality. By the end of the year, an image I took at one of the football games ended up on the cover of the yearbook. For me, that was "THE moment"— no longer would I become a doctor, lawyer, anything remotely normal, I was to embark on this crazy-insane photography journey of a lifetime.

I then went off to college to study Business Entrepreneurship, and began shooting for an event photography company on the weekends. I even assisted a wedding photographer during that time. I did not necessarily love shooting weddings, where everything was rushed and photojournalistic, but it was good practice nonetheless. Sometimes

finding your style is figuring out what you do *not* want to shoot.

During my Junior year, I applied for a fashion photography study-abroad program with Syracuse University. I went to London and Prague to study with the incredible professor Doc Mason and the world-renowned fashion photographer Jeff Licata. What I learned there shaped my style and view of the world forever. I loved the fantasy involved with fashion, how a team of people—hair, makeup, wardrobe, models—could create magic within the lens. There were no rules, no boundaries, just pure self-expression. I came back from that experience completely pumped and eager to launch my career.

ABOVE **Beginnings**
One of my first lingerie-inspired images, the model's friends were in the room, which made for a relaxed atmosphere. The "bed" is actually an inflatable mattress and a prop headboard.

When I returned home, I received some excellent advice from the Dean of the Business School at my university, Mr David Minor. He said, "If you are interested in owning a business in a particular industry, join and get involved in the trade associations related to that industry." That very night I joined every single photography association I could find and afford the student version of: WPPI (Wedding and Portrait Photographers International), APA (Advertising Photographers of America), ASMP (Association of Media Photographers), PPA (Professional Photographers of America), and SPS (Student Photographic Society). And as a member, I entered all the contests they had going on. To my luck, I ended up winning one of them somehow, and the prize was a trip to Vegas to attend WPPI's yearly conference. The president of the organization who had selected my portfolio, Skip Cohen, and his team, including Arlene Cohen and George Varanakis, have played a pivotal role in my career ever since.

ABOVE **Storytelling**
Backlit by the sun and front-lit by a reflector, the aim of the composition here is to have elements in the frame that hinted at a story but didn't take focus.

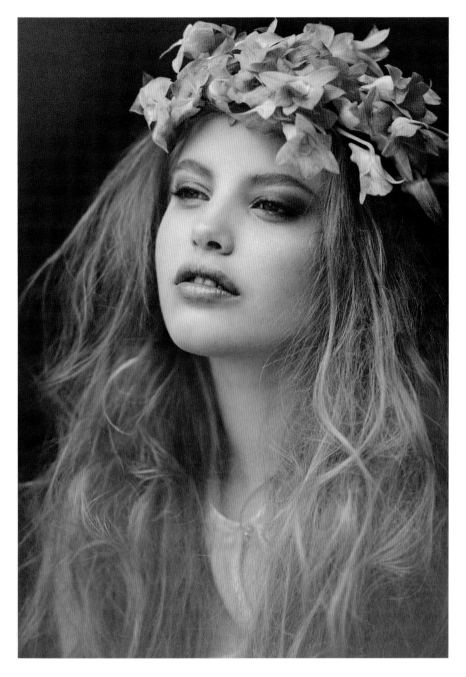

ABOVE **Deliberate haze**
This was shot through a window to create an ethereal look with haze at the bottom.

"Don't put off your passion, now is the time if you're going to go for it. What is there to lose?"

Model. I even got a job assisting the catalog photographers at JCPenney's headquarters, as well as with other great local fashion shooters.

So by the time I graduated, I knew what I wanted to do, but I was afraid. When you set out to pursue your passion, fear often sets in. And this is a crossroad where you decide if you are going to give it a shot, or settle. I nearly let fear get the best of me when I got a normal 9–5 investment job right out of school, but I ended up turning it down at the great advice of my business mentor, Calvin King. He said to me, "Don't put off your passion, now is the time if you're going to go for it. What is there to lose?" So that is what I did! The road has been challenging, and I have messed up more times than I can count, but I would not change it for anything. This life is for the living and you are the only person who can go out and make your dreams happen. Explore all those things that make your heart sing! That is how you make a life, not just a living.

This trade show experience opened up a whole new world of learning. I was hooked, like an addict; a photo-conference junkie, if you will. I can remember sitting in on all the lectures and being so inspired, soaking up all the information like a sponge. I would stand in line after the talks and ask the photographers if I could assist them, and sometimes it worked. I was able to work with Matthew Jordan Smith, an amazing beauty photographer and now a great friend who has been on *America's Next Top*

Upon graduation, I began shooting everything: portraits, weddings, boudoir, fashion, interiors, headshots. I shot it all to pay the bills, but the way I broke into fashion, the niche that I loved, was to only post and share my fashion commercial-style work on my website. You know what happens when you only show the type of work that you want to shoot? People start hiring you for exactly that. It may take a while, but it's amazing when the gigs you attract are ones that you love.

CASE STUDY

MY BIG BREAK

My first big break was shooting for a TV show on AXS Television called *Get Out*. I was introduced to the production company through a good friend and talented cinematographer, Adrianne Porcelli. The producer, Robert Bennett, was looking for a stills photographer for one of his shows, *Doheny Models*, which aired on MAV Network. To my excitement, he liked my portfolio and hired me. I flew out to LA and shot for a week there. At the wrap party afterward, I mentioned how much I loved working on the project and told him if he needed a photographer for any of his other shows, I would love to work with them again. The very next week he flew me out to Miami to shoot for *Get Out*, and I ended up working with that show for its eight final seasons.

I spent four years photographing swimsuit models in places like Spain, Miami, and Puerto Rico. The show was a docu-reality travel show that featured models exploring destinations all over the world, and we held a photoshoot in each new location. The images were used on the show as well as in the advertising.

It was the largest crew and production that I had ever worked on at the time. We would have a motorhome parked on the beach filled with models, hair, makeup, wardrobe, cinematographers, and assistants. There was one main DP (Director of Photography), Bill Garcia, and he and I worked closely during the photoshoot sections to choose the lighting and location for each shot. This experience working on set with Bill was invaluable. This is where I truly discovered my style as a photographer.

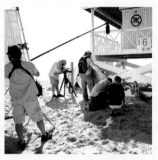

ABOVE **Television scenarios**
Docu-reality adds an extra level of stress to a photographer's task; you need to be conscious of the needs of the recording crew yet firm enough to tell them to keep out of your light.

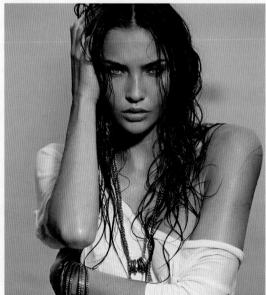

LEFT & OPPOSITE **TV or not TV**
While you might not find yourself dealing with a TV crew (straight away, at least), having someone record you at work can provide you with promotional material for yourself, for example, for a YouTube channel.

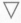

TOP TIPS

- Only share the genres of work that you love to shoot in your portfolio, the work that feeds your soul! That is how you attract your dream clients.

- Get involved in photography trade organizations like ASMP, WPPI, etc. This will allow you to learn from other photographers in the industry as well as possibly gain some photography mentors.

- Don't be afraid to network and express your intentions to gain further work and experience. You never know when someone will take you up on an offer and what it could lead to.

- Always over-prepare when you are traveling. Test your equipment and bring spares of anything vital.

CASE
STUDY

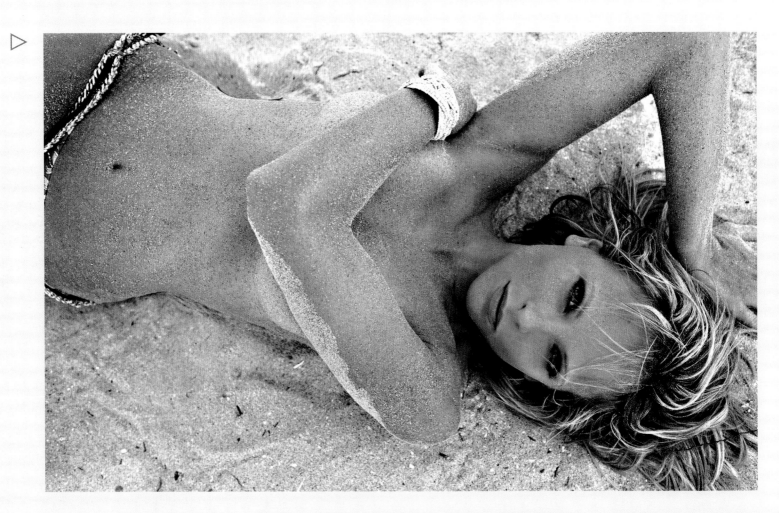

The trickiest part of shooting for the show was that we had to light for both the stills and the video as they were shot at the same time. We opted for HMI lighting, which is a beautiful constant light source that made the models look gorgeous in both the stills and video. We also used natural light and reflectors whenever possible.

The final season took place in Ibiza, Spain, which was a whole adventure in itself. Traveling abroad can be a bit intimidating, not to mention traveling abroad alone (I had to meet the crew in Ibiza) . . . with luggage (I don't pack lightly), and with camera gear (which cannot be checked). I figured I was well prepared with all the right equipment—battery chargers, outlet converters, an Apple travel kit for

ABOVE & OPPOSITE **Shapes**
Triangles, as well as S-curves, create strong compositional elements that are pleasing to the eye. In this image above, the model's arms create triangles, while in the image on the right the model's body creates an S-curve.

"We'd shoot sunrise, break during the midday light, and then shoot again at sunset. The light then is incredible—warm, glowy, and super soft."

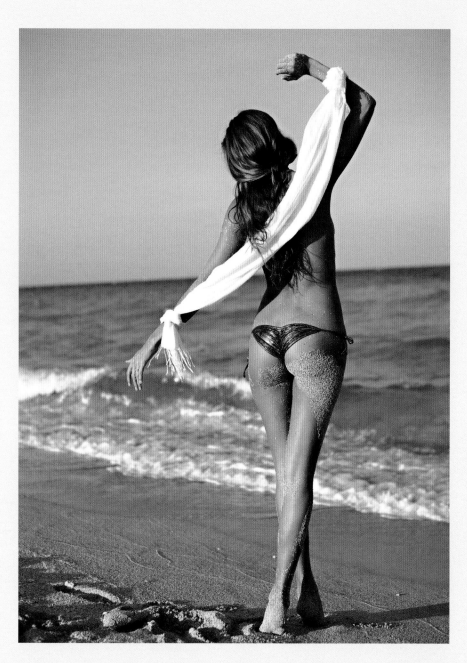

my computer, a bag full of camera gear, backup gear, hard drives, and roaming set up on my iPhone, etc. You can never be too prepared!

But when I arrived in Barcelona to make my connection to Ibiza, I turned on my iPhone and all I got was a message flashing "Out of Service Area." My first thought was to find a pay phone, but there were none, so I browsed the airport for a cheap cell phone. Waiting to board, I opened my new cell to set it up, however, all the text was in Spanish and I had to add minutes to the phone before I could use it. To my relief, I sat next to a man on the plane who was able to set up my phone and change the language to English.

When I arrived at the hotel and headed up to my room to freshen up, I found my handy outlet converter, plugged in my straightening iron, and went to grab water. It was a good thing I wasn't gone long . . . my straightening iron was smoking and on fire when I returned. Apparently the converter didn't do its job properly, and meant I couldn't plug my gear in to charge.

To my surprise, the rest of the trip was a dream. We shot twelve gorgeous models for the show. We'd shoot sunrise, break during the midday light, and then shoot again at sunset. The light then is incredible—warm, glowy, and super soft. By the end of the shoots, I had around 12,000 pictures and a bunch of full hard drives.

1 COMMUNICATING YOUR ARTISTIC VISION

FINDING YOUR STYLE

FIND WHAT YOU LOVE

YOUR VISUAL VOCABULARY

FINDING YOUR STYLE

Your style is not something you have to go out in search of. Your style is not something that is outside of you; it already exists within you. The more you learn to know and love yourself, and the more you shoot things you love, the easier you will find communicating your style and vision.

Expressing your style is an organic process that never ends. It is a constant exploration. Literally everything you have experienced in life has shaped your style: the way you grew up, the music you have listened to, the places you have been, the people you have been around, and, most importantly, the way you personally process and see the world.

If you are starting from scratch, the best way to begin is to shoot anything and everything that interests you. Spend a couple years doing this and eventually you will discover what you love shooting most. Once you discover what you love shooting most, focus on that and build a body of work around that focus. This will become your first portfolio. For me, I love photographing fashion and I discovered that very quickly.

BELOW LEFT **Props**
Props can add a lot to your images. The bright colors here give this image a festive feel.

BELOW **Storytelling**
Even when I'm shooting for a fashion brand, I still love to capture some beauty images to add to the story.

"Once you discover what you love shooting most, focus on that and build a body of work around that focus."

Each adventure you take with your camera will give you a flood of ideas and inspiration. You have to go out and take chances, travel, go to art exhibitions, get in touch with nature, and, ultimately, give up your attachment to outcome—just go create.

And don't be afraid to be a beginner . . . When we go into something not knowing the rules, we don't pretend to know how to figure everything out, and so we don't yet know what we should be afraid of, and that, my friends, is a beautiful thing! It creates a space and a freedom to think and create from your soul. Not everything you create is going to be a

masterpiece, so don't get discouraged when you're first starting out, just shoot, shoot, shoot. Shooting all the time is the name of the game, that's how you learn!

BELOW **Pink flamingos**
Early on I discovered that I enjoyed making use of bright colors, fun props, and natural light; all of that can be seen here.

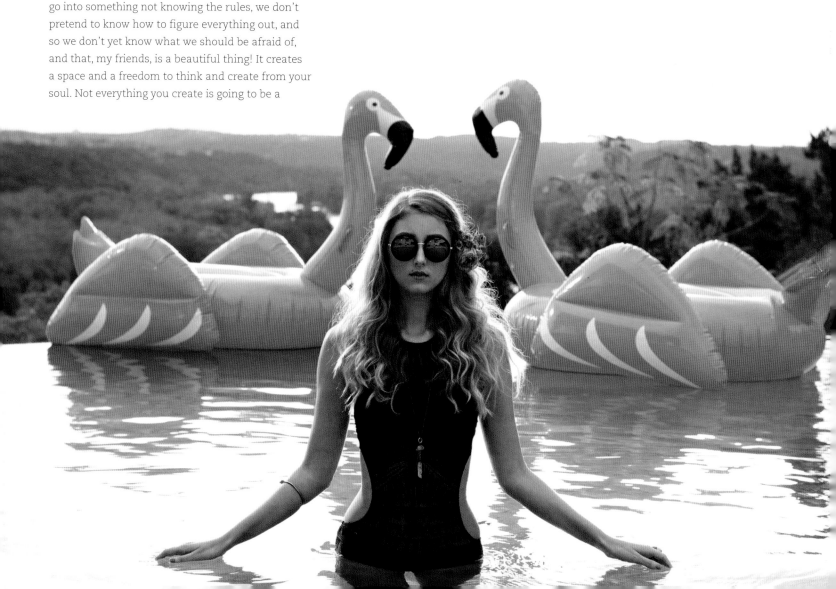

FIND WHAT YOU LOVE

Here is a self-assessment that can help you figure out what you love to shoot:

What kinds of magazines are you drawn to? I have always been drawn to fashion magazines and the advertising within them. That is how I realized I wanted to be a commercial fashion photographer. If you are inspired by magazines like *National Geographic* then you should focus on shooting the kind of subject matter that exists in those pages, such as nature and wildlife, or travel.

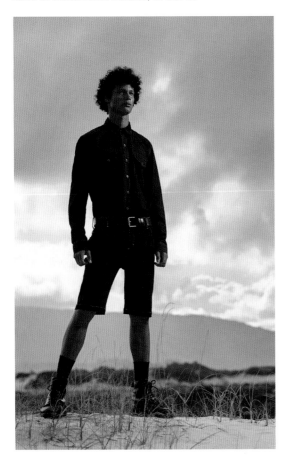

What kinds of advertisements peak your interest? Check out billboards, advertising in magazines and online.

What are your favorites? This gives you clues into what you are drawn to visually. I particularly love the fashion ads for companies like Guess, Calvin Klein, and other fashion brands that have a classic style.

What kinds of places are you drawn to? These are the areas you should express in your images. I am obsessed with the beach and warm climates. You may notice that I tend to shoot warm color tones and a lot of beach scenes.

What kind of light are you inspired by? Browse over the images you picked out of the magazines and take note of the light in them. These are the lighting styles you are most attracted to and you should try recreating this type of light in your own way.

What makes you feel alive, connected, and inspired? These are all clues as to what you should be shooting.

BELOW LEFT **Stand strong**
The model's masculine stance is further exaggerated by shooting from a low angle.

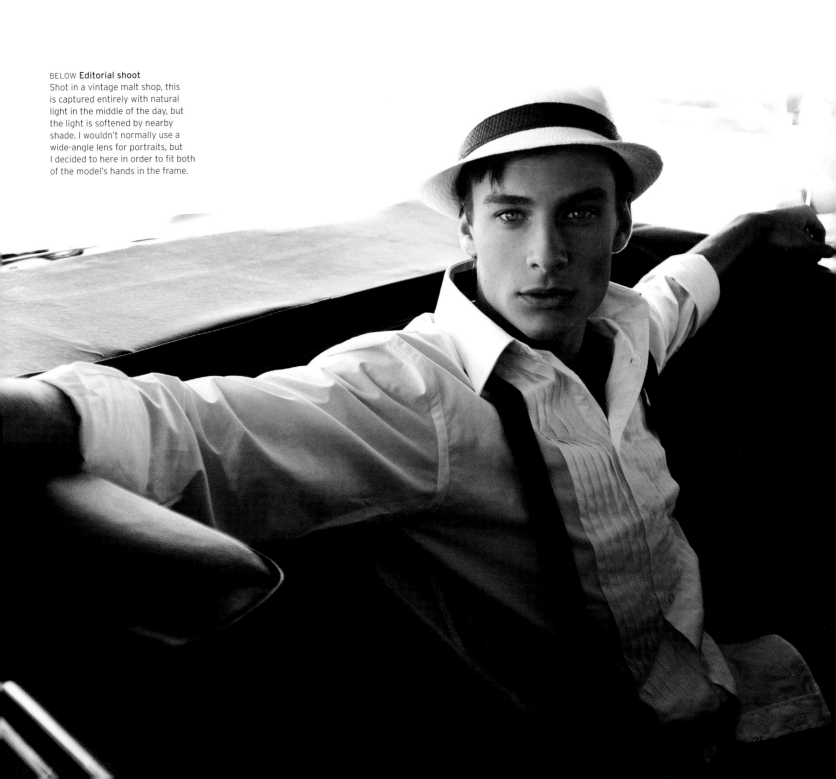

BELOW **Editorial shoot**
Shot in a vintage malt shop, this
is captured entirely with natural
light in the middle of the day, but
the light is softened by nearby
shade. I wouldn't normally use a
wide-angle lens for portraits, but
I decided to here in order to fit both
of the model's hands in the frame.

YOUR VISUAL VOCABULARY

Ultimately, when figuring out your style, it's all about the details . . . There are things that every genre of photography has in common, but there are so many variables in the equation that will express your vision—the way you portray your subject, the way you use light, the expressions you bring out of your subjects, the subjects you single out, the way you edit, the way you interact with your clients, the music on set . . . I could go on and on. All of these small variables express your vision or visual vocabulary. It is the knowledge and mastery of these variables that ultimately determines your style.

Look at all the well-known photographers out there—Annie Leibowitz, for instance; no matter what she shoots, there is always a quality in her work that screams that it's hers. It's that subtle quality that reflects your uniqueness, that's what you're looking for. And how do you find this within yourself? Like I said:

"Shoot A LOT! Always be shooting, the more you use creativity, the more you get, it's not something that can be used up!"

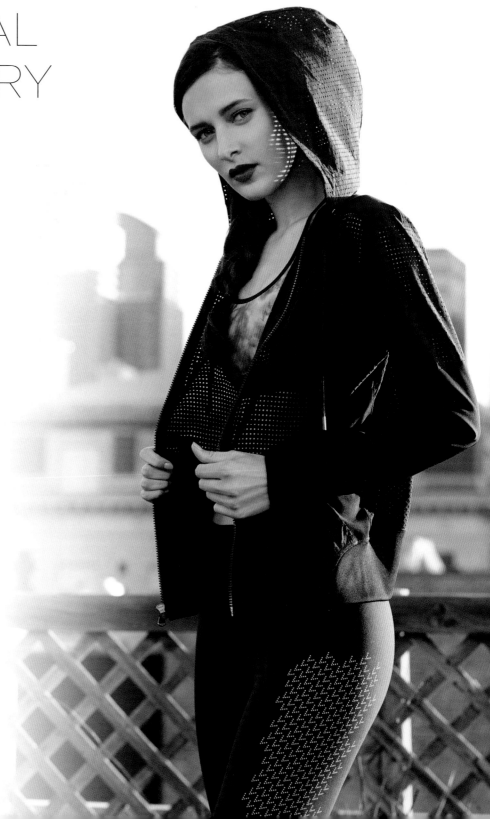

26

GEAR

GEAR BASICS

MY CAMERA BAG

LENSES

MY LENSES

TRAVELING WITH GEAR

GEAR BASICS

My camera has always been my sidekick in exploring the world, my third eye, and my medium of expressing my soul. A camera is to the photographer what the paintbrush is to the painter, and the instrument is to the musician. The tool does not make the artist; the artist's vision makes the artist.

Many photographers get all caught up in the gear when they first begin creating, but the truth is you can create amazing images with just the simplest equipment. When it comes to your camera, the key is to try out many different types until you find the one that suits what you do best. The first camera I ever felt connected to was the Nikon FG, a 35mm

BELOW **Your sidekick**
Believe it or not, this dog's name is Dixie Belle and I had the opportunity to photograph her for a Nikon Project. I had no idea she would show up with her own wardrobe . . . She is still one of my favorite models.

LEFT **Nikon DF**
A digital camera body with
a bit of old-school charm.

film camera, and I have been shooting with Nikons ever since. I love the sound of the shutters, the weight and feel of the cameras in my hands, and the sharpness of the image quality.

In the beginning, I tried shooting with various other cameras, such as medium format, but I always felt that my Nikons allowed me to best express my vision, because they allow me to be fully present in the moment and candid with my subject. I tend to move around a lot when I shoot to find the best angles and light.

A great way to find out what gear suits you best is to rent it first. I have used sites such as borrowlenses.com and lensrentals.com to work with gear I am interested in purchasing before I make the plunge. You can rent everything from cameras, lenses, and lighting equipment to support equipment and accessories.

MY CAMERA BAG

Here is a look at my current camera bag.

NIKON D5—"THE BEAST"

This is one of my all-time favorite cameras and is a beast in every way. It grabs focus quicker than any camera I have ever worked with, which makes it great for shooting swimwear and lifestyle photography. It has a touchscreen, which I find very helpful; when I'm on location, I can quickly zoom into an image to check sharpness, hair/makeup, and many other little details.

As a fashion and beauty photographer, capturing perfect skin tones is extremely important, and I feel like this camera really excels in that area. It's very true to skin tone and captures rich colors really beautifully. Thanks to its continuous shooting speed and autofocus, you can now capture what you hadn't been able to before: those split-second moments that happen in between expressions are usually the best shots.

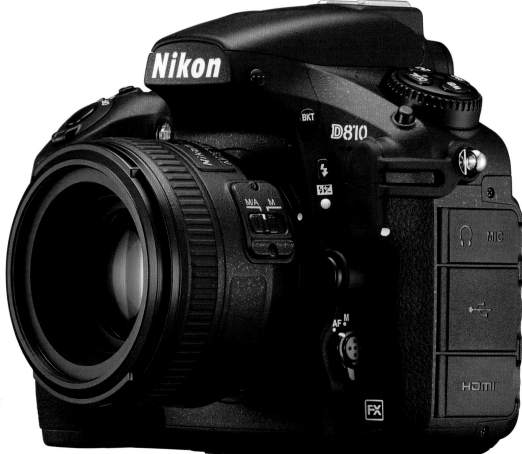

RIGHT **D810**
First into my bag is "the beast," followed by more compact models, but there's no reason to copy my approach. The D810, pictured, sits somewhere between the two, offering power and features without the size of the extra portrait grip.

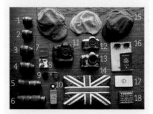
NIKON D810

Holy huge file size—the detail this camera is able to capture is insane. When I am shooting advertising work that requires billboard-size printouts, this is the perfect camera for that. I love the image quality, vibrant colors, and the smooth, film-like look that come out of it. I personally own two of these. It is very important to have at least one or two backup cameras on set in case you drop your camera or something happens to your gear.

NIKON D5500—THE COMPACT DLSR

This is a small compact camera that I love shooting personal work with because it is so lightweight and can be packed easily to take anywhere. It has a DX sensor which makes your normal FX lenses even longer because of the crop factor. I have been extremely impressed with the gorgeous image quality that comes out of this compact camera.

NIKON 1 AW1

A tiny mirrorless, waterproof, shockproof, and freeze-proof camera. Need I say more? I love this one for vacations. You can also use your normal DSLR lenses on it above water. I really enjoy working with it.

NIKON FG

The original 35mm film camera I was given; and I still love shooting personal work with it! I have always loved the film quality. The camera is fully manual so it was a great teacher on how to get things right in-camera when I was starting out.

I have also owned many other cameras—Nikon D70s, Nikon D200, Nikon D300, Nikon D700, Nikon D3X, and Nikon D4s—which I've loved as well, and I have bought new equipment as I've grown my business.

LENSES

Your lens choice is extremely important. Lenses have the power to change your whole perspective. They are the eye of the camera and in some ways the most important part of your gear.

Different DSLR cameras have image sensors in different sizes, and these are fixed in the camera. Many cameras feature a sensor measuring 24x16mm (called "DX" by Nikon, "APS-C" by some in the trade, or "1.5x crop"). Others feature a sensor of 36x24mm, around the same size as 35mm film, and known as "FX" in the Nikon world. I recommend investing in high-quality FX lenses as they tend to produce the best image quality and the least noise, and are more flexible in the long term. DX cameras are able to use both FX and DX lenses, so if you upgrade to an FX camera, you don't have to upgrade the lenses too.

When considering what lens to choose, consider what you are photographing. If you are looking to create a beautiful landscape or environmental image, you might go with a wide angle such as a 35mm or a 24mm. If you are photographing a full-length fashion look, you might go with a 50mm lens to capture the model and the outfit with no distortion to the edges of your subject. If you are photographing small features such as a closeup of lips, eyes, or jewelry, you'll need a great macro lens such as a 105mm.

When shooting headshots, you'll usually want to go with longer lenses. The reason being that they will make your subject's features look a lot more beautiful, as you see in the example opposite. The longer lenses have a compression effect, which

ABOVE **Telephoto lens**
Telephoto lenses, which see farther, will be larger with more glass. As a result, they will include a tripod mount halfway along the base so the lens doesn't pull your tripod over.

flatters the face. When you use a lens as wide as 35mm and wider, it tends to distort people's faces. The model's nose and forehead appear larger, but suddenly when you move to a 85mm lens she looks gorgeous.

The minimum focal length I use for headshots is 85mm. And when you get to 180mm—wow—that is an iconic headshot. So if you have a 70–200mm lens, for instance, try zooming all the way into 200mm

and then step back and take your headshot. This will blur your background, drawing more emphasis to your subject.

Also consider the location when choosing a lens. If you're shooting in low light, you'll want fast glass with apertures such as $f/1.4$ or $f/2$. This allows more light into the lens.

"Your lens choice is extremely important. Lenses have the power to change your whole perspective."

BELOW **The effect of lenses**
With a wide-angle lens the model's features are distorted; the longer the lens, the more natural they look.

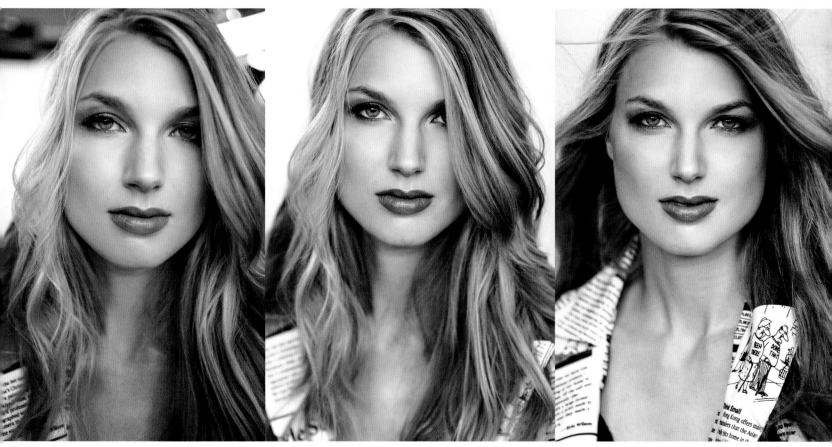

35mm lens 85mm lens 180mm lens

MY LENSES

Investing in high-quality fast glass will make all the difference in your photography. I personally love the prime NIKKOR lenses because of their insane sharpness and simplicity, so you could say I am my own "walking zoom." Here are some of my favorite lenses:

AF-S NIKKOR 35mm ƒ/1.4G

This lens is perfect for lifestyle group shots and full-body fashion shots where I want to capture a lot of environment in the background.

AF NIKKOR 50mm ƒ/1.4G

I used this lens most when I first started out, and I still use it a lot for full-body fashion and waist-up shots because it creates no distortion on the edges of my subjects. This is a great sharp lens to begin with because it is less expensive than most of the other ƒ/1.4 lenses and it is great in low light.

AF-S NIKKOR 58mm ƒ/1.4G

I just got this lens and it's sharp! Just a little longer than the 50mm, it's still around the range that can be approximated to normal human vision.

ABOVE **Nikon 35mm AF-S**
The measure of ƒ/1.4 is what tells you that this lens is "fast," meaning it can let a lot of light in, which in turn allows you to use a fast shutter speed. A fast shutter speed means a tripod isn't essential. It is this flexibility that you are investing in.

35mm

> "Investing in high-quality fast glass will make all the difference in your photography."

50mm

58mm

60mm

85mm

105mm

AF Micro-NIKKOR 60mm ƒ/2.8D

This was my first macro lens and I still use it for product photography as you often have to get very close to your subject and still be able to get a sharp focus. I tend to prefer the 105mm Macro for shooting people and beauty shots that focus on features like lips, nails, and eyes because you don't have to be as close to your subject as with the 60mm, so the focus distance is less of an issue.

AF-S NIKKOR 85mm ƒ/1.4G

This is one of my favorite lenses. It's great for portraits as it's super sharp and blurs the background nicely.

AF-S VR Micro-NIKKOR 105mm ƒ/2.8G IF-ED

This is my favorite macro lens. It's perfect for shooting closeups of facial features such as lips without being too close to your subject.

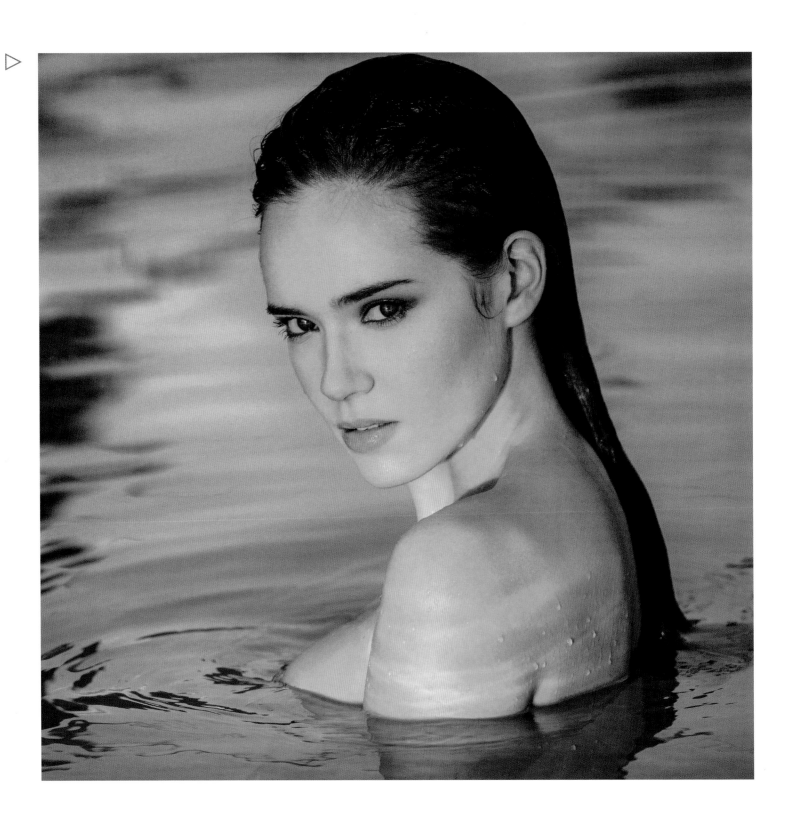

135mm

180mm

300mm

> "The 200mm is my favorite lens, ever. It is bokeh-licious and the sharpest I have ever shot."

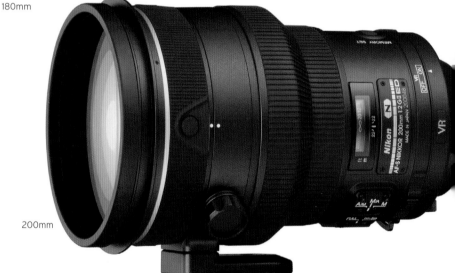

200mm

LEFT **Beautiful bokeh**
I photographed this particular image with the Nikkor 300mm lens in order to completely blur out the background and create a stunning bokeh. The longer the lens, the better for headshots!

AF DC-NIKKOR 135mm ƒ/2D
This is an amazing headshot lens and creates a beautiful bokeh in the background. It's from the film days, but I still use it often because it has a certain quality that I love and the defocus ability.

AF NIKKOR 180mm ƒ/2.8D IF-ED
This is the second lens I ever owned and I still use it all the time for gorgeous headshots. It's truly one of my all-time favorite lenses, and one of the most overlooked and underrated, in my opinion. Since this is an older lens made for 35mm film, it doesn't have the nano-crystal coating like the newest digital lenses, so you end up with more lens flare, which I love for fashion photography!

AF-S NIKKOR 200mm ƒ/2G ED VR II
My favorite lens, ever. It is bokeh-licious and the sharpest I have ever shot with. The focal length is nice too because it blurs out your background beautifully. It is quite heavy so I usually work with it on a tripod or monopod.

AF-S NIKKOR 300mm ƒ/4 PF ED VR
A super-lightweight lens combined with a super-long telephoto—an amazing package. This is a great lens for capturing subjects that are far away without having to carry a monopod or tripod.

TRAVELING WITH GEAR

I usually travel with my camera gear and hard drives, and rent lights, stands, and tripods wherever I go. Here are some of the essentials that mean I'm never exactly traveling light:

Memory Cards: Speed and reliability are essential; I trust Lexar and, at the time of writing, the XQD range is the fastest.

X-Rite ColorChecker Passport: An extremely important tool for controlling color, fine tuning skin tones, and creating a great raw file. Have your model pose with one of these in the lighting setup before you get started. This creates a great starting point for the color balance.

X-Rite i1Display and Software: Literally, the second piece of equipment I purchased after my cameras. The i1Display and software color-corrects your monitor and creates a color profile for you so that what you see on your screen matches what you get when you print.

Manfrotto Tripod and Head: The 055 carbon fiber tripod is extremely durable and light because of its carbon fiber design. It features a 90-degree column that can extend vertically or horizontally. I use this in low-light situations, for blurred motion shots, and for landscapes.

Manfrotto 410 Junior Geared Head: This is by far my favorite tripod head because of its ease of use, with adjustable knobs for precise movement.

The Bag Itself: I have found the Manfrotto bags to be very reliable. When I am jumping on a flight, I need a roller bag that can fit ALL of my camera gear,

and fit in the overhead compartments, and keep everything safe and secure.

Once I get to a location such as the beach, where I am dealing with sand and the elements, I like to put my gear essentials into my Active backpack, so I can wear it and shoot at the same time. It has easy-to-access compartments, so I can switch lenses quickly.

Storage: I am obsessed with storage since I learned the hard way! G-Technology makes the very best drives and I currently use the G-Dock for on-set backup—it makes two duplicate backups on set via Thunderbolt. At home a G-SPEED Studio XL provides a huge capacity and enterprise-quality drives, set up with RAID—I have three of these, and one is an archive drive with all of my Raw files and one is a working drive. The third I keep at a different location

for safety. I also have a bunch of G-Drive Slims and some of their RAID drives for video editing.

Business Cards & Promo Materials: For these I use WHCC (White House Custom Color). I love the cards for their thickness and beautiful presentation.

Portfolios: First I design my portfolios with Graphistudio online software. I then upload an order and Graphistudio prints and binds the porfolios in Italy. I like the glass covers and their minibooks, which are great to leave behind with potential clients.

Hats: I can't not mention this one! I am passionate about hats and have a ton of Brixton Hooligans.

Although I've covered a lot of gear in this chapter, keep in mind that you can make amazing images with the simplest of gear. I started out with one camera and one lens and got by just fine. I rent gear a lot on a job-by-job basis, and have grown my inventory of equipment as my business has grown.

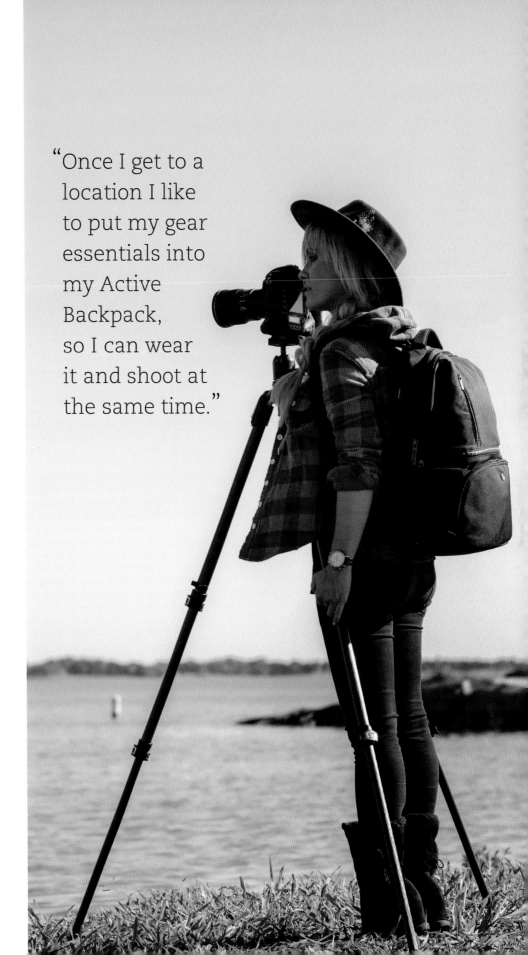

"Once I get to a location I like to put my gear essentials into my Active Backpack, so I can wear it and shoot at the same time."

3 TECHNIQUE

CAMERA SETTINGS

FOCUS MODES

COMPOSITION

THE IMPORTANCE OF COLOR IN PHOTOGRAPHY

CASE STUDY: SHOOTING WITH COLOR

CAMERA SETTINGS

Familiarity with your camera's key settings will open up creative possibilities, so going beyond auto is essential. That's not to say you'll need to learn every feature in the menu, but these are the settings important to every fashion photographer.

The exposure triangle: Consisting of ISO, shutterspeed, and aperture, the exposure triangle is the key to making great images. The act of balancing these settings may take some practice to master. When I first started in photography, I worked primarily in Aperture Priority mode so I could focus on my connection with my subject and allow the camera to do the heavy lifting. Once I got the hang of that, I began shooting in Manual mode, since it allows you more control. Now shooting in Manual feels like second nature.

Aperture: Choose your aperture based on how much of the photograph you want to be sharp. The wider the aperture (the larger the opening of your lens), the shallower the depth of field—the depth of field being the distance in front of the camera in which the picture is in focus.

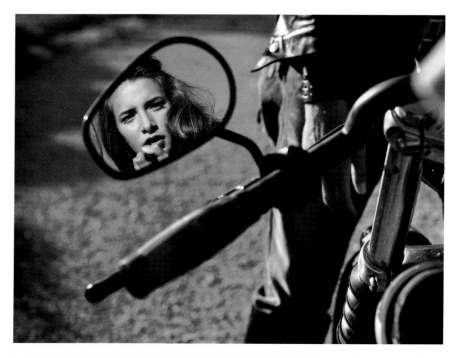

ABOVE RIGHT **Mirrors**
This image was shot with a shallow depth of field, wide open at f/2. The focus distance is the distance from the lens to the mirror and back to the model (there and back). The mirror is only half that distance, which is why the mirror frame doesn't appear in focus.

RIGHT **Group focus**
In a shot with multiple people, keeping everyone in focus means you can't use a very shallow depth of field.

f/2.8

> "I love using a shallower depth of field, where the background falls beautifully out of focus."

If you want your entire image tack-sharp, such as when you're photographing landscapes, you should use a narrower aperture, such as *f*/8 or *f*/11. Additionally, when photographing high-end jewelry, the client usually wants both the model and jewelry sharp, so I shoot these situations at *f*/8 or *f*/11 as well.

If I am shooting portraits or moody fashion images, I love using a shallower depth of field, where the background falls beautifully out of focus. This is when I tend to keep my apertures fairly wide open at *f*/2.8, or *f*/4 if I am photographing dresses.

If you want to shoot a portrait at the widest aperture, at *f*/1.4, you need to be careful of what you focus on, as you may end up with one eye in focus and the other eye soft. It all depends on your vision.

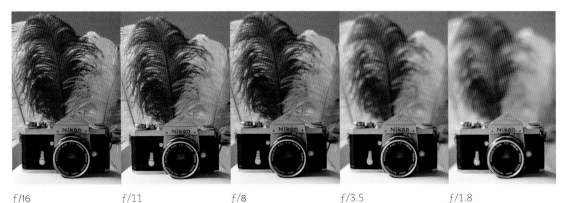

f/16 *f*/11 *f*/8 *f*/3.5 *f*/1.8

LEFT **Aperture effect**
From left to right, a comparison of what happens to an image as you narrow the aperture. A 58mm lens was used.

45

▷ **Shutterspeed:** This basically controls how long the camera's sensor is exposed to light. Shutterspeed dictates how much movement you want in your image. If you are looking to add an intentional blur, you might slow your shutterspeed down to 1/30. Normally, I keep my shutterspeed at 1/250 or higher to avoid this motion blur and yield a tack-sharp image.

ISO: The lower the ISO number, the less grain and the better the image quality. ISO essentially determines the sensitivity of the image sensor, and I always choose the lowest ISO possible in the situation, such as ISO 100 in daylight. The higher the ISO number, the more noise. However, the new cameras today can handle much higher ISOs, so if you are shooting on the fly and need to increase the ISO in a darkroom, you have the capability to do that.

Of course, while newer cameras are far more capable in lower light, it's still better to use light if it's available. Image sensors will still take advantage of good light!

ABOVE (BOTH) **Shutter speed**
This was taken for the Nikon D5500 campaign, to show the fast autofocus of the camera. Both of these shots were captured at 1/1250 sec.

"ISO, shutterspeed, and aperture are the key to making great images. The act of balancing these settings may take some practice to master."

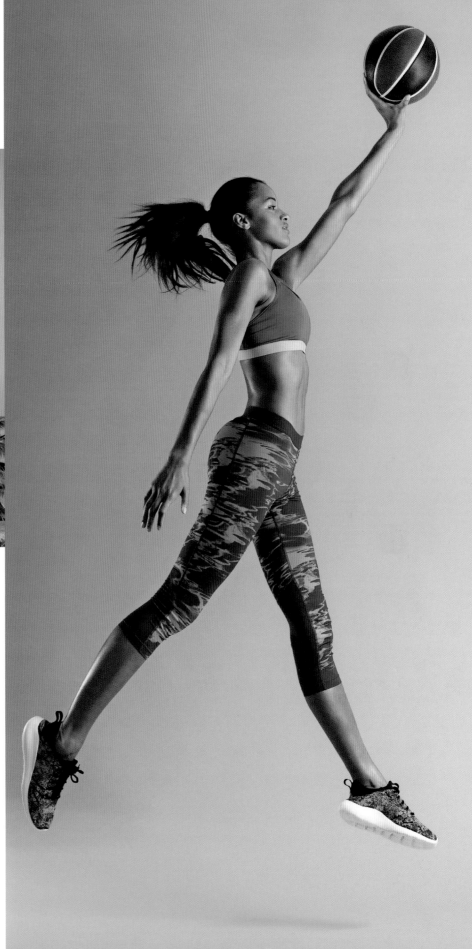

ABOVE **Mirrorless**
I photographed this with a mirrorless camera, the Nikon 1 S1, which is super-compact, yet still has interchangeable lenses like DSLRs.

RIGHT **Fashion basketball**
This image was captured for talented athlete Arielle Roberson, for her portfolio. A fast shutterspeed is essential for movement shots like these.

FOCUS MODES

Creating sharp imagery is a delicate balance between your settings and focus technique. I've experimented with all the various focus modes on my D5, but I usually prefer Single Point Autofocus mode or AF-S in most situations because it allows me to compose my frame first and then move the tiny focus point to the eye of whoever it is I'm shooting. It takes some practice, but it will become second nature.

Single Shot Mode (AF-S): My favorite mode, as mentioned above. This is great for stationary subjects and creating the sharpest images. Stationary, by the way, doesn't mean fixed solid like a landscape; it just means that the distance between you and the subject isn't going to change. It works just as well with models!

Continuous Focus Mode (AF-C): This mode is great to use when photographing moving subjects because it continuously tracks your initial focus point and automatically readjusts your focus accordingly.

Auto Modes (AF-A): This particular setting allows the camera to decide on which mode to use, but I have found that Single-Shot mode and Continuous are more accurate.

Manual Focus Mode: You have the ability to use Manual focus, however, I rarely use it for still photography because Autofocus is so accurate. The only time I will use Manual focus mode is when I am shooting video.

ABOVE **Focal point**
Focus is not just a technical requirement. It drives the eye, and is an important compositional tool for you as a photographer.

ABOVE **Focal point**
The advantage of a single-
shot focus mode when you're
working in fashion is that you
can first compose your image
and then move your focus point
to the subject's eyes for a
tack-sharp frame.

COMPOSITION

The key to successful composition is to guide the viewer's eye where you want it to go within your photograph. You want to draw the eye to your main subject in the image, the most important aspect of your photograph. You can effectively control this with framing techniques such as using the Rule of Thirds, leading lines, triangles, and S-curves within your composition.

The Rule of Thirds: If you divide your image into a 3 x 3 grid, the Rule of Thirds basically states that you are better off placing your subject where there are lines or intersections. I find that I use it instinctively in my photography; it's natural and pleasing to put negative space on one side or another.

Place the point of interest at the intersections

Eyes meet at the intersection

"The Rule of Thirds is a natural and pleasing way to put negative space on one side or another."

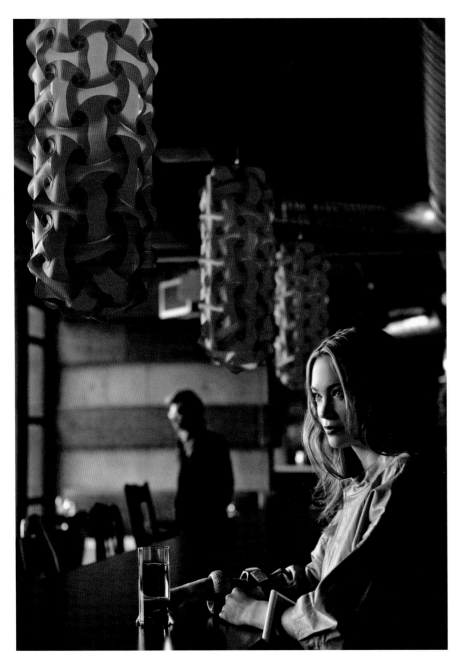

Leading lines: You can make a model, or any other subject, take up a smaller part of the frame and have just as much impact, or more, using leading lines. It's easy to get a bit caught up thinking about your main subject, but looking at the background is important in composition (to avoid something weird pulling the eye away). Why not be all the more proactive and find leading lines?

Leading lines draw the eye naturally to the point of interest

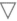

S-curves: S-curves are very pleasing to the eye, and models create these naturally with their bodies a lot of the time. Another example of S-curves is winding roads, which always photograph nicely.

Look at your images and figure out where your eye is drawn first—it is usually drawn to the brightest and sharpest point of an image. So you should ensure that the most important part of your image is a sharp and bright area, such as the eyes in a portrait. Then see where your gaze turns next. You could try positioning the model's arms in a triangle to point to the key piece of clothing, for example, or, as in the shot above, let her arms lead your eyes away to see the setting. It is important to think about this as you shoot.

ABOVE & LEFT **S-curve**
The model is framed by the edges of the building and she is creating an S-curve with her body.

OPPOSITE, TOP LEFT
Framing a headshot
In this case, the top of the head is less interesting than the model's hair, so it can be cropped out.

OPPOSITE, TOP RIGHT **Composition**
The girl sitting on the floor was the youngest ballerina in the room.

OPPOSITE **Composition**
The light and shadows create an interesting composition that frame the subject, with negative space left for text.

FRAMING

Here are some basic rules when framing your images:

- Avoid cropping people at the joints.

- When framing a headshot, crop from just below the shoulders to the top of the head.

- I like to shoot headshots from a slightly higher angle because whatever is closest to your lens appears larger, which makes the eyes stand out. I will rarely shoot a headshot from a low angle.

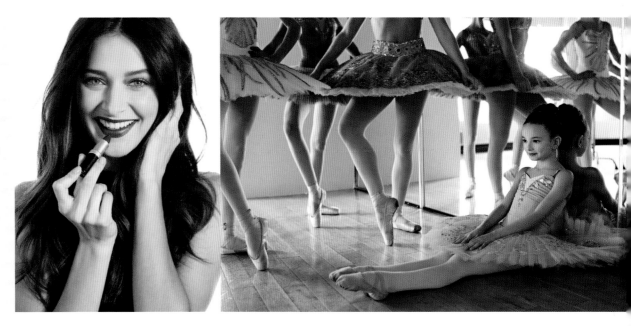

"Composition is even more important because it is not only about the image but where the copy and logos will go."

COMPOSING CLIENT IMAGES

When you begin shooting for clients, composition is even more important because it is not only about the image but where the copy and logos will go. It is always a good idea to try to get layouts before the shoot so you know how much negative space to leave. Most magazine covers need space up top for the name of the magazine, and most double-page spreads start out with a two-page opener image with negative space on one side for the text. Thinking about these details in advance allows you to create freely while knowing you've captured what the client needs.

THE IMPORTANCE OF COLOR IN PHOTOGRAPHY

Most people don't realize how much color demands attention and creates certain feelings within your viewer. If used effectively, color has the power to evoke a strong visceral response because it directly effects the viewer's state of mind. There have been times when I've been so concerned with lighting, composition, and gesture that I've forgotten the importance of controlling color as well. I would only notice later when I realized I loved certain images for some reason more than others. These certain images stood out to me, and I found that the reason was color.

Believe it or not, color is actually perceived in our minds before virtually anything else. So it makes sense that we should use color to our advantage when trying to tell a story. The color sets the overall mood of your image.

For instance, blues and greens are calming and associated with nature, so if you are shooting for a client such as a yoga studio, you might consider using blue or green to evoke a calming effect instantly. Oranges and yellows create warmth and energy, while red is a color of power, passion, and love. If you are photographing the cover of a book that centers around romance, you might use red within your photograph. Red is also the heaviest color visually, so the viewer's eye will be drawn to anything red in your image—you need to be careful how you use it.

Green = natural Blue = calm and soothing Browns and beige = soft and sombre

bored
aggravated
cranky
distracted
upset
irritated
regal
frustrated
distaste
angry
disgusted
energetic
apathetic
anxious
confused
disdain
relaxed
concerned
distraught
sombre
worried
despair
disappointed
surprised
depressed
terrified
natural
warm
hurt
awed
exuberant
astonished
afraid
sad
apprehensive
thrilled
amazed
unsure
excited
mesmerized
overjoyed
intrigued
enthusiastic
happy
interested
giddy
calm
satisfied
content
jolly

"We should use color to our advantage when trying to tell a story. The color sets the overall mood of your image."

In general, vivid colors create a mood full of energy and excitement, while dull and pastel colors create a soft, sombre mood. Think of the story you would like your image to tell and then choose which colors you could use within your image to tell that story best.

Yellow = warmth and energy

Orange = energy and excitement

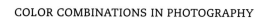 Complementary

Analogous

COLOR COMBINATIONS IN PHOTOGRAPHY

Utilizing certain color combinations is extremely effective in photography. There are a bunch of color combinations or color schemes that are particularly pleasing to the eye—these are called color harmonies that contain two or more colors with a relation to each other in the color wheel.

I use a ton of "complementary" colors in my work. Complementary colors sit opposite from each other on the color wheel. So if you start by choosing a color—blue, for instance—look directly across from it and you'll see the color orange. If you use these two colors in the same image, your image will be visually engaging and three-dimensional. This complement creates the strongest contrast of color.

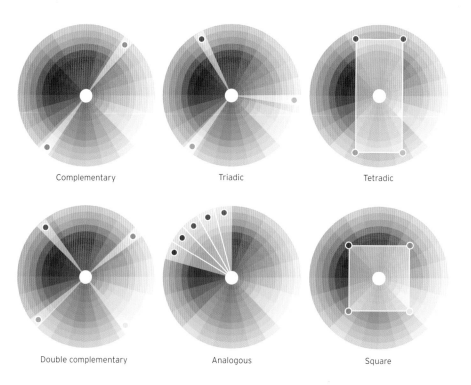

Complementary

Triadic

Tetradic

Double complementary

Analogous

Square

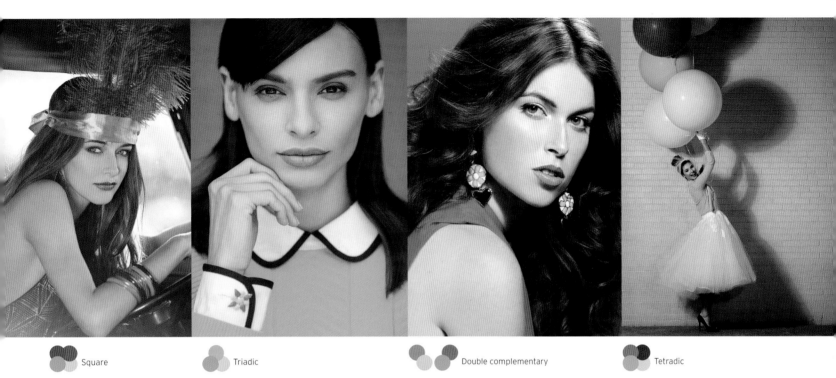

Square Triadic Double complementary Tetradic

Here are a few other color schemes that create visually inspiring images:

Complementary: Two colors directly across from each other on the color wheel. A complementary scheme creates a high-contrast, vibrant look, full of saturation.

Analogous: This uses colors that are right next to each other on the color wheel, such as orange, yellow-orange, and yellow. These schemes are found in nature and appear harmonious to the eye, particularly when you use one color to dominate, a second as a support, and one as an accent.

Triadic: Three colors that create a triangle within the color wheel. For instance, orange, purple, and green. To create the most effective look, one color should dominate while the other two act as accents.

Double Complementary: This is a variation of my favorite color scheme, complementary. Basically it uses three colors; it takes one color and matches it with the two colors adjacent to its complementary color. For example, red, yellow, and blue.

Tetradic (Rectangle): This particular combination uses four colors arranged into two complementary pairs. You can balance between warm and cool colors. For instance, try pairing blue and orange with yellow and green.

Square: This is similar to the rectangle but with all four colors spaced evenly around the wheel. This works best when you let one color be dominant. Red, blue, green, and yellow is an example.

CASE STUDY

SHOOTING WITH COLOR

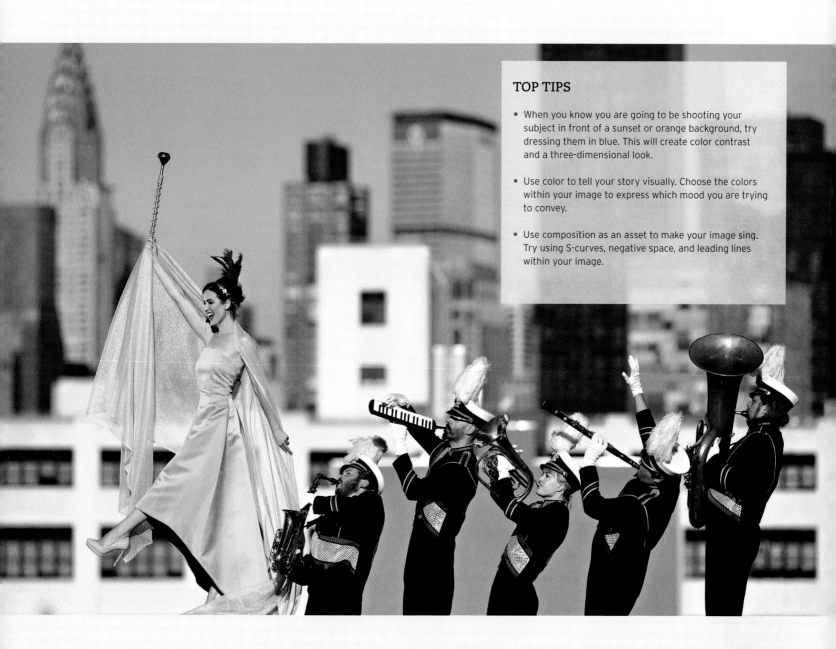

TOP TIPS

- When you know you are going to be shooting your subject in front of a sunset or orange background, try dressing them in blue. This will create color contrast and a three-dimensional look.

- Use color to tell your story visually. Choose the colors within your image to express which mood you are trying to convey.

- Use composition as an asset to make your image sing. Try using S-curves, negative space, and leading lines within your image.

"My vision was to showcase bold complementary colors—colors that are directly across from each other on the color wheel."

I was insanely excited when Nikon's ad agency in Japan asked me to be one of the featured photographers for the campaign of their newest flagship camera—the Nikon D5. One of the camera's signature features was the quality of its color sensor, from detail in skin tones to rich tones. As a lifelong Nikon shooter, I've got to admit that this was the happiest moment in my photographic career.

The photoshoot called for images ranging from beauty to fashion to portraits at rooftop and studio locations, and in tons of whimsical colors that showcased the camera's capabilities. The trickiest part was that it all had to be accomplished in one day and there was to be no Photoshop—they used the JPEGs right out of the camera throughout the entire campaign, so I had to be sure to get everything right in-camera.

These types of productions require an incredible team, from hair and makeup to wardrobe, lighting tech, digital tech, and the muses. In this case, we also had the immensely talented Corey Rich and his entire crew filming the whole process.

The overall theme that we came up with was "The Beauty of Music," which is close to my heart as I grew up playing saxophone in a marching band. My vision was to showcase bold complementary colors—colors that are directly across from each other on the color wheel.

So, for instance, blue and golden yellow are complementary, and when used in the same image you get a three-dimensional effect. I also used red in one of the main images as it is a power color.

4 LIGHTING

LIGHTING BASICS

THE PRINCIPLES OF LIGHTING

CHOOSING YOUR LIGHTING

DIFFERENT TYPES OF LIGHT

NATURAL LIGHT

USING REFLECTORS

CONSTANT LIGHT

COMPACT CONSTANT
LIGHT SOURCES

STROBE LIGHTING

LIGHT SHAPERS

LIGHTING SETUPS

SPECIAL EFFECTS

LIGHTING BASICS

Lighting has the power to transcend a normal moment into pure magic, a simple photograph into art. It expresses the mood and vision of your photograph. The iconic photographer Joe McNally said it best: "Light is the language of photography."

Before I choose how to light a particular photograph, I always consider the client's vision first. The vision should dictate the light. For instance, if your client is creating an advertising campaign that is all about capturing natural slice-of-life-style moments, I will go with natural light and lens flare, as opposed to dark, moody lighting. If the client is after a more emotional, feminine look in black-and-white portraits, you could go with soft window light, for example. There are many ways to communicate with lighting, you just need to consider your vision first and let it dictate how you craft your light.

HOW TO LIGHT A PHOTOGRAPH

The truth is, there is no right or wrong way to light a photograph. Yes, there are lighting ratios and various techniques, but there is no universal template for lighting a photograph. There are a million different ways to light an image.

I was so intimidated by lighting when I first started shooting, because I'm not a technical person. But it doesn't come down to a math equation. You can have all the lighting ratios correct and the lighting might still not look quite right. Go with what you think looks gorgeous, not what is technically perfect. Every single situation, location, and subject is different, so lighting is always going to vary. The key is to have experimented so much with different lighting styles that when given a particular assignment you ultimately know or have an idea of what lighting style you think will work best.

That always gives me a starting point. And just because something you do lighting-wise goes against the grain or the "rules of lighting," doesn't mean it doesn't look good. So learn the rules and then break them creatively. Ultimately, you have to go with what looks beautiful to you. The key is to learn the basic principles of lighting, experiment with them, and use the types of lighting that speak to your soul.

OPPOSITE **Beauty dish lighting**
The model is lit by a beauty dish to the side, creating strong shadows. The background is lit very evenly with a couple of large softboxes (diffused lights).

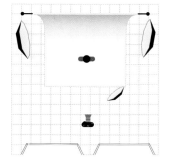

"Just because something you do lighting-wise goes against the grain or the 'rules of lighting,' doesn't mean it doesn't look good."

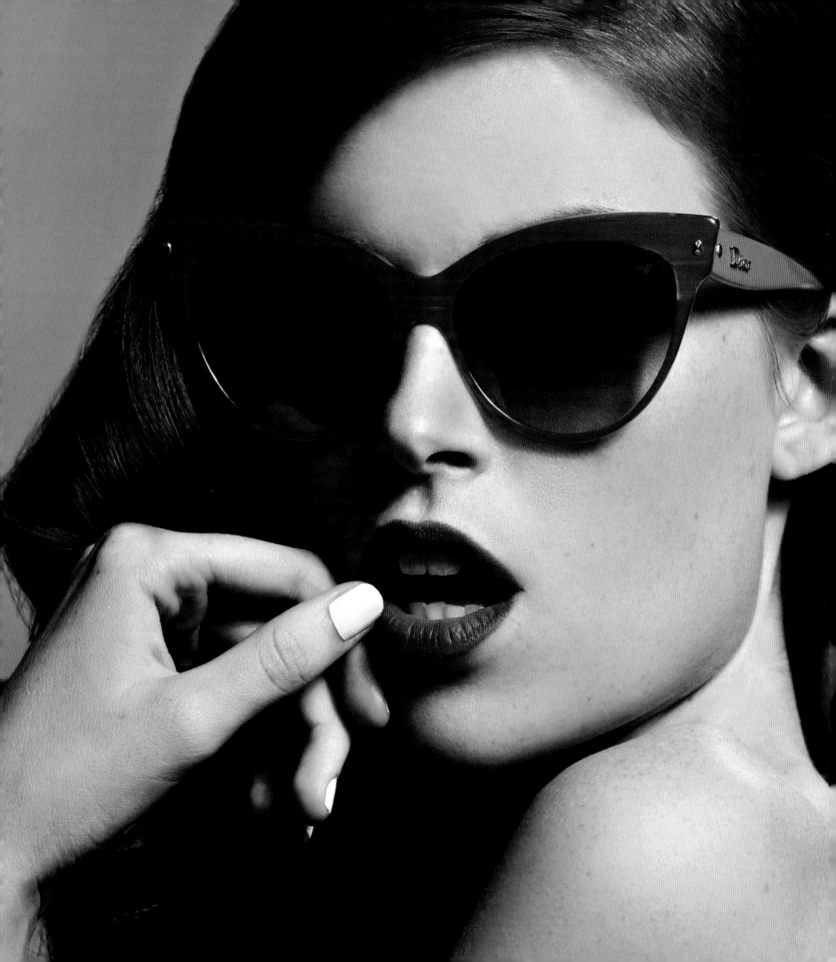

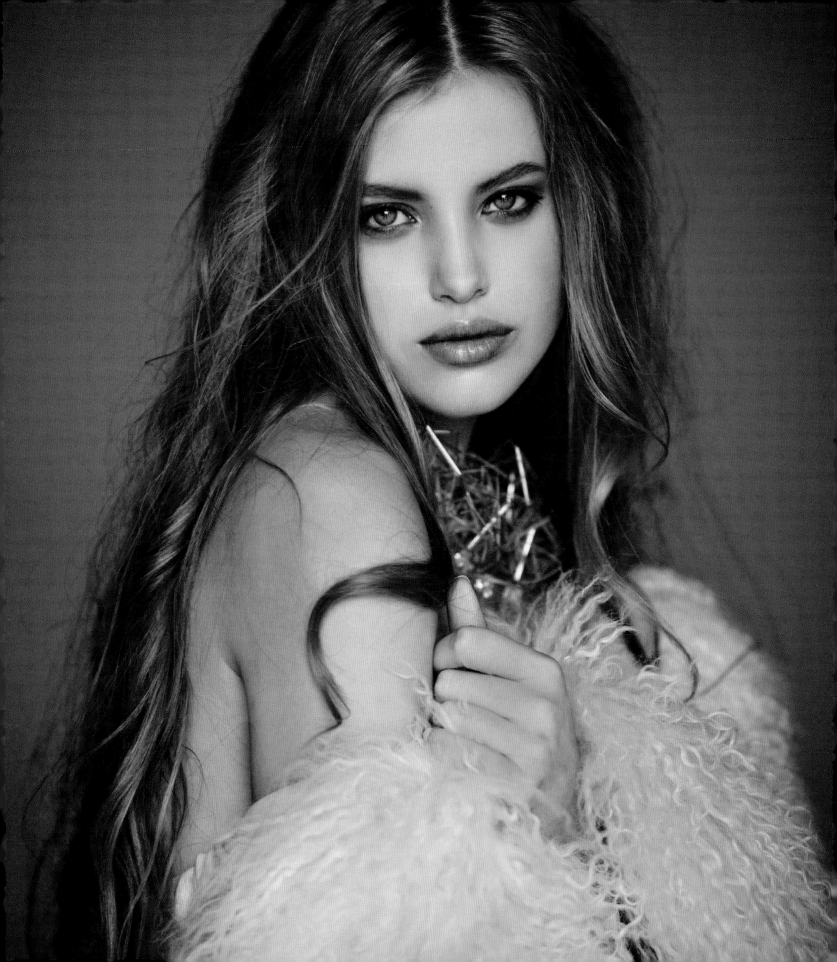

THE PRINCIPLES OF LIGHTING

Lighting ratios mathematically measure the amount of light falling on the highlighted side of the face as compared to the side of the face in shadow. The greater the difference, the more dramatic the lighting. But it honestly does not matter what your ratio is as long as the lighting looks good and fits your vision. This is why I have never spent much time worrying about what the ratio is.

A 1:1 ratio as a rule may be considered flat, even lighting, and great to use only on children, but I often love to use this ratio on women as well to give them a beautiful soft and innocent look. A 4:1 ratio will create a more dramatic look, so the higher the ratio, the more drama. These ratios are fine to know, but you don't need to spend time worrying about them and whether they are perfect.

A few simple lighting basics that I live by:
Size: The larger or broader the light source relative to your subject, the softer it will be. This reduces contrast and texture. The smaller or narrower the light source, the harsher it will be. I tend to use

larger sources because I like the soft beauty-style light they create. This all depends on your style though. If you prefer a harsher look in your style of photography, you can go with a smaller light source.

Distance: The closer the light is to the subject, the softer it will be. So when shooting ambient window light, I will move my subject very close to the window where the light becomes much softer. The farther the light is from the subject, the harder the light.

Texture: Lighting from the front basically lessens texture, while lighting from the side emphasizes it. When photographing women, I like to lessen the texture so I will position the light more frontally. When photographing men, I might position my light to the side to make them look more rugged. Another favorite lighting technique of mine is to use backlighting to create a beautifully airy, soft, and diffused look, which lessens texture. To achieve this you place your light directly behind your subject and adjust your settings accordingly. The background may get bright, but I especially love this look.

ABOVE **Parabolic reflector**
The parabolic reflector creates a soft yet contrasty light that also provides specular highlights.

OPPOSITE **Soft light**
This was lit with natural light from a big window in front of the model, so the light wraps around her. She has great skin, and a shallow depth of field adds to the soft effect.

"When shooting ambient window light, I will move my subject very close to the window where the light becomes much softer."

CHOOSING YOUR LIGHTING

Lighting communicates the mood of the photograph to the viewer. So before you light an image, consider your vision first. Think about the following:

What mood are you trying to convey? If you or your client is after a light, airy, and effortless vibe, you might opt for natural light. If your client is looking for a moody fashion image, you might go with a more shadowy look of a constant tungsten spot positioned off to one side to create a Rembrandt-look.

Where is your final image going to be used? If you are shooting a cover, you might check out past covers the magazine has run and find that in a lot of the images the lighting is glossy and bright. In that case you might consider using high-key lighting. If the final image is going to be used as part of a fashion editorial, all the lighting across the images should be similar so they sit well together in a story.

Think about your subject matter. If you are shooting a portrait of a musician who sings soulful, moody songs, then you might try lighting that is dark and moody, such as Rembrandt lighting.

What are you selling in the photograph? If a client is selling a product, you want to light the product to look its best, as well as the model.

BELOW LEFT **Golden hour**
Sunrise and sunset give a tonally pleasing light, which can be enhanced with a golden reflector.

BELOW **Dappled light**
Instinctively we look straight at the face and eyes when we look at a portrait photo. The splash of light on the model's face quickly makes us realize we're outdoors, hinting at freshness and nature.

OPPOSITE **Striking light**
This was lit straight on from behind the camera with an HMI, and from above and behind the wall with another. A fog machine provided a little extra atmosphere.

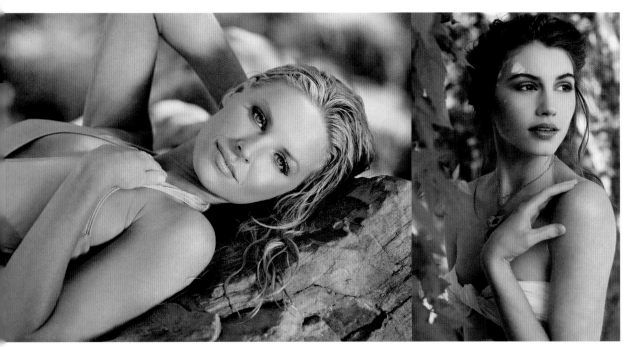

DIFFERENT TYPES OF LIGHT

Photography is about light, and these days we live in a world with many subtle different kinds of light as different technologies produce slightly different shades.

THE MAIN SOURCES OF LIGHT

Daylight: The qualities of daylight vary with the weather and the time of day. Different techniques are necessary to take best advantage of, say, brilliant sunshine, and an overcast evening.

Continuous artificial light: This may be normal lighting, or produced by special photoflood lights. The properties of different light sources vary— household incandescent lighting, fluorescent lighting, sodium discharge street lighting, etc., are very different and produce different results, and call for different correction if a subjectively neutral rendition of colors is required.

> "Different lighting techniques are needed to take advantage of the time of day."

Flash/strobe: Photographic flash, or strobe lights, are extremely brief but very bright, triggered automatically by the camera. Because it's difficult to know exactly what shadows will be cast, some include modeling lights; that means an extra bulb that is on all the time so you can get a rough idea of the effect before the flash fires.

Other: For special purposes, lightning, electric sparks, fireworks, moonlight, or other light sources may be exploited.

OPPOSITE **Halo effect**
A still shot for a commercial for TCU (Texas Christian University), lit with one light, as well as the room lights.

BELOW LEFT **Barn shot**
This was shot just inside a barn, so the real barn doors were used to control the natural light.

BELOW **Soft natural light**
If the light is gorgeous in a location, you don't need to overcomplicate it with strobe. The natural light here was spilling over the subject from the window and created a mysterious mood.

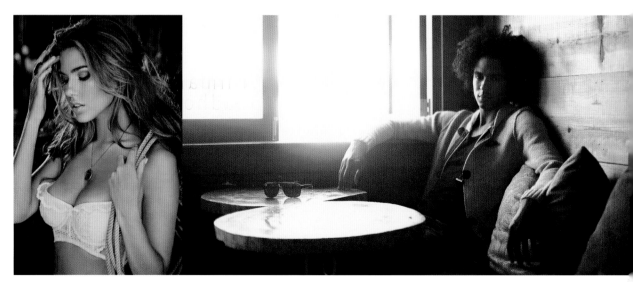

NATURAL LIGHT

Natural light is light from the sun. It can be soft and beautiful or hard and edgy, depending on how you use it. If you utilize sunlight as a backlight, the light will look soft and diffused. If you use the sunlight directly, coming from the side of the subject, it will tend to look harsh, while placing your subject in the shade allows you to capture indirect soft light.

Direct light

This type of lighting works best during the first and last hour of daylight, often called the golden hour or magic hour. It is essentially when the sun shines directly on your subject, so your subject is facing the sun. It is clean, crisp, and warm.

Direct side light

This is direct light as well, yet your subject will be angled so the sun is to the side. This brings out texture, which is great for muscular male models, but it's not the most flattering style for females.

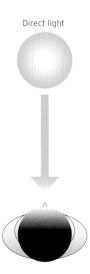

Direct light

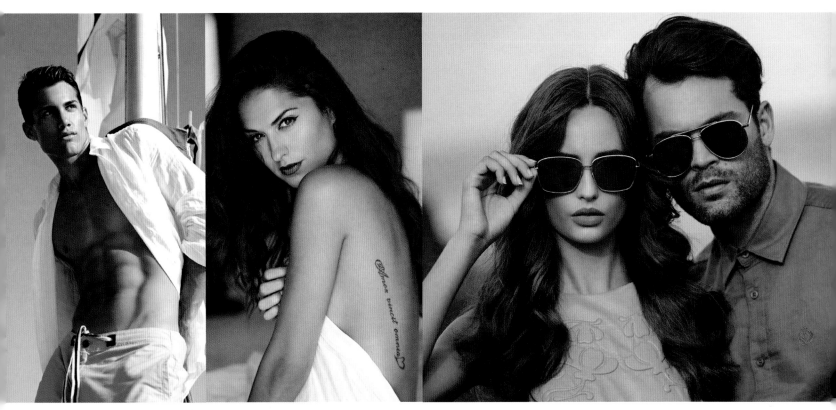

Direct side light Window light Golden hour

"The first and last hour of daylight is often called the golden hour or magic hour."

Overcast light

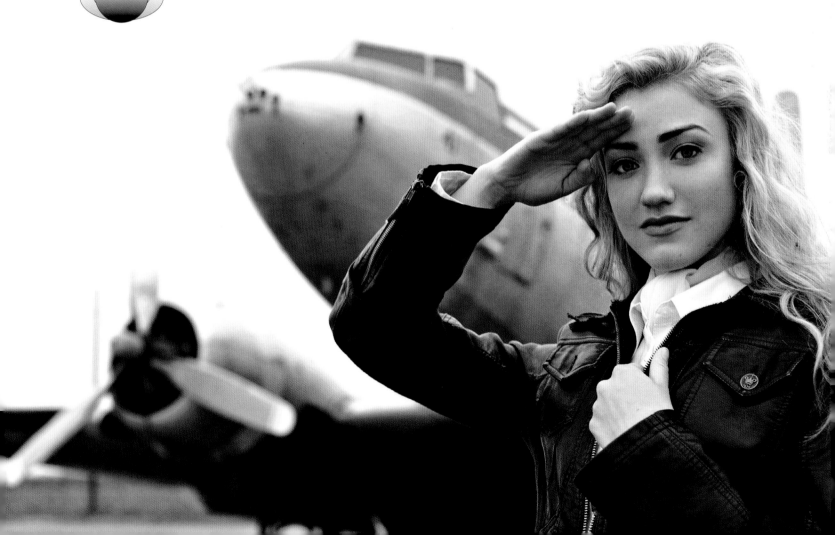

Overcast light
Overcast lighting is soft and diffused, as opposed to being punchy and contrasty like direct light. It makes for some moody imagery.

Window light
Window light is one of my all-time favorite light sources because it wraps around your subject beautifully! My favorite way to use natural window light is to place my subject very close, facing the window, so the light wraps around them. Then I place my back against the window and shoot. This lessens texture and is one of the most flattering types of lighting—diffused and soft.

▷ "To make great images at times when the direct light is not ideal, we can find shade, use reflectors, or try positioning the subject differently."

SHOOTING WITH NATURAL LIGHT

You will always get the most beautiful images during the first and last hour of the day, which is why photographers often refer to the "magic hour" when talking about these time periods. However, we don't always have the luxury of shooting at these times. So, to make great images at times when the direct light is not ideal, we can find shade, use reflectors, or try positioning the subject differently.

When you are shooting in midday sun, you tend to get shadows under the eyes as the light is coming from high above. To avoid this, you should first try to find some shade and place your subject in this more diffused light. To create even more contrast, you can have your assistant stand in the sun and bounce light into your photograph using a reflector.

RIGHT **Midday solution**
You can also angle your model's face up toward the sun. Here I had the model lie on the car, so the sun is overhead. Had she been standing, the light would have created harsh shadows on her face since it is directly above. Her position on the car allowed for a nice direct light source.

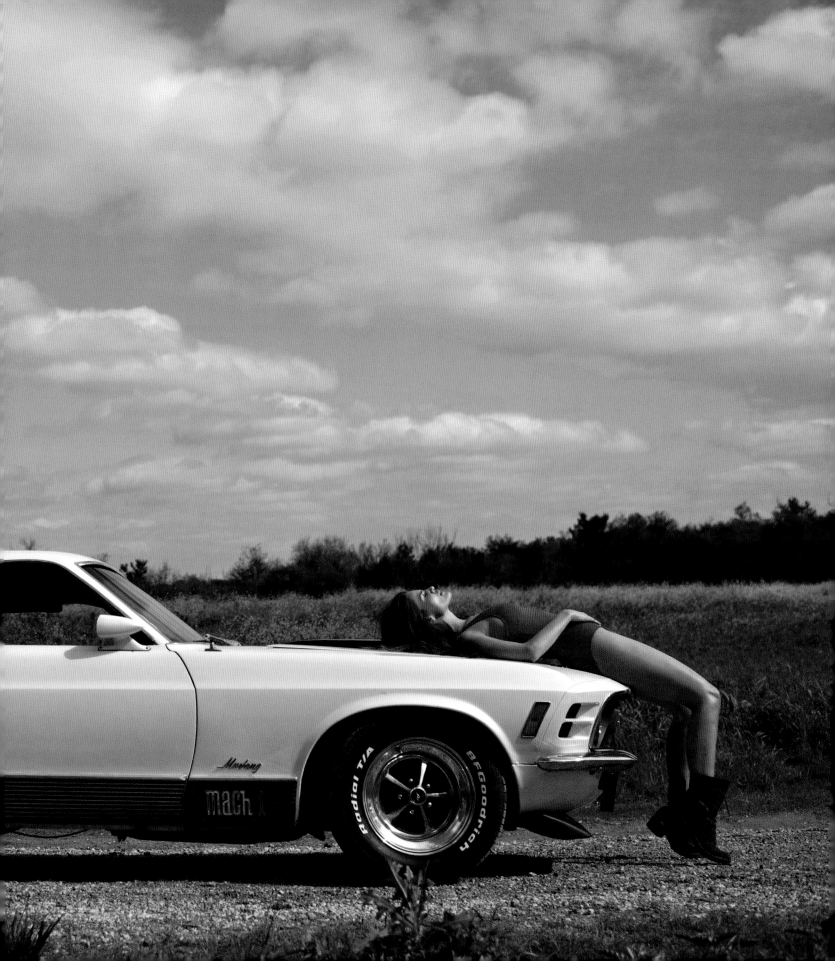

USING REFLECTORS

"A gold reflector brings a warmth and glow to your images whereas a silver reflector will make your images feel cooler."

To create indirect light you can also use gold, silver, and white reflectors like a bounce card. Often, I have to shoot swimwear when it's super-cold outside, and the natural lighting looks very frigid. But when you use a gold reflector to bounce sunlight onto your subject, this will warm up their skin tone. It's like instant summer. A gold reflector brings warmth and glow to your images.

On the other hand, a silver reflector will keep colors the same, but brightened. Use it when you want to preserve the colors but need to brighten up your subject. If you want to create a more moody effect, start rotating your subject around. The more you move your reflector to the side, the more moody it gets.

A white reflector is a nice tool to highlight your subject in a softer, more diffused way than with a silver reflector. The effect you get from a silver reflector tends to be more punchy, while the white reflector looks softer and reflects less light.

BELOW **Gold reflector**
Here golden hour sunlight from behind is reflected back onto the models with a gold reflector.

OPPOSITE **Silver reflector**
While a gold reflector gives a bronze glow to an image, a silver reflector, as used here, is more true to the actual color balance and a model's skin tone. The model here already has an olive skin tone.

There are many ways to utilize reflectors:

1. Put your model in shade, and then bounce light into their face. (The shot on the right was done this way.)

2. Backlight your model with the sun and place the reflector in front to light up their face. This is my favorite method. (A lot of people think that the images on this page were shot with lighting gear, but I only used natural light and a reflector.) If you have a hard time getting your reflector to cover a large subject, sometimes you can bend it like a taco and the light will spread out a little bit. This is also good for full-body shots. You just have to play with it until it looks right.

3. Use a reflector as a nice rim light. If you place your subject in direct light, facing the sun, you can make your image look even more dynamic by adding a reflector at the back to bounce the light and give your subject an edge light or hair light.

4. Use a small reflector. When photographing beauty headshots in a studio, I will utilize a small white reflector just under the chin to bounce the light into the subject's eyes to make them stand out. Reflectors are beneficial in the studio as well as in sunlight. The same technique can be used in both scenarios.

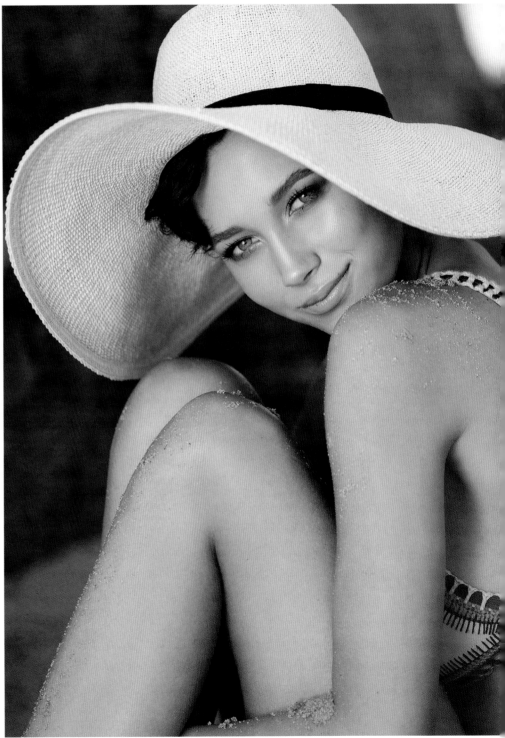

CONSTANT LIGHT

Now I'd like to talk a little about constant light or video light, which I have really come to love for a few reasons. Constant light refers to all types of artificial sources that remain constant or powered on, unlike strobes that emit light in bursts. There are many types of constant light including tungsten sources, fluorescents, HMI, and LED. The big advantage of constant light over strobes is that you get to see exactly how the scene will look and where exactly the light is falling before you click the shutter. So as with natural light, what you see is what you get.

SHOOTING WITH CONSTANT LIGHT

Constant light comes in very handy when you want to shoot quickly, as you don't have to wait on the recycle time of a strobe. I also find it particularly helpful when I am working in a space with nice ambient light and I just want to accent it with a constant light. The first thing I do when I shoot in a space is I check out the ambient light. I look at the window light and the quality of light in different parts of the room, and then I choose which areas would work best to shoot in. Window light is naturally beautiful, and when you add video light to it you can get some amazing results.

If you're looking to recreate daylight in a studio or space, there is nothing better than an HMI light like an ARRI. HMI stands for Hydrargyrum Medium-Arc Iodide. It is a beautiful and high-quality light source that produces light at a temperature of 5600K. It uses an arc lamp instead of an incandescent bulb.

HMIs are popular among directors and production companies because they allow you to create daylight

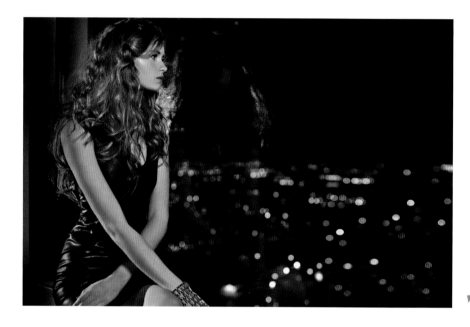

wherever you need it. If you are not familiar with HMIs, just think about a movie that takes place outside but that you know was filmed in a studio, like *Pirates of the Caribbean*.

Over the following pages I'll discuss some of my favorite constant light sources.

ABOVE **Ambient light**
For this image, I wanted to capture the bokeh of the city lights in the background. Then I used a GL1 Hotlight to highlight the model in the frame—the mix of these constant lights worked well.

OPPOSITE **Shadow**
Here a black flag over an HMI light creates a sense of mystery.

"You can figure out how to make a beautiful photograph just about anywhere."

RIGHT **Stairs**
On this set of imagery, we used two HMIs: one underneath the stairs and one directly on the model with a softbox over it to soften it.

STAIRCASE

We wanted to create more interest so we used lighting, hidden behind the stairs, to create leading lines. To exaggerate the modern architecture I shot using cool tones for a futuristic feel. The yellow ball was chosen as it is a complementary color of the blue, and that can take a pretty normal space—a gym staircase—into something interesting.

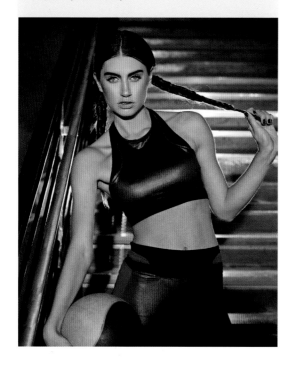

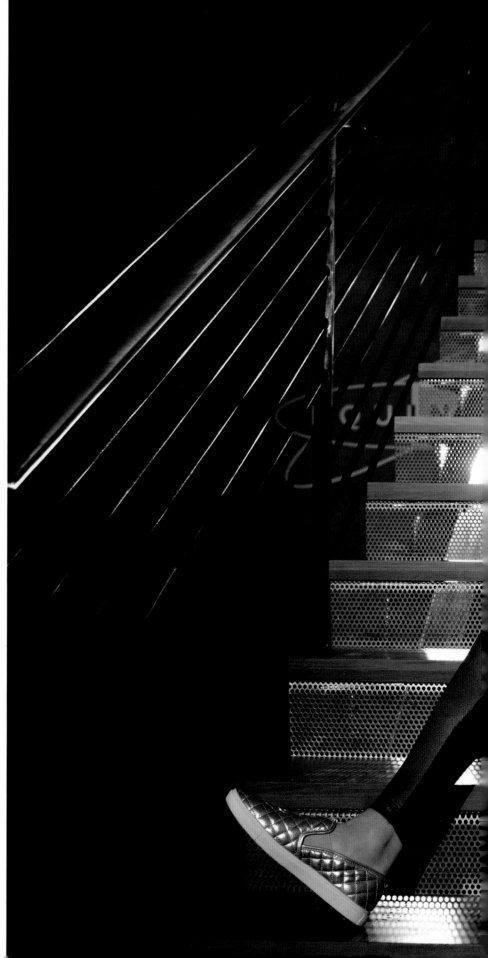

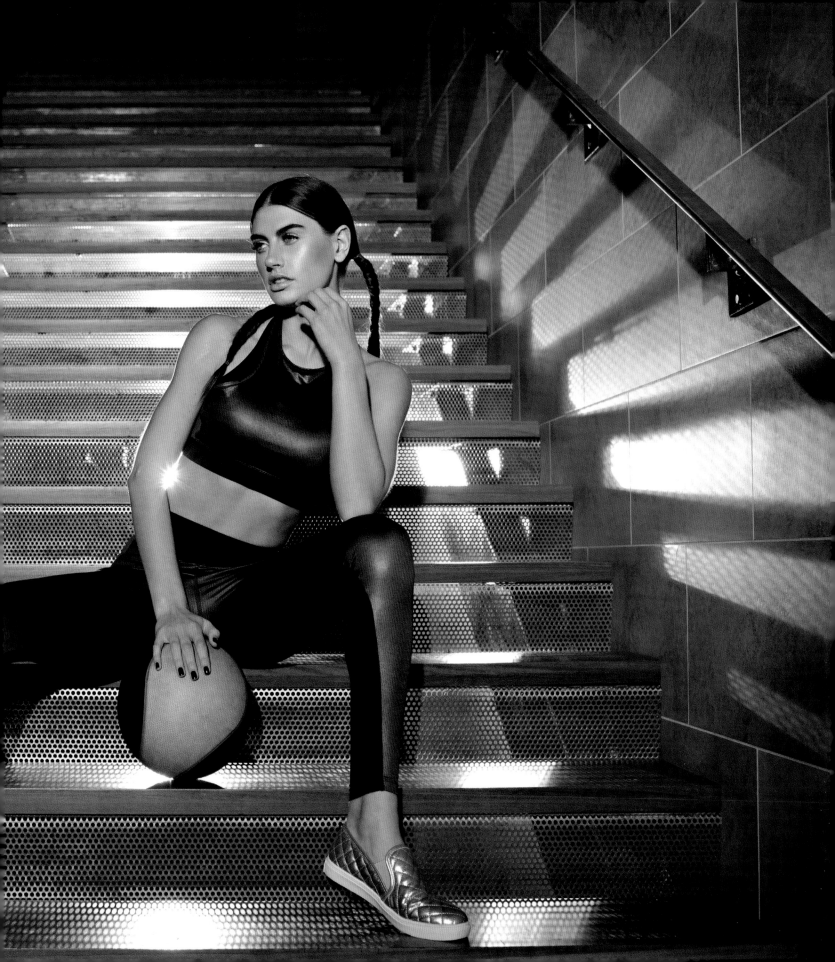

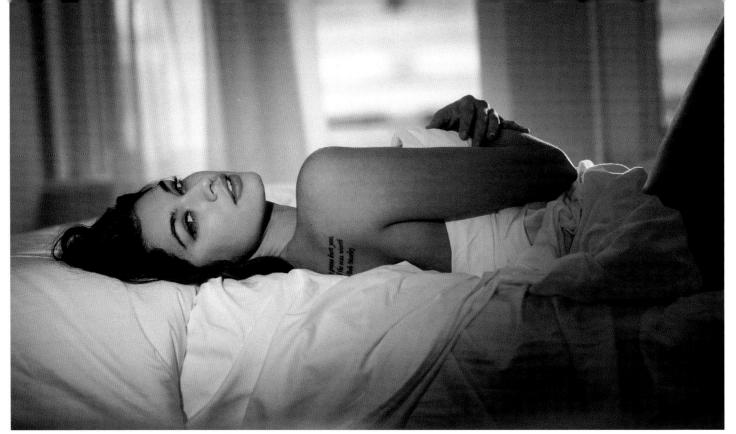

COMPACT CONSTANT LIGHT SOURCES

GL-1 HOTLIGHT

The Lowel GL-1 Power LED is an amazing compact tungsten light source. It is extremely bright, has a focusable head, lockable dimmer, and a tripod mount. It's compact, handheld, and you can either plug it in or utilize the battery so it is super-portable. I started using it when I was shooting weddings/events because of its ease of use and portability. You can also focus the light if you're using it as a hair light or you can pull back and use it as a soft main light. When working with this type of lighting, I love shooting with pretty wide-open apertures like F2.8. This creates a moody, dramatic feel because the background falls out of focus and it draws more attention to your subject.

"What I love about this type of lighting is it is pretty much 'plug and play'—you can see exactly what it is going to look like in-camera since it's a constant light source."

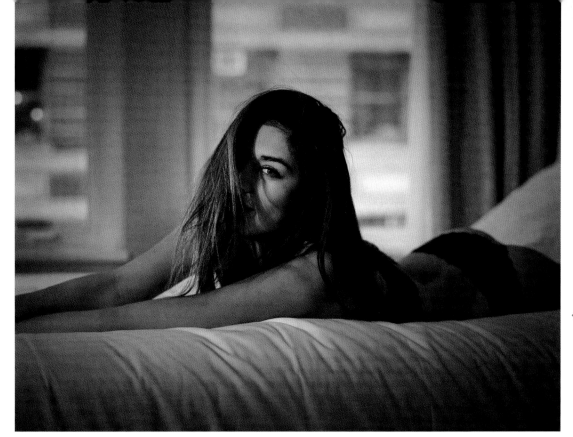

ALL Compact lights
For this story, I was looking to create beautifully simple yet moody lingerie fashion images. It was an overcast day so we didn't have much natural light coming through the windows. I used the Lowel GL-1 Power LED to illuminate the model and create dynamic lighting that is punchier than the overcast daylight, hiding one of the lights on the windowsill behind the model. What I love about this type of lighting is it is pretty much "plug and play"—you can see exactly what it is going to look like in-camera since it's a constant light source. I used the Nikon D810 and the NIKKOR 85mm f/1.4 lens for most of these shots.

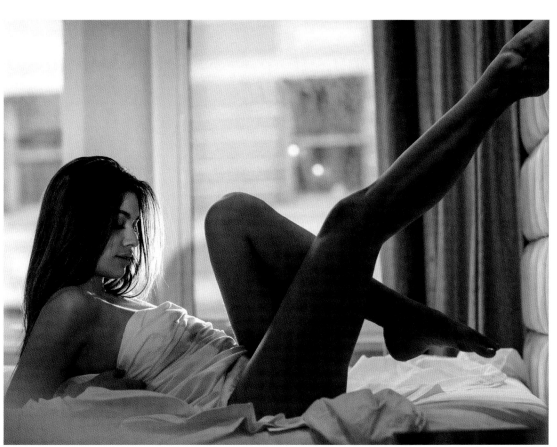

LEFT **Beauty light**
For these images I used natural window light as the key light and the Ice Light to illuminate the model's hair.

OPPOSITE **Diva-Lites**
The Diva-Lites are great when shooting on location inside and you want to work with the ambient light that is already there, since the Divas are dimmable and you can change color balances.

ICE LIGHT

The Westcott Ice Light 2 is a beautifully compact LED that is daylight balanced. It produces soft, even light and runs both AC and DC power, which makes it a great travel light source. I particularly use this light on location when I want to add to the ambient light. You can add barn doors to create a more focused light source.

Once again, it's about trusting your own eye and going with what you think looks right. The best way to use this light is to play around with it. The direction you hold the light (horizontal, vertical, or in between) is very important.

DIVA-LITE (KINO FLO)

One of my favorite constant light sources is the portable Diva-Lite or Kino Flo, which is basically a high-powered soft fluorescent light source. The big advantage of these over HMIs is the size—they are much smaller and more compact so you can fit them in smaller spaces. They also boast a full range of features from full-range dimming, remote control features, and color balance capabilities that you achieve by switching out the bulbs.

"Once again, it's about trusting your own eye and going with what you think looks right."

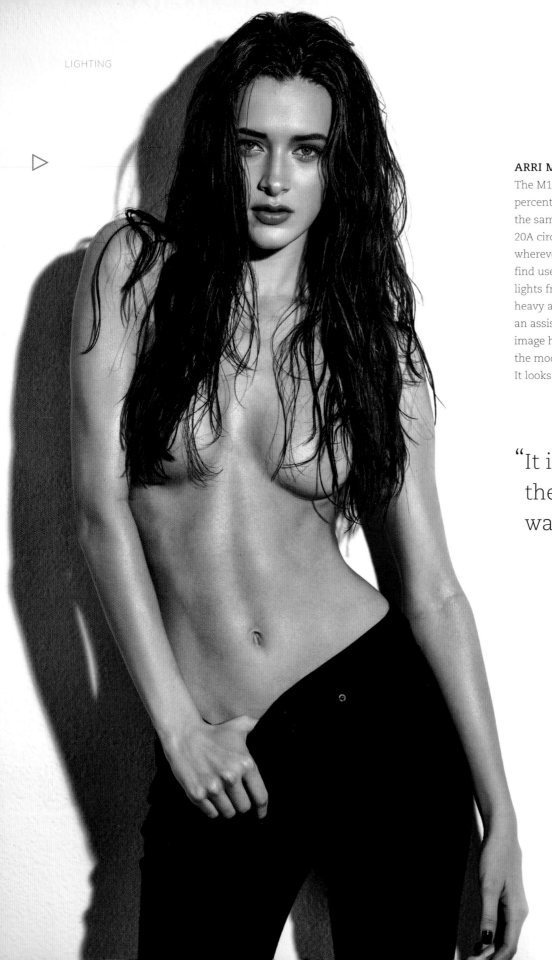

ARRI M18

The M18 is my favorite HMI light because it is 70 percent brighter than the 1200-watt HMI, but it is the same size and you can still plug it into a normal 20A circuit. It is basically like putting the sun wherever you want it! It is this type of lighting you'll find used on movie sets, and you can rent these lights from local video rental houses. They are very heavy and require a ballast, so it is best to work with an assistant when using this type of lighting. The image here was shot with just one HMI directly on the model, creating the sharp shadow behind her. It looks a lot like natural light.

"It is basically like putting the sun wherever you want it!"

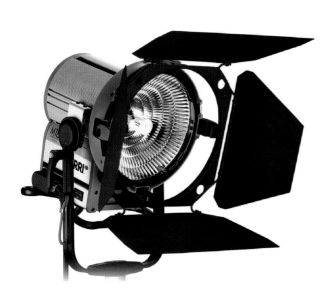

It's important to rent flicker-free HMI lights. If you don't, you'll end up getting different color balances in every image. I've personally experienced this and it can be a retouching nightmare. When you first fire one up, wait 15 minutes before you begin shooting as the color balance tends to look green while the light is warming up.

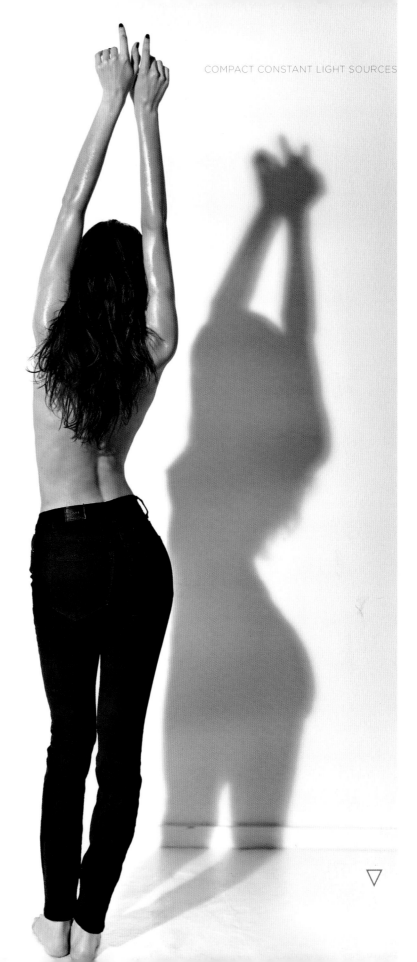

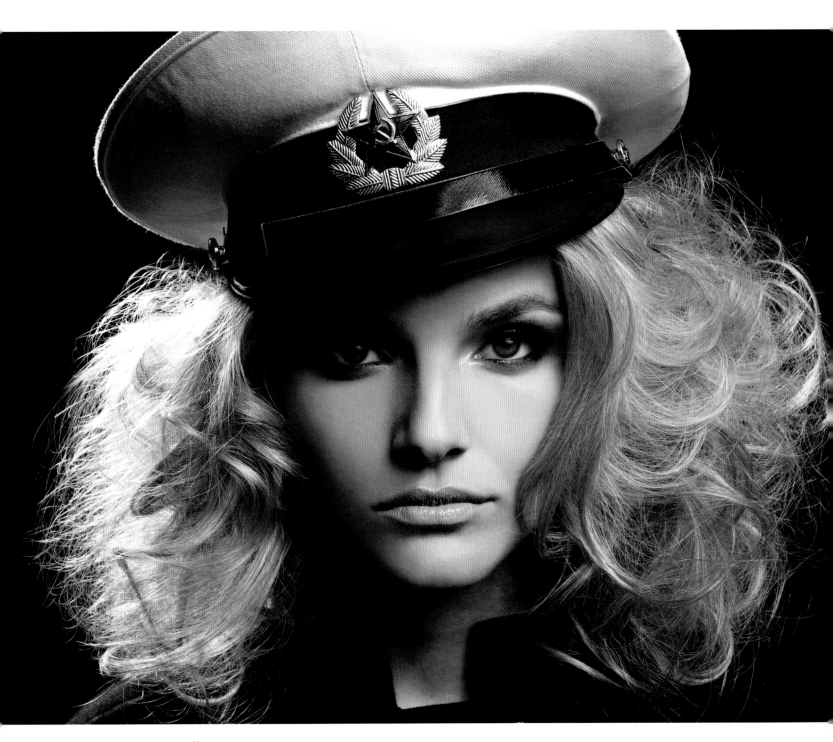

"Strobes allow you to use fast shutterspeeds and
freeze any motion to get a very sharp image."

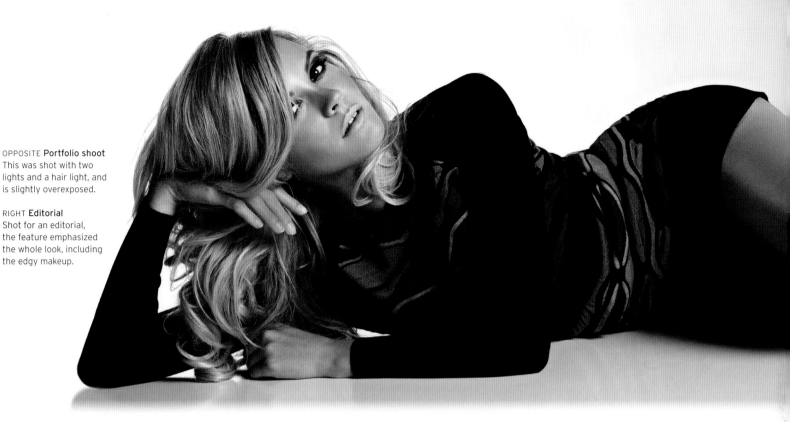

OPPOSITE **Portfolio shoot**
This was shot with two lights and a hair light, and is slightly overexposed.

RIGHT **Editorial**
Shot for an editorial, the feature emphasized the whole look, including the edgy makeup.

STROBE LIGHTING

Strobe lighting produces short, intense flashes of light that can freeze the motion of rapidly moving subjects. It is great for fashion and sports photography because of this capability. Strobe closely matches daylight color balance, has a very high light output so you are able to overpower the sun if needed, and uses AC power. The biggest advantage of strobes is the quantity of light output over a short time period, which allows you to use fast shutterspeeds and freeze any motion to get a very sharp image. Since strobes operate at low temperatures, there are a lot of beautiful lighting modifiers available to shape the light. I love the Profoto B1s, which are battery-powered moonlights and are great for using on location as you don't have to plug them in. I always bring extra batteries, just in case.

SHOOTING WITH STROBE LIGHTING

To learn how to use strobe lighting, I rented a studio by my house for a few hours a week to experiment. I would bring in a fashion image and try to recreate the lighting in it. The studio owner, Kauwuane Burton, was extremely helpful in guiding me on how to use the strobes and where to place them. I learned so much from him as his lighting is exceptional and I'm forever grateful for his help.

Here are my basic go-to settings when using strobes:
• Shutter speed 1/250 OR use High Speed Sync for faster shutterspeeds with a Profoto TTL-N remote.
• Choose your aperture based on how much depth of field you want or how much of the image you want in focus.
• Use a low ISO.
The key to learning any type of lighting is really just plenty of experimentation.

TOP TIPS

Here are some tips for learning how to use strobe lighting:

• Start with one light at a time. This is key!

• Try it at different heights and distances and see what you like best.

• Try different modifiers on that one light.

• Once you have a good understanding of the effects of one light and the modifiers, add in another light, maybe a hair light, and do the same thing.

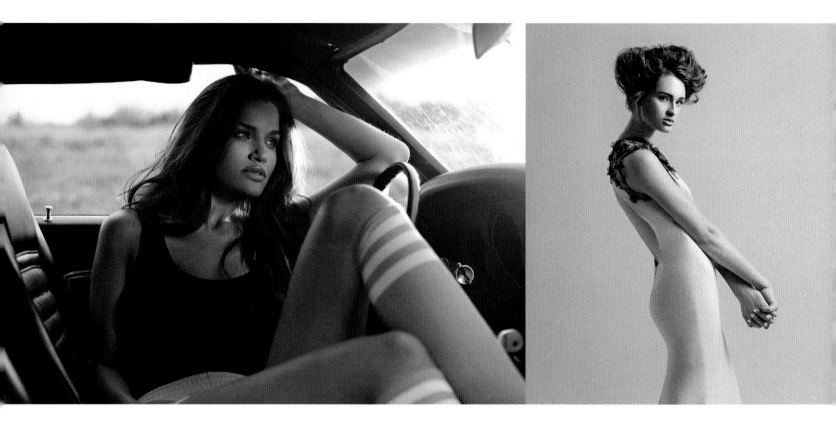

LIGHT SHAPERS

BEAUTY DISH

The beauty dish is a shallow parabolic dish that reflects light back into itself and out of the sides, and creates light that wraps around the subject. It is a soft yet contrasty light shaper and one of my favorites for photographing fashion and beauty. I prefer the beauty dish with the white interior coating as opposed to the one with the silver interior because it is much softer. The Mola Setti is one of my favorites because it is even softer than most beauty dishes.

UMBRELLA

This is a collapsible and broad light modifier that is soft and diffused and throws light in many different directions. The big advantage of umbrellas is their portability and versatility, yet it may be tricky to get contrasty, moody light from this type of shaper.

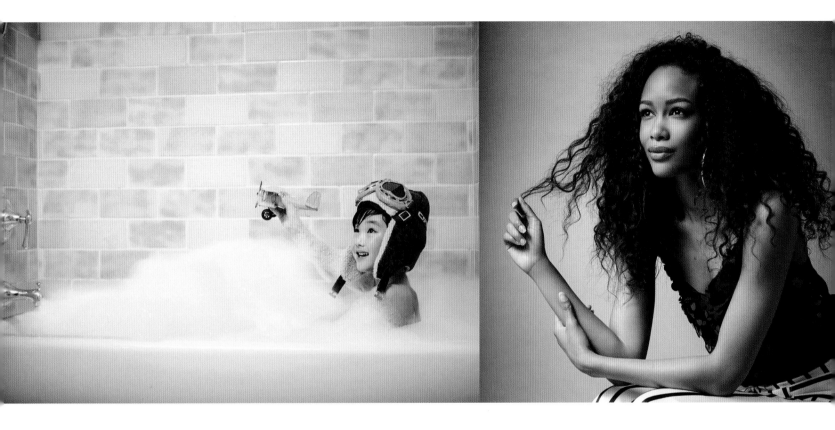

"Parabolic has a unique look where the light wraps around the subject and creates specular highlights that emphasize details."

SOFTBOXES

A softbox is one of the most flattering light modifiers on all skin tones because it creates soft diffused light and a gradual transition from light to dark. There are many different sizes and shapes of softboxes and one of my favorites is the large 8ft Octa, which creates a broad soft light, as well as the strip boxes, which are great for creating rim light.

PARABOLIC

The parabolic is one of the most gorgeous fashion lighting modifiers because it has such a unique look where the light wraps around the subject and creates specular highlights that emphasize details. This type of modifier is great for bringing out hair texture while also making skin also look gorgeous.

LIGHTING SETUPS

There are infinite possibilities when choosing lighting setups, depending on your subject and situation. I tend to try to keep the setup as simple as possible, and always work hard to make my subjects look their best. Here are some basic go-to setups that I often use.

HIGH KEY

High-key lighting is bright with no shadows and a white background. The biggest mistake I see with this type of lighting is that a lot of photographers tend to overexpose the background. The background only needs to be about half a stop brighter than the subject in order to get the bright white look. If you overexpose the background, you end up with lens flare, which may not be desirable in this situation.

LOW KEY

Low key is the opposite of high-key lighting. It utilizes dark shadows, heavy contrast, and a dark background to convey a sense of drama.

BELOW **Seamless background** In order to avoid footprints on a white background you can use white panel board, which is essentially linoleum flooring. It should be the solid, shiny board, so the light blows out to create this seamless effect.

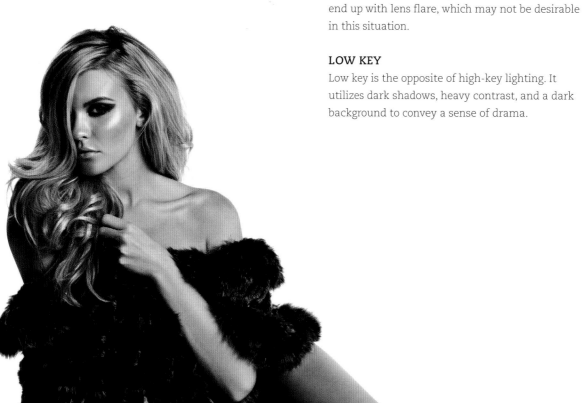

"The background only needs to be about half a stop brighter than the subject in order to get the bright white look."

ABOVE **Focusing attention**
By letting so much of the frame fall into shadow, attention is naturally pulled toward the face, particularly his blue eyes.

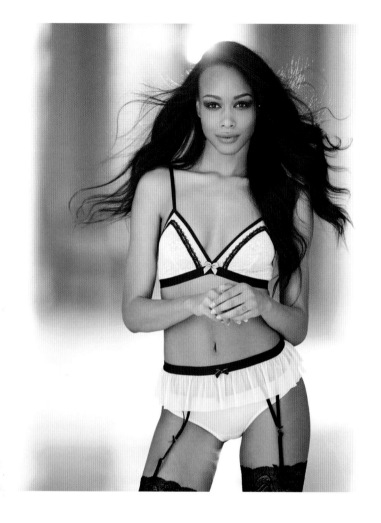

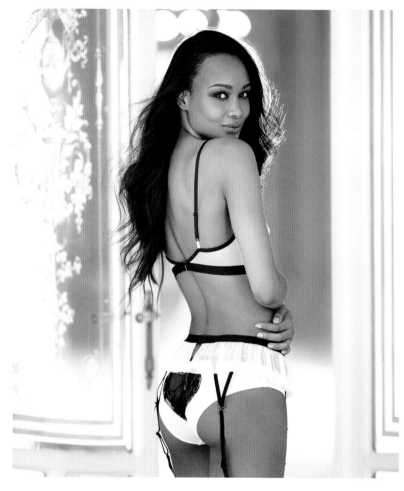

▷ **BOUNCING STROBES OFF WALLS**
If you are looking for lighting that is soft and airy, instead of positioning your light directly on your subject, you can position it to bounce off a wall onto your subject for a softer, more natural look.

MIXTURE OF STROBE AND DAYLIGHT
Mixing daylight and strobe creates a nice punchy light that brings out colors. You can overpower the sun to create a high fashion look.

"There are infinite possibilities when choosing lighting setups depending on your subject and situation."

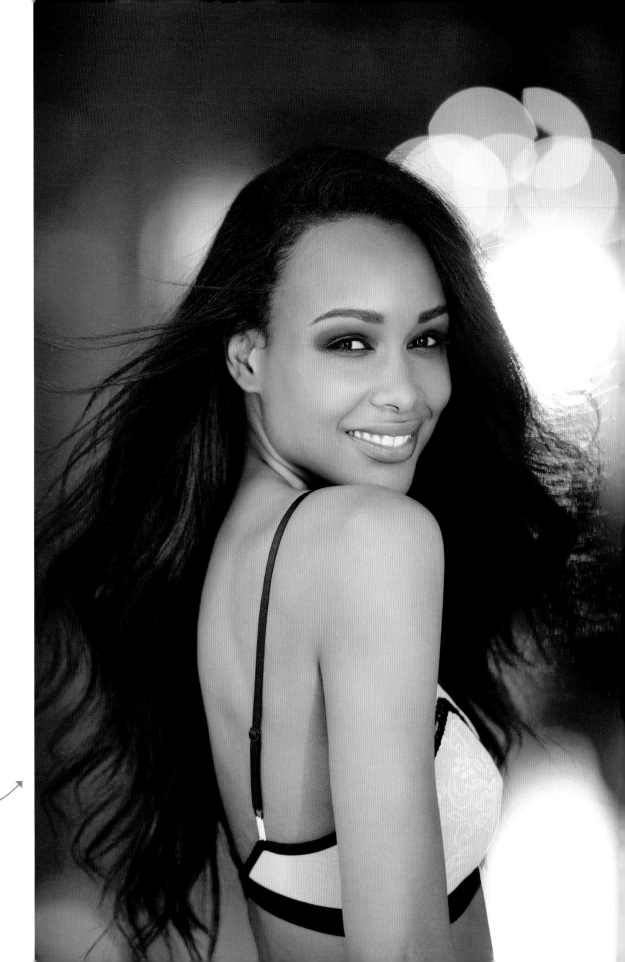

OPPOSITE & RIGHT **Multiple sources**
This shoot used a complicated
arrangement of lights. Profoto
D1 bare heads bounced into the
corner of the far wall (set at 3), and
another pointed at the back of the
model (set at 6). A B1 bare head
(set to 2.5) was bounced onto the
opposite wall of the main lobby
(behind the model), and finally
another B1 bounced into the corner
of the hallway where the camera
was placed (set to 4).

SPECIAL EFFECTS

The biggest secret to photography is experimentation. The more you experiment in your photography, the more unique your pictures will be! You should experiment with different light sources, setups, filters, and special effects.

FILTERS IN FOCUS

Tiffen 8pt Star Filter: On this particular shoot, the client was looking to create the look of a high-end production on a tight budget. The original setup we made was for an album cover so I ended up shooting personal work the next day with a similar concept, background, model, and dream team. For the background, we strung a bunch of small tungsten lights from the hardware store and two nine-lights in some of the images. To illuminate the model, we used a Profoto B1 with a strip box as the key light. Then we then added in a fog machine to create a

moody haze, but it was still missing something. So I decided to put a Tiffen 8pt Star Filter on my lens, which created a dramatic flare effect with all of the background lights. You can see the HUGE difference in the before and after images. Basically, the filter creates multiple points of light from central light sources and you can rotate the filter for placement of the effect. So if you're looking to experiment and create some unique cinematic looks, you might try using filters like this. I shot these images with the Nikon D3X camera and a long lens, the NIKKOR 180mm ƒ/2.8. This is an older lens made for film cameras, so it doesn't have the nano-coating of newer lenses, and creates more lens flare, which added to the overall effect. My settings were: aperture ƒ/5.6; shutterspeed 1/125; ISO 100.

BOTTOM LEFT & MIDDLE **Unfiltered**
On the left is the test shot showing the standard tungsten bulbs from the hardware store; in the middle image you can see the effect of the Tiffen star filter.

BELOW RIGHT **Filter effect**
The Tiffen star filter creates a high production feel.

OPPOSITE **Filter on powerful lights**
The star filter has an even more pronounced effect in front of the big square shapes of the nine-light lights.

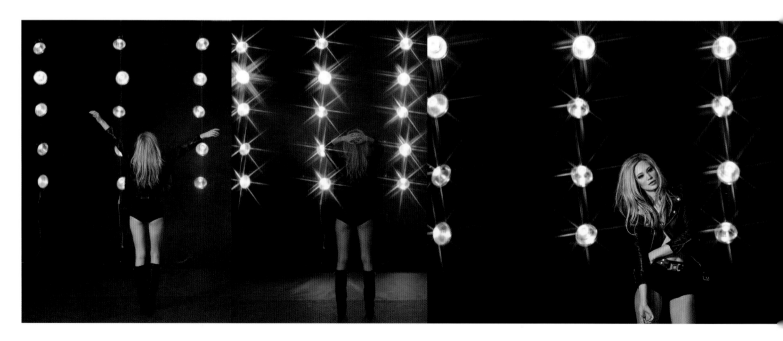

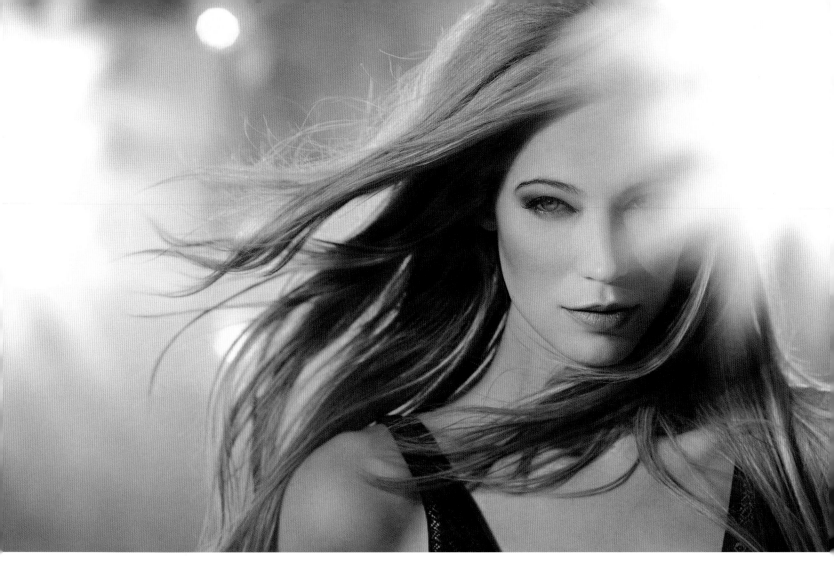

"The more you
experiment in
your photography,
the more unique your
pictures will be!"

▽

▷ **EFFECTS IN FOCUS**

Vaseline: These were test shots for a magazine submission. I wanted to bring out the ethereal look of her clothes and beautiful feminine lines. So, I tried something I've never done before. Do you guys know how this was shot? Bet you would have never guessed I used Vaseline!

I bought some Tiffen filters and put a ton of Vaseline at the bottom half of the filter. This blurred out the bottom of the frame and made it look like the model was floating. Pretty cool right? And yes, you could accomplish this effect in Photoshop, but I would rather do this in-camera; it's more organic that way.

"Yes, you could accomplish this effect in Photoshop, but I would rather do this in-camera; it's more organic that way."

OPPOSITE **Simplicity**
We positioned the light with a shoot-through umbrella at a 45 degree angle to the model. Some of the most effective lighting setups are very simple.

RIGHT **Three-for-one**
One night I was up late retouching images and this was the result of a happy accident; the image was duplicated in a lower opacity in Photoshop. The dress designer is Nha Khanh, and this dress is one of her most popular sellers on Rent the Runway.

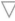

▷ "Using crystals in front of my lens creates a nice twinkly light that is particularly beautiful for wedding fashion and couture looks."

Crystals: One of my favorite tricks to create bokeh in the foreground of a fashion image is to use crystals in front of my lens. This creates a nice twinkly light that is particularly beautiful for wedding fashion and couture looks. The key is to use a longer focal length lens like the 105mm, and then tape the crystals to the lens at the edges. You can also place a string of crystals a foot in front of the lens and shoot through them. You want to shine a light on them from the front in order to get them to stand out and not look muddy.

OPPOSITE **Depth of field trickery**
Because things placed very near the lens will be well outside the depth of field, they will not be in focus. If they have a very tiny point of light, that point will create a shape revealing the camera's shutter—this is the bokeh. That's what is happening here.

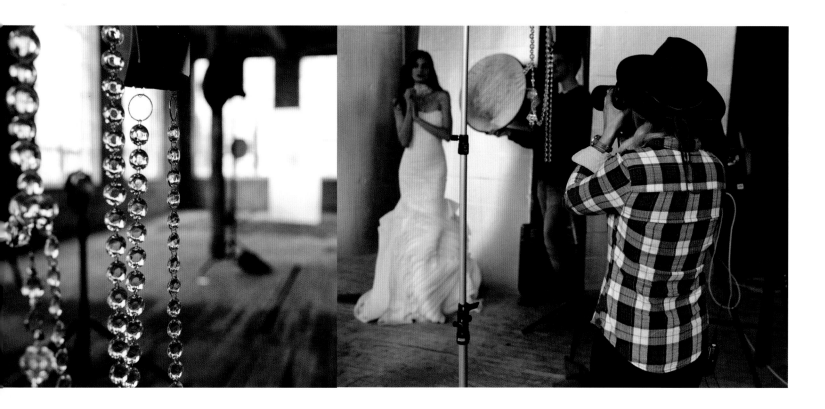

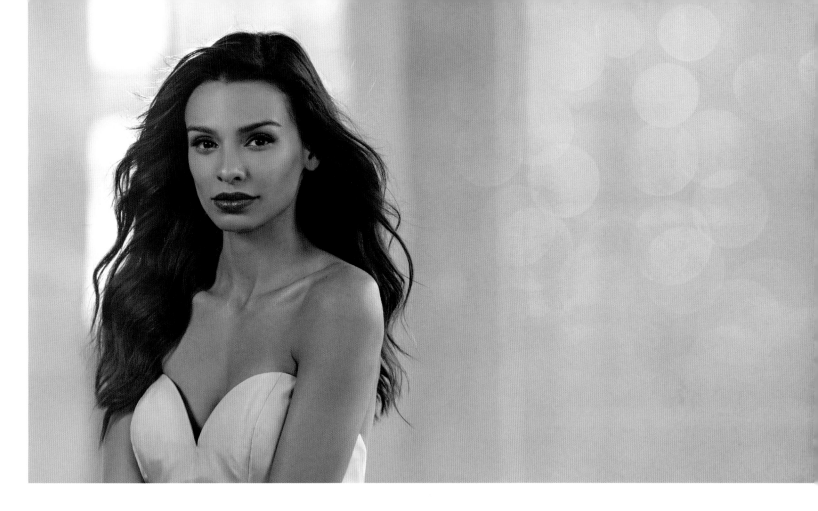

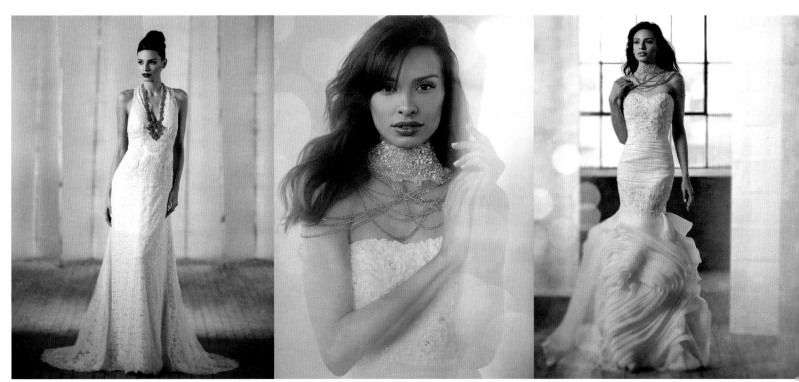

5 THE FASHION PHOTOGRAPHY INDUSTRY

GENRES OF COMMERCIAL
PHOTOGRAPHY

FASHION IN FOCUS

BEAUTY IN FOCUS

LIFESTYLE IN FOCUS

EDITORIAL IN FOCUS

SWIMWEAR IN FOCUS

LINGERIE IN FOCUS

CASE STUDY:
AN EXTRAORDINARY CLIENT

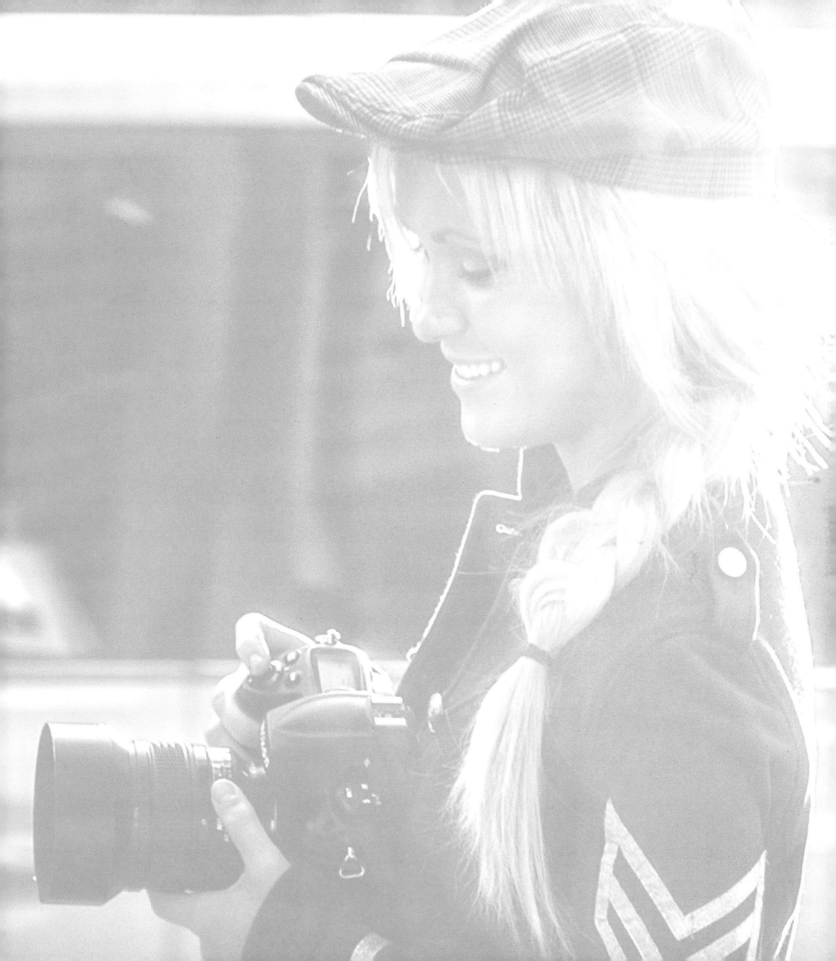

GENRES OF COMMERCIAL PHOTOGRAPHY

As a commercial advertising and fashion photographer, my passion is bringing brands' visions to life. I love getting to know each brand I shoot for, almost like I would a person. There is a ton of research that goes into this, including looking at their logo, fonts, color palette, and overall persona. I will research all aspects of the brand, and ask a lot of questions of the client so I can bring their vision to life in the imagery I create for them.

Whether you are shooting fashion, beauty, lifestyle, editorial, swimwear, or lingerie, or any other genre commercially, the key to being a successful commercial photographer is to fully understand the client's vision, and then to execute it in your own style. Commercial clients are essentially hiring you for your own vision and style, so you want to bring them to life in the images while capturing their concept.

Within commercial photography there are many sub-categories; here are some I often shoot:

FASHION

Fashion photography is not just about selling garments, it is more importantly about selling the lifestyle, the dream, the fleeting feeling of wearing the fashion. It depicts a mood that tells the story of the fashion. There are no rules, no boundaries, just pure self-expression.

Most fashion photography showcases the models as mannequins or hangers to display the fashion, but I prefer to look at each model as an icon, a muse; a beautiful soul with a personality. It is always my goal to bring out the personality of the model in addition to illustrating the story of the fashion. There are two main types of fashion photography: editorial, which is shot for magazines and is a

BELOW LEFT TO RIGHT **Genres** Fashion, beauty, lifestyle, swimwear, and lingerie.

reflection of an idea, and commercial fashion photography, which is selling a particular brand, piece, or collection. This would also include designer lookbooks, which showcase the garments within a designer's collection, and high fashion/couture, which tend to look more like fine art.

BEAUTY

Beauty photography focuses primarily on faces and, depending on the shoot, may focus on makeup or hair to sell cosmetics or products, or, if we are speaking of editorial beauty for magazines, it may explore a certain style of makeup or hair. Beauty photography can also advertise products such as jewelry.

LIFESTYLE

Lifestyle photography is all about creating an environment for the viewer to live in. It may capture an essence or mood, or a fleeting moment. Just about every industry utilizes lifestyle photography in their advertising, from healthcare to travel to consumer and

business products. This is a huge part of the commercial industry and a genre I often shoot.

SWIMWEAR

Swimwear photography obviously focuses on capturing models in beachwear for swimwear brands. This type of swimwear photography focuses more on the product and brand, whereas photographing models for magazines such as *Sports Illustrated* showcases the location, mood, and connection with the subject, as well as the models' physique—the swimwear is secondary.

LINGERIE

Lingerie and intimates focuses on photographing models wearing lingerie. It could be selling the lingerie itself, perfume, or other products.

"My passion is bringing brands' visions to life. I love getting to know each brand I shoot for, almost like I would a person."

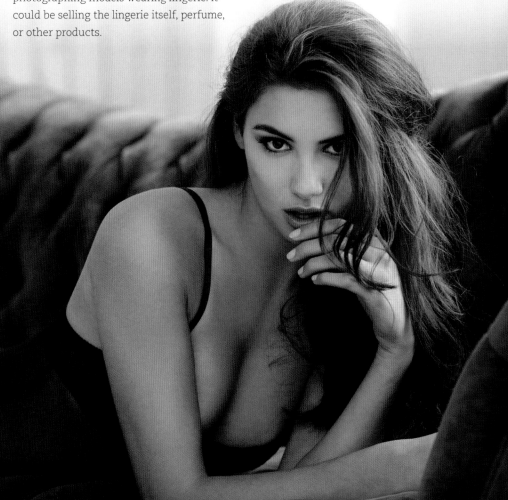

FASHION IN FOCUS

SLATE DENIM CAMPAIGN

I received an email from a marketing director at a denim company called Westmoor Mfg. [Manufacturing] Co., which owns brands from Panhandle Slim [Panhandle Western Wear] to Rock & Roll Denim. They handle all their shoots in-house, and when I met with them I discovered that they wanted to hire me to photograph their newest line, called SLATE Denim & Co., which has a younger demographic than their other traditional brands.

The art director gave me creative freedom to bring their brand to life. I was able to direct the entire production.

RESEARCH

My starting point for this job was to reverse-engineer the company's branding process. I found their brand definition, which I used as a starting point:

"SLATE" noun
a fine-grained gray, green, or bluish metamorphic rock. Slate is created by the metamorphosis of materials over time, and can take on many different shades of gray with tints of green, blue, cyan, or even purple based on the surrounding minerals. As with the stone, an individual, based on their surroundings, influences, and experiences is shaped and formed over time. It's the individuality in the stone from which SLATE Denim & Co. draws its inspiration.

"I was able to direct the entire production."

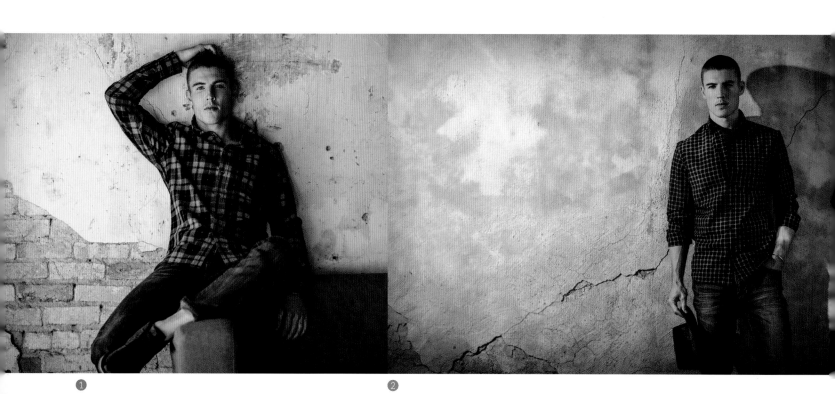

1

2

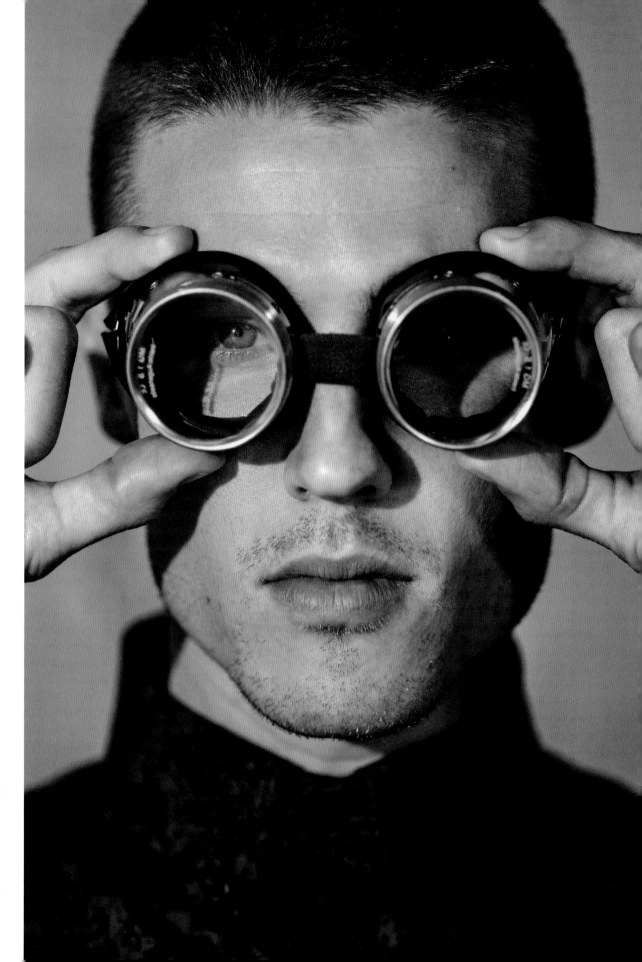

1. Lens: 85mm ƒ/2.8 | 1/500 sec | 400 ISO

2. Lens: 58mm ƒ/1.4 | 1/640 sec | ƒ4 | ISO 160 | Flash fired

3. Lens: 180mm ƒ/2.8 | 1/800 sec | ƒ/2.8 | 400 ISO | Flash fired

ALL **Consistency**
For this particular shoot, the lighting had to be consistent in all of the images, which was challenging since we were shooting both inside and outside. Most of the natural light was soft and muted, so we added in a strobe to create some contrast and edge. You can use side-lighting on men more so than women, and this brings out more texture within the garments, which is an added bonus.

3

▷

"The format they required was primarily horizontal for their lookbook and website, which was a little challenging since I am so used to shooting vertical images for fashion commissions."

①

②

TOP TIPS

- Research your brand thoroughly when you take on any job.

- When art directing a campaign, find a starting point and build your vision around this, considering how the set, models, lighting, and camera settings can bring your vision to life.

- It is essential to find out if the client has any requirements regarding the placement of text. Often with advertising work, as well as editorial commissions, there will be specific places that text will need to be placed. You will need to leave space for this, and make sure there are no distracting elements in this area.

1. Lens: 85mm ƒ/1.4 | 1/800 sec | ƒ/2.8 | 400 ISO | Flash fired
2. Lens: 58mm ƒ/1.4 | 1/250 sec | ƒ/3.5 | 400 ISO | Flash fired
3. Lens: 58mm ƒ/1.4 | 1/640 sec | ƒ/4.0 | 160 ISO | Flash fired

ALL **Textures**
I always look for interesting textures for backgrounds, and this coffee shop, called The Book Club Cafe, had the perfect look inside and out.

My vision was to capture the denim and shirts with a mix of textured backgrounds and choose an edgier model for the job—that was key. I immediately thought of a model I had photographed before who has a shaved head, sharp jaw line, and would give the images the exact vibe they were looking for. I remember a coffee shop that had great textured walls so my producer called them and asked if we could shoot there. The ambient lighting outside and inside of the coffee shop was relatively soft, so we added one light to give it some contrast. We used the Profoto B1 with a beauty dish and positioned it to one side to bring out the texture in both the jeans and the walls.

The format they required was primarily horizontal for their lookbook and website, which was a little challenging since I am so used to shooting vertical images for fashion commissions. The horizontal format worked well as it provided negative space for them to place their logo and info. However, I always shoot some images for my book after I've nailed the shots on their list. They ended up using some of these vertical images as well.

③

BEAUTY IN FOCUS

MACADAMIA NATURAL OIL CAMPAIGN

I was stoked to get a phone call about shooting a beauty campaign for a hair company called Macadamia Professional. I had worked with one of their marketing directors on a previous shoot for a different beauty company, and it is always nice to get a callback from creatives you've worked with before. There is a level of comfort in the relationship that allows you as a photographer to push the envelope creatively.

Their vision for the campaign was to showcase naturally beautiful, effortless hair in order to bring life to their Natural Hair Oil product. After researching the brand, I found important information about the line: "Macadamia Natural Oil contains the highest amount of Omega 7 than any other nut oil . . . Omega 7 is exceptionally lightweight and non-greasy with no build-up, which makes it ideal for all global textures, from the finest to the coarsest hair."

So, the shoot had to feature a couple of different hair colors and textures. The client requested an online casting, which means casting from online portfolios. The agencies submitted a ton of beautiful women, but the key was to choose models with great skin and hair. The color scheme we went with was clean and neutral so as to not distract from the hair.

When you are shooting for a commercial client, it is extremely important to draw attention to the product they are selling, and in this case, it is the hair. When photographing hair, we almost always choose a soft yet contrasty lighting modifier to bring out the hair texture—the Para 177 with silver is my favorite on the Profoto D1; so that one light and modifier is all you need. We then placed two black V-Flats on either side of the models to prevent light from spilling everywhere. When you use a black V-Flat close to the model, it creates a dark edge around the person, so it is great for creating separation between the model and the background.

ALL **Black and white vs. color**
The client almost always uses the images in color, so I always shoot color and then convert to black and white in Adobe Photoshop using Kubota actions. My favorite action is "Bronze Goddess," which I then tailor to the model's skin tone within the layers.

TOP TIPS

- Always consider which product the client is advertising. This should stand out in some way within your image through lighting or composition.

- The model chosen for a particular campaign should embody the persona and look of the brand and the ideal demographic that the brand is selling to.

- Consider which lighting style will make the product look its best, while also making the model who is wearing or using the product look great as well. You may need to light them separately. To showcase the texture of a fabric, you'll want to light it from the side.

1. Lens: 85mm f/1.4 | 1/250 sec | f/5.6 | 100 ISO | Flash fired
2. Lens: 85mm f/1.4 | 1/250 sec | f/5.6 | 100 ISO | Flash fired
3. Lens: 105mm f/2.8 | 1/250 sec | f/5.6 | ISO 100 | Flash fired

"Their vision for the campaign was to showcase naturally beautiful, effortless hair in order to bring life to their Natural Hair Oil product."

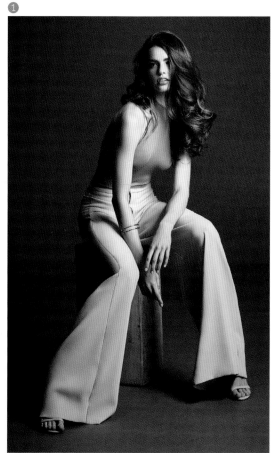

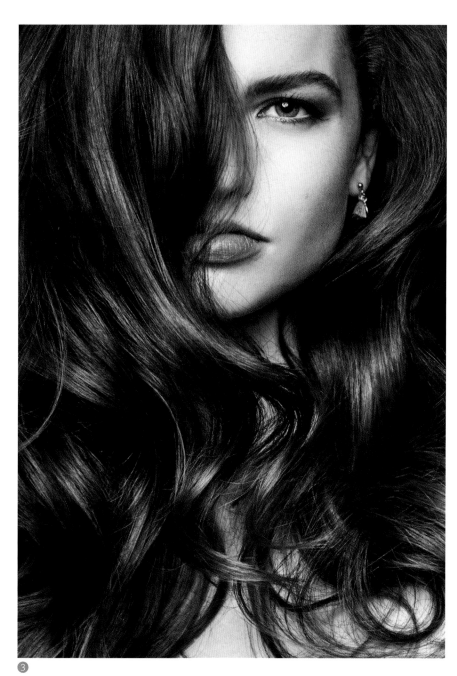

LIFESTYLE IN FOCUS

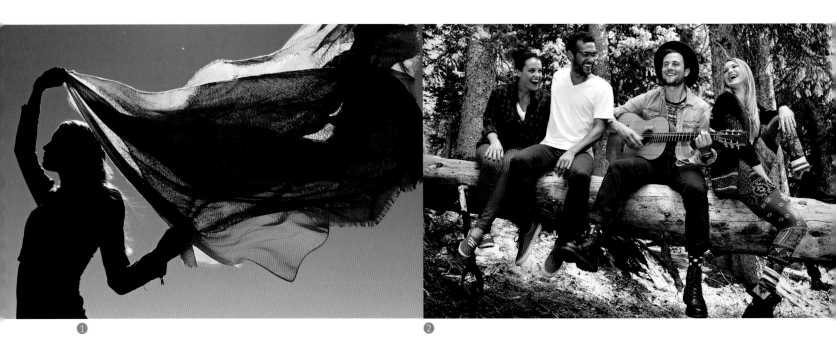

1 2

NIKON D5500 CAMPAIGN

From a production standpoint, the Nikon D5500 Campaign was definitely one of the most rewarding and challenging shoots I've had the opportunity to work on with over sixty total shots and locations and a crew of about twenty.

Nikon's ad agency in Japan reached out about the possibility of photographing the first-ever touchscreen DSLR camera, which was a huge honor and quite possibly one of the most exciting moments in my career. We spent countless hours on Skype with the incredible creative team in Japan, and we talked through the camera's capabilities, which I would need to showcase in the final imagery.

Their vision for the campaign was to capture the fun, hip lifestyle of twenty- to thirty-somethings on a cross-country adventure, so naturally I thought we should include a vintage Ford Mustang. The client approved Colorado for the location after I pitched them a few options from Arizona to California. Colorado provided a unique backdrop for the images that allowed us to capture both city scenes in Denver as well as beautiful mountain areas.

The concept focused on lifestyle imagery as opposed to high fashion, since their proposed demographic of the camera user would be hobbyists and enthusiasts looking to take better pictures. We primarily used natural light to keep the setup simple and quick, and to match what the camera's demographic would likely be using.

TOP TIP

- Consider your demographic. Key to shooting for a client where you are selling a product is to think about who your are selling it to. What do they like? What do they want? Who do they want to be?

"Their vision was to capture the fun, hip lifestyle of twenty- to thirty-somethings on a cross-country adventure."

There were four main challenges to the shoot shown above:

1. I wasn't able to work with the camera until the day before the shoot. Because the camera hadn't been released yet, security was a very important factor so as not to leak anything to the public.

2. No photoshop would be allowed on the final imagery. This meant that I would have to capture everything perfectly in-camera.

3. The detailed shotlist required the exact aperture, shutterspeed, and lens choice, so I had to stay on top of these details when shooting.

4. Nikon preferred non-professional models for the shoot, so we cast four college students for the campaign. They did a really great job.

One of the coolest aspects of shooting for Nikon brochures is that everything you see, from the stills to the video, is actually shot with the camera they are promoting—so there is truth in the advertising.

ABOVE **Behind-the-scenes**
A big part of these kinds of campaigns is video, since it drives traffic to the website and imagery. For this job I brought on an incredible cinematographer, Sam Ryan, to capture behind the scenes of the entire shoot, and we used a Steadycam to create smooth clips. You can see the video on Nikon's YouTube page.

1. Lens: 24mm f/2.8 | 1/640 sec | f/11 | ISO 200

2. Lens: 35mm f/2.8 | 1/250 sec | f/5.6 | ISO 200

3. Lens: 58mm f/1.4 | 1/640 sec | f/5.6 | ISO 400

4. Lens: 58mm f/1.4 | 1/800 sec | f/8 | ISO 160 | Flash fired

▷ **JAMES AVERY JEWELRY**

The day we shot the James Avery Jewelry fall campaign was the day of an enormous storm and torrential downpour, but you would never know it in the final images. In fashion, everything is shot in the opposite of the current season, so winter clothes are usually shot in the summer, and vice versa.

When we shot this campaign it was spring and mostly green outside. The client had specified that they wanted fall colors, along with Japanese Maple trees in the background. The location we found had the right trees but the rest of the property was green, so we had the stylist order faux leaves and branches for the background.

On the day of the shoot it was extremely overcast and cloudy. We managed to pull off the first images before it started pouring down with rain. We ended up having to shoot on the porch the rest of the day, but somehow got all the shots they needed.

ALL Lifestyle casting
Casting is especially important for lifestyle jobs because the models have to bring a lot of energy to set. I always choose the models who show a lot of enthusiasm and personality at the casting. Ultimately the client has final say, but I always give them my recommendations.

1. Lens: 85mm f/1.4 | 1/200 sec | f/2.5 | 400 ISO | Flash fired
2. Lens: 180mm f/2.8 | 1/250 sec | f/2.8 | ISO 400 | Flash fired
3. Lens: 180mm f/2.8 | 1/250 sec | f/2.8 | ISO 640 | Flash fired

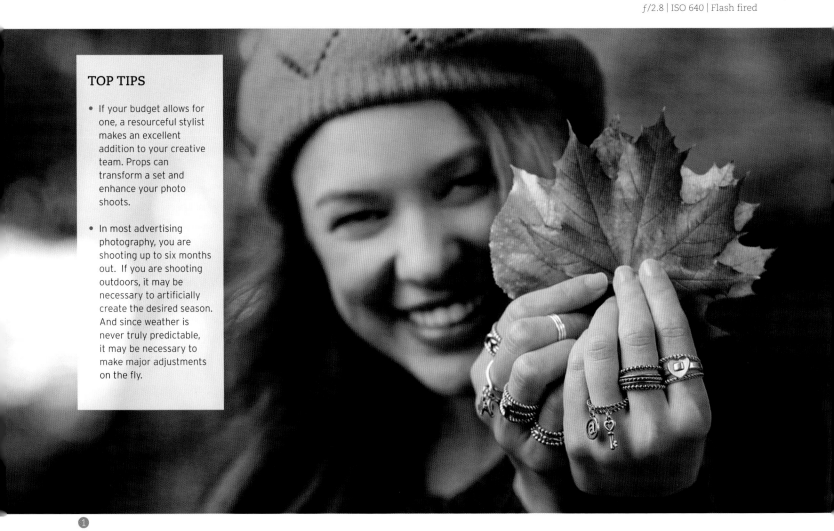

TOP TIPS

- If your budget allows for one, a resourceful stylist makes an excellent addition to your creative team. Props can transform a set and enhance your photo shoots.

- In most advertising photography, you are shooting up to six months out. If you are shooting outdoors, it may be necessary to artificially create the desired season. And since weather is never truly predictable, it may be necessary to make major adjustments on the fly.

①

"When we shot this campaign it was spring and mostly green outside. The client had specified that they wanted fall colors."

2

3

113

① ②

VIRGIN PULSE

A talented art director at a local ad agency reached out to my agent and asked if I would be interested in photographing some lifestyle work for Virgin Health Miles, which he was rebranding as Virgin Pulse. As a big fan of the Virgin brand, I was excited to sign on for this project.

The brief: "Virgin Pulse, part of Sir Richard Branson's Virgin Group, designs technology that cultivates good lifestyle habits for your employees. Configured to complement your culture, our technology, and the overall well-being experience we deliver, drives superior outcomes for your people and your business."

The concept was to capture employees having a blast at the office and hire local, "real people" talent to pose as the employees. They had a wide variety of demographic needs and we did a full day of casting. When working with non-professional talent, the casting day is so important. I always hire the people with the most energy because I know they will bring enthusiasm to the shoot.

We scouted a few offices and found a modern office building with clean lines and good light. The natural light was imperative because the art director asked for lens flare in every image, even the inside shots. So where there wasn't natural lens flare, we had to create it. The best way I've found to create the lens flare haze is to place a strobe in the background, coming from where the sun might be, and face it toward my lens.

An extra step we took here was to place a piece of glass, or a filter, with Vaseline on the edges to create an even more dramatic flare in-camera. Yes you could do this in Photoshop, I just find that it tends to look more authentic when you create effects in-camera. Overall the images were fairly clean and simple in order to accommodate the large logo and text that would be displayed over the image.

ALL **Real flare**
This group of pictures was shot using Vaseline on some glass over the lens, but for different situations I moved the glass so the Vaseline was in a different place relative to the shot. There was a lot of dancing during this shoot because the client wanted movement. I find that if I start awkwardly dancing to show the models what I'm looking for, it makes the talent comfortable enough to bust a move.

1. Lens: 24mm ƒ/2.8 | 1/200 sec | ƒ/4.0 | 320 ISO

2. Lens: 50mm ƒ/1.4 | 1/250 sec | ƒ/5.6 | 400 ISO

3. Lens: 50mm ƒ/1.4 | 1/250 sec | ƒ/4 | ISO 200

4. Lens: 50mm ƒ/1.4 | 1/250 sec | ƒ/2.8 | 400 ISO

③
④

"The art director asked for lens flare in every image, even the inside shots. So where there wasn't natural lens flare, we had to create it."

EDITORIAL IN FOCUS

LIVING MAGAZINE

Early in my career I was approached by *Living Magazine*, a local publication, to photograph a fashion editorial about Audrey Hepburn in *Breakfast at Tiffany's*. So I watched the film, took notes, and focused on figuring out who Audrey Hepburn was, because if I was to capture her essence, I would need to have a good idea of her personality, how she dressed, and what made her an icon.

I reached out to all the local modeling agencies and found one particular model who embodied her look and short haircut. We found a location in Dallas, a hotel called The Crescent, which had a bar area and balcony that reminded me of parts of the film.

The first couple of images were shot with very low light, but luckily I was using the Nikon D700, which excels in low light. I mainly worked with ambient tungsten light and the natural window light, but I added a constant tungsten LED to highlight the model.

There was a color balance issue between the natural light and the tungsten, making the windows appear blue and the model yellow in tone, but I knew I would be making most of the images black and white.

The model wasn't allowed to light her cigarette in the bar so I ended up having to add smoke in post-production. I googled "how to add smoke to a picture" and a YouTube tutorial came up walking me through exactly how to do it. That's the beauty of learning photography today!

ALL **Essential style**
The makeup artist, Rocio Vielma, has captured the essence of Audrey Hepburn in these images. The styling, hair, and makeup is essential in fashion.

1. Lens: 50mm f/1.4 | 1/125 sec | f/2.0 | 250 ISO

2. Lens: 50mm f/1.4 | 1/200 sec | f/2.5 | 100 ISO

3. Lens: 50mm f/1.4 | 1/125 sec | f/2.0 | 250 ISO

4. Lens: 50mm f/1.4 | 1/125 sec | f/2.0 | 250 ISO

① ② ③

"The model wasn't allowed to light her cigarette in the bar so I ended up having to add smoke in post-production."

TOP TIP

- Tungsten lights mixed with natural window light create a look where the natural window light appears blue and the artificial lights look orange, which in my opinion can be a cool effect! If you want to fix it, you can add a blue gel to your tungsten light source to match it to the natural light.

4

TOP TIPS

- Black-and-white photography naturally creates a mysterious mood. It tends to showcase more of the vibe and soul of the person you're shooting because you aren't distracted by the clothes.

- Posing is an art form in itself. I tend to prefer more natural poses instead of overly structured looks. The best way I have found to pose models and make it look natural is to show them an example image of a pose and get them to recreate it in their own way.

LEFT **Black and white**
If color isn't adding to your photograph, try it in black and white to make more of an impact. I used one light to illuminate the models here—a Profoto D1—and a beauty dish.

1. Lens: 50mm $f/1.4$ | 1/125 sec | $f/8$ | ISO 100

2. Lens: 85mm $f/1.4$ | 1/500 sec | $f/2.8$ | 400 ISO

"Keep in mind that if color isn't adding to your image,
try black and white to see if it has better impact."

DAPPER MAGAZINE

Editorial work is a stellar marketing tool as well as a portfolio builder. Most of the time you have creative freedom to express your vision as a photographer, as I did for my shoots for *Dapper Magazine*. This was an ongoing client of mine for a while and I had the opportunity to photograph a couple of their covers as well.

They didn't choose this [opposite] particular shot for the magazine, but it was one of my favorites for the models' *Madmen*-style looks and expressions. We lit this in a studio with one light slightly off to the right—a beauty dish on a Profoto D1.

At first the couple were switched and the male model cast a shadow on the female model, so I had them trade places which allowed for them both to be illuminated. The colors in the image were pretty muted so I decided to process the image in black and white, which made a huge difference. Keep in mind that if color isn't adding to your image, try black and white to see if it has better impact.

This second image was also part of an editorial for the magazine and this is the one I was hoping they would choose for the cover. They ended up going with another shot, so I used this one in my portfolio. I was looking to create a dynamic shot by centering the model in the middle of the dartboard. There was great natural direct light shining in from the window, which allowed me to capture the model's expression and suit nicely.

SWIMWEAR IN FOCUS

There is a real art to making swimwear photography appear effortless. Overly-posed swimwear images can look like they are trying too hard. The biggest trick to creating gorgeous swimwear images lies in first making the model comfortable. In order for them to look sensual, they must first feel good in the swimwear. It makes a big difference if the swimwear fits the model's body type. For instance, you wouldn't want to put a high-waisted bottom on a model with a short torso. You want to elongate their figure, so low-rise bottoms work better. You'll also want the color of the suits to fit with their skin tones. You wouldn't want to place a nude suit on a pale-skinned model because it wouldn't stand out. If the swimwear fits the model well, this makes her feel confident, which goes a long way when you're photographing.

For each look, I try a lot of different scenarios. To mix it up, I may start with the model standing, and then have her lie in the sand or try some sitting poses. The best way to get natural poses is to give the model a direction of what you're looking for and then let her create the poses in her own way.

Lighting-wise I tend to keep it very simple. I love natural light for swimwear whenever possible. We will usually augment the natural light with reflectors to give it an extra "oomph." If it is overcast outside, like it is in this image, we will add in a strobe and match the ambient light to give it more contrast. Sometimes, if I am looking for more of a sunlit look, we might even add a strobe behind the model, just out of frame, to create a flare-like look. Both of these techniques work well for swimwear.

Your focus will depend on the type of swimwear photography you're shooting. For example, if you're shooting for a designer, you will want to emphasize the look and style of the suit. If you're shooting an editorial for a magazine such as *Sports Illustrated*, you can focus more on the vibe of the model and less on the swimwear itself.

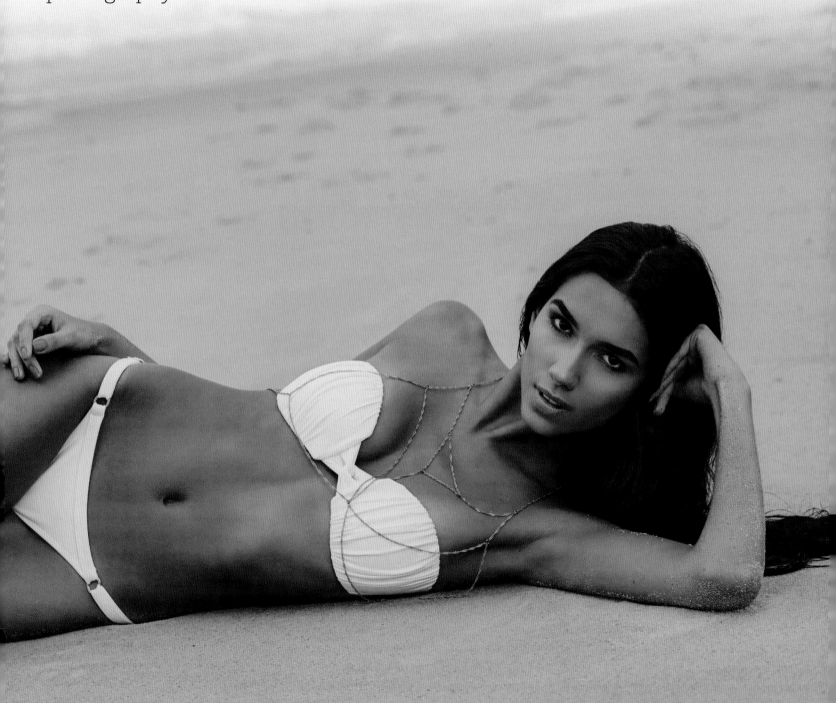

"There is a real art to making swimwear photography look effortless."

LINGERIE IN FOCUS

PIPER'S PERFUMERY

What I love about fashion photography is the ability to create "the dream" and really capture the feeling of a particular brand or fashion. Fashion photography, for me, depicts a perfect world in which romance is always alive, and that is what I truly love about it. You are able to come up with your own visual vocabulary and truly speak through your images.

The campaign for Piper's Perfumery was one of those wonderful moments when an art director hires you to shoot your own vision, and he even used images from my website as inspiration for the campaign. The concept called for a couple of beautiful faces that would be featured as the essence of "Piper" and the main treatment would be in black and white with the perfume bottle in color. A second treatment was in color.

The ads ended up running in *In Touch* magazine, targeting a young twenties demographic. The client asked me to be the director in both the stills and the video, so I had a great cinematographer, Erik Clapp, film simultaneously as I shot the stills, as we were so limited on time.

The biggest challenge was the fact that I had chosen the location for how gorgeous the natural light was inside, but the day of the shoot it was pouring down rain and dim. My team and I placed HMI's outside on the porch and shone them through the window to make it look like natural light. The two models chosen for the campaign had excellent chemistry, which played out beautifully and brought the mood to life.

ALL **Plan for weather**
Always have a backup plan. You never know when it might rain on the day of a shoot, so always have backup gear and a backup location with the option to shoot inside.

1. Lens: 58mm ƒ/1.4 | 1/320 sec | ƒ/3.5 | 640 ISO
2. Lens: 50mm ƒ/1.4 | 1/320 sec | ƒ/3.2 | 800 ISO
3. Lens: 50mm ƒ/1.4 | 1/500 sec | ƒ/3.5 | 640 ISO
4. Lens: 50mm ƒ/1.4 | 1/500 sec | ƒ/3.2 | ISO 640

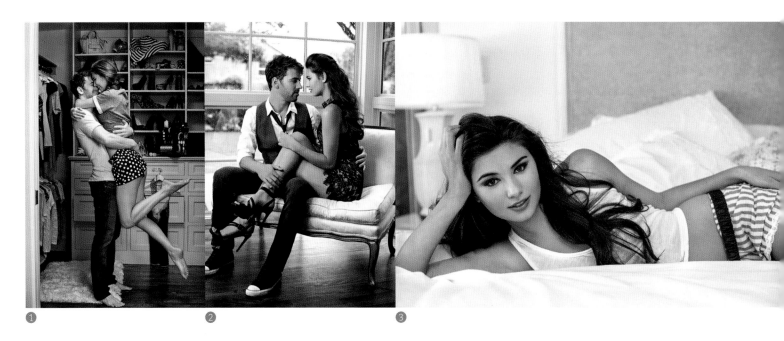

① ② ③

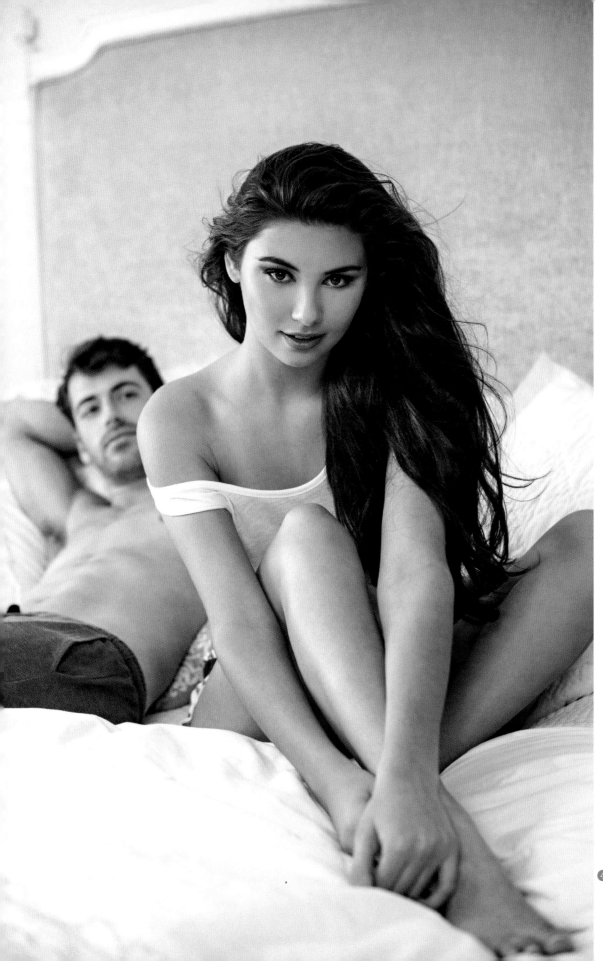

TOP TIPS

- Always shoot in color and then convert to black and white in post-production. You never know when a client who said they wanted black and white might prefer a few images in color after the fact.

- Always have a backup plan in case of weather. We always try to choose a location with both indoor and outdoor areas in case of rain, and we bring trash bags on set in case we have to cover gear to protext it from light drizzle.

"What I love about fashion photography is the ability to create 'the dream.'"

4

123

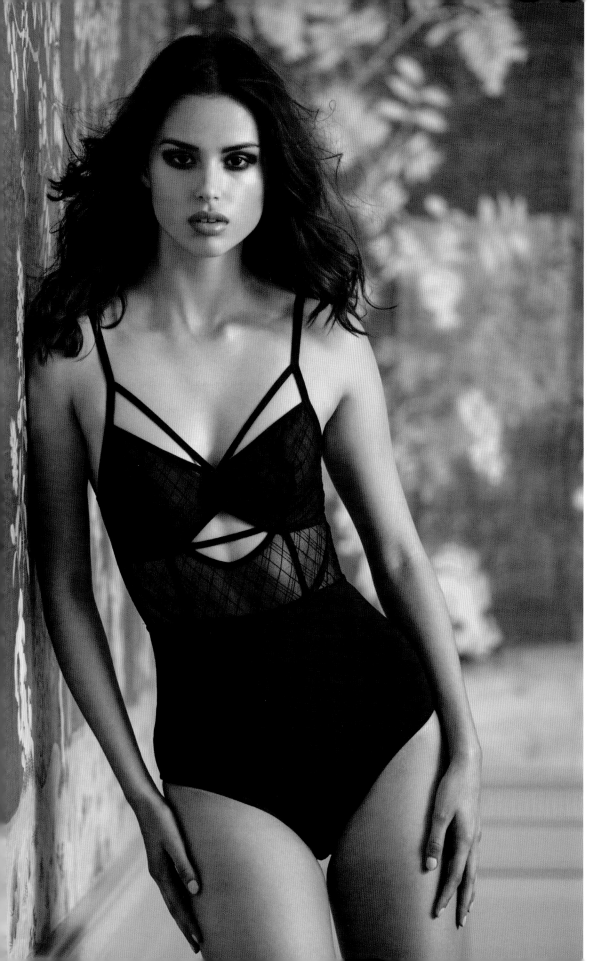

"A good rule of thumb makeup-wise is that you either choose heavy eye makeup OR heavy lip color."

1

ALL Natural light
For this particular shoot, the lingerie had a very delicate feel so we found a location that had soft wallpaper, clean lines, and long hallways that matched the lingerie perfectly—very classical. The only challenging part was that the location was quite dark and required a lot of lighting to make it look natural.

1. Lens: 180mm $f/2.8$ | 1/250 sec | $f/2.8$ | ISO 250
2. Lens: 200mm $f/2.0$ | 1/200 sec | $f/2.0$ | 250 ISO | Flash fired
3. Lens: 180mm $f/2.8$ | 1/250 sec | $f/2.8$ | ISO 200
4. Lens: 200mm $f/2.0$ | 1/200 sec | $f/2.0$ | 250 ISO | Flash fired
5. Lens: 85mm $f/1.4$ | 1/250 sec | $f/3.2$ | 800 ISO | Flash fired

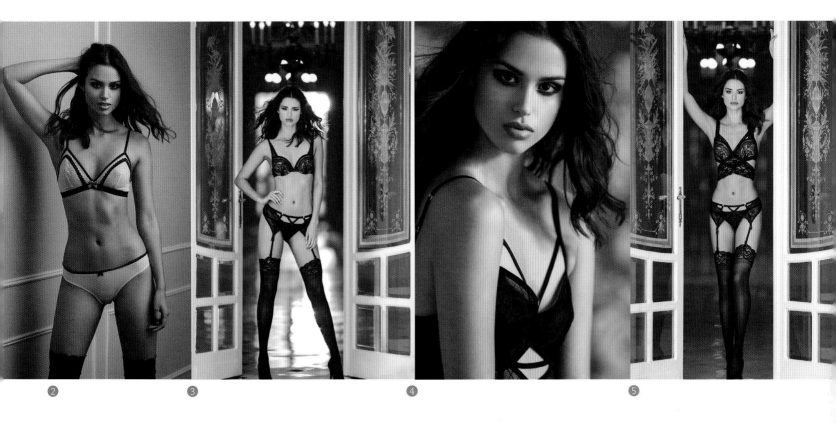

② ③ ④ ⑤

The location is extremely important in lingerie photography. It can be anything from a beautiful room filled with natural light to a Japanese rose garden, or a simple studio space, but it needs to appear in harmony with the lingerie. We chose this location because of its delicate textures, wallpaper, and ambiance. There was a very long hallway with glass doors, which made for a perfect place to shoot.

The room was fairly dark on the overcast day of the shoot so we placed strobes far in the background behind the model, as well as in front, bouncing off the white wall and then onto the model. To get movement in the hair, I use a battery-operated leaf blower from a hardware store.

For the shot against the wallpaper, I wanted to shoot with a fairly wide-open aperture in order to blur the wallpaper and bring all of the attention to the delicate lingerie. The makeup is quite heavy here but it works well with the lingerie to give it an edge. A good rule of thumb makeup-wise is that you either choose heavy eye makeup OR heavy lip color. You never want to go with heavy eye makeup and lipstick at the same time because it tends to look too contrived. Lighting-wise, we used the Profoto B1 and bounced it off the wall on the right side to give it a soft gradient.

In shooting lingerie fashion, it is very important to always have music the model enjoys playing throughout the shoot. It is a very delicate kind of photography and you will want to go to great lengths to make the model feel comfortable.

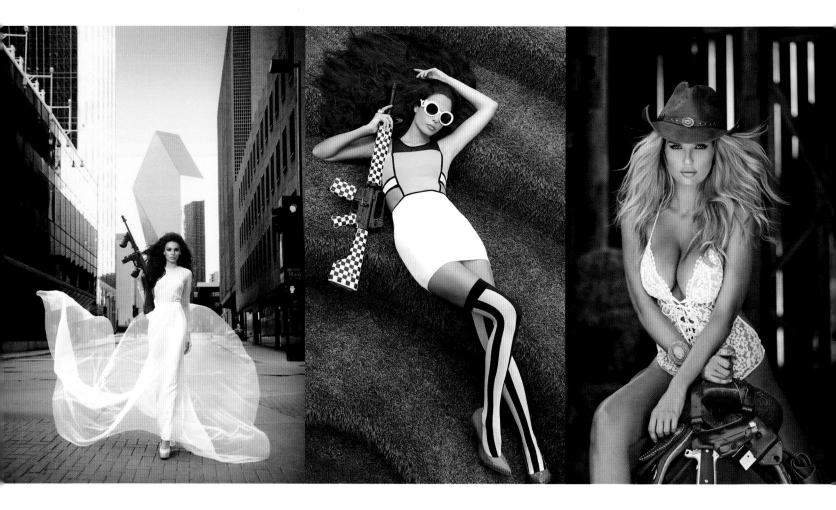

AN EXTRAORDINARY CLIENT

This was one of my favorite jobs because of the uniqueness of the brief and the dream team involved in the making of these calendars. I have had the opportunity to shoot three of them in the past few years!

When I was first contacted about this project, my amazing producer, Nancy Franks, misheard me, and thought that they were calling about doing a calendar to promote gum. As it turned out, the client was looking for a high-fashion calendar featuring their gun accessories, with proceeds of the calendar going to the military and their families. One of my favorite art directors, Kiley Wirtz, came up with the concepts and each month featured a completely different setup. That meant some "military strategy" was needed in our planning; 13 different locations (to include a cover shot) in only three days. This was accomplished by ensuring that each location was not far from the previous one, and scheduling in traveling time.

ABOVE **Calendar girls**
Magpul Industries was looking for a different take on an American classic, the gun calendar.

"The word 'shoot' causes all sorts of dangerous problems on set . . ."

The models for each month were hand-picked by our team and the client. Every aspect of this shoot was planned out in detail—location, model, wardrobe, hair and makeup, props and accessories. We had a vision board for every single shot. For projects like these, the more planning you do beforehand, the better results you get.

On the last day, during the last shot—the cover shot—it started pouring down rain. I was worried we wouldn't get the shot because we couldn't shoot in

the rain with all the gear and the gown. We sat it out for an hour or so, and waited. There was a 15-minute window, just before the sun went down behind the skyscrapers, when the rain stopped and allowed us to run out there and get the shot. This was also during 5 o'clock Sunday traffic off Main Street in downtown Dallas, so we hired policemen to stop traffic for a couple minutes at a time for me to shoot and then they would let the traffic go by. It was quite an exhilarating experience and we ended up getting the shot.

ABOVE **Calendar girls**
When the model got up, the hair stayed there! Seriously, in the last shot the model was wearing hair extensions, and when she got up, her "hair" stuck to the pool float.

6 BUILDING YOUR CAREER

YOUR COMMERCIAL PHOTOGRAPHY TEAM

TEAM MEMBERS

HOW TO CHOOSE YOUR TEAM

HOW TO BUILD YOUR DREAM TEAM

WORKING WITH MODELS

BEHIND THE SCENES

YOUR COMMERCIAL PHOTOGRAPHY TEAM

In commercial photography, your team is everything. Many people don't realize that there are huge creative teams involved in creating commercial imagery.

On most high-end fashion and advertising sets there are an enormous amount of people present during the shoot, including makeup artists, hair stylists, models, wardrobe stylists, art directors, the client, and a producer, as well as the photographer's assistants, which might include a digital tech, a

retoucher, a lighting assistant, and grip assistants, who help lift, operate, and transport production equipment.

The size of the team depends solely on the type of job and the photographer's style of shooting. Most advertising and commercial jobs require a large crew, while editorial and lower budget productions may allow for a small crew. When approaching commercial clients, they will expect you to have a go-to team of people that you work with who can

ALL **Teamwork**
I call these amazing creatives pictured here the "dream team," because they are insanely talented and bring their "A game" to every shoot. It took me years to find them, and I am forever grateful to get to work with them on all my jobs.

You can start building your team on sites like modelmayhem.com, which is a networking site for the fashion/commercial industry. Most people on that site are just starting out and want to work on portfolio shoots for free, in trade for great images. This is how I started out.

"Amazing images can be created with the smallest of teams, and you can grow your team as you grow in your craft and your career."

pull off the job and make the magic happen. This can sound like an overwhelming and daunting undertaking for photographers just starting out, but you can rest assured, knowing that amazing images can be created with the smallest of teams, that you can add production value to your images without breaking the bank, and you can grow your team as you grow in your craft and your career.

The following pages will introduce you to key members of any commercial photography team and show you how you go about building one.

131

TEAM MEMBERS

I personally call my commercial photography team the "dream team" because these are the crew members that inspire me creatively and who understand my vision. I rely on them over and over again to bring their A game to every production we work on. In the commercial world, your team is everything.

Clients may not remember what you said, but they will remember how you made them feel. This is why I work with a select group of people: The energy you create on set leaves a lasting impression on your clients. You have to consider not only how you but your crew made the client feel during the shoot. Did your team set them at ease or stress them1 out? This is almost equally as important as the final images you deliver to your client.

I have listed information on each team member below. Keep in mind that smaller markets often have lower rates. Rates in LA and New York can be much higher than the beginning rates listed here.

PRODUCER

A producer handles all aspects of making the photoshoot happen, including creating an estimate, handling the pre-production, location scouting, scheduling, casting, securing permits, hiring the crew, managing budgets, invoicing, and anything else needed to make the job happen successfully. A producer allows the photographer to focus on that which he or she does best—the photography.

Rate range: $650 upward per day. They charge for pre-production days as well as shoot days.

BELOW **Collaborate**
My crew chief, Eric Jang, pictured here, is extremely talented and is just as passionate about lighting as I am about making pictures, so we make a great team.

OPPOSITE **The art of makeup**
When you're starting out and the budget doesn't allow for a makeup artist, you can send your model/talent to the makeup counter at the local department store to have their makeup professionally done. This will save you a lot of time retouching.

MODELS

The talent for the shoot (see also the casting section on page 162, and Working with Models on page 144). There's a big rate range here between agency and non-agency talent.

Agency talent rate range: $1,500 upward + 20% agency fee + usage.
Non-agency talent rate range: $250 per day upward.

MAKEUP ARTISTS

Makeup artists are extremely important in the commercial fashion world and you should choose the right one depending on the client's vision for the shoot. Makeup artists have a style just like photographers do. So if the client is looking for dramatic makeup, you need to search for an artist who has dramatic looks in their portfolio. Keep in mind that while you are shooting, the makeup artist is continually coming onto the set to fix the model's hair and makeup. When scheduling your models, it

"The energy you create on set leaves a lasting impression on your clients. You have to consider how not only you but also your crew made the client feel during the shoot." ▽

BEHIND THE SCENES

usually works best to schedule the more natural looks first so that your makeup artist can add to the makeup as you shoot. Hair and makeup for the first look usually takes 1–2 hours, with subsequent touchups and additions throughout the job.

Rate range: $650 upward + 20% agency fee per day.

HAIR STYLISTS

Often you will find a person who does both hair and makeup, although this is not usual in New York, L.A., and Miami. You need to be sure that this person is strong in both areas. When shooting for a hair client, there will usually be a separate artist for the hair since it is the main focus.

Rate range: $650 upward + 20% agency fee per day.

HAIR & MAKEUP ASSISTANTS

If the job calls for several female models, hair and makeup artists may require an assistant to help speed up the process of getting everyone ready. Their rate range can be the same as the hair and makeup artists themselves.

Rate range: $650 upward + 20% agency fee per day.

WARDROBE STYLISTS

Wardrobe stylists put together the wardrobe for the shoot. You can find these artists through local agencies. It is important that you or your producer send the wardrobe stylist the models' sizes before the job so that they can pull clothes that fit. It is also important to send them the color scheme, style, and vision that the client has in mind. The best

ALL **Prepping models**
Be sure to tell your models or subjects to come to the shoot with clean hair, a clean face, and a manicure. This will save a ton of prep time. Also make sure you tell them what kinds of undergarments and shoes to bring. Your stylist should tape the bottoms of shoes if they are borrowed from a store, so you don't get them dirty or damaged.

stylists have relationships with local stores to borrow clothes from a few days beforehand and return them afterward. They work extremely hard to keep the clothes in new condition, but in case the clothes get damaged during the shoot, the client should have a budget for non-returnable items. The stylist may buy and later return certain items for the shoot, as well. In that case, they may ask for your credit card to do that. On set, the stylist will pin the clothes to fit the model perfectly and adjust while you are shooting to ensure the best fit.

Rate range: $650 upward + 20% agency fee per day. They also charge for days they spend pulling and returning wardrobe after the shoot. In addition, they will often charge a "kit fee" of $50–100/day.

Wardrobe Styling Assistants

A stylist usually has an assistant, especially on larger projects, who will help transport the wardrobe and accessories, unpack and steam the wardrobe, help the talent dress and undress, hang up the clothing, keep track of everything, and pack it all back up at the end of the shoot.

Rate range: $250 upward + 20% agency fee.

"Send the wardrobe stylist the models' sizes, and vision that the client has in mind."

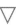

PHOTO ASSISTANTS

The photographer's assistants are a huge asset to a production. I tend to work with the same assistants on every job because we know each other well and work like a well-oiled machine. There are different types of photo assistants and the number you need depends on how big the job is. At the bare minimum, a photographer will have one assistant and usually a digital tech.

Rate range: $250 upward

PRODUCTION ASSISTANTS

Production assistants help with various aspects of the production from running errands, printing releases, carrying gear, and even getting coffee—whatever is needed. I prefer to have at least one or two PAs on set to help everything run smoothly.

Rate range: $150 upward

"The lighting technician will take the vision of the photographer and client and light the set to fit that vision"

DIGITAL TECHNICIANS

The digital technician makes sure all the images shot on the job are backed up and saved effectively. On most commercial jobs, the photographer shoots tethered to a computer using capture software and a tether cord. I prefer using Capture One software because it renders the best quality exports and creates the best workflow on set. "Digitech's" can also make quick adjustments on set for the client to see to get a better idea of how the final images will look, from color balance to cropping.

Rate range: $650 per day. Some will come with their own computer and tethering system for which they will charge a rental fee of around $150–$300.

LIGHTING TECHNICIANS

The lighting technician is a specialized assistant whose job it is to take the vision of the photographer and client and light the set to fit that vision. These folks are easy to find in New York, L.A., and Miami, but harder to come across in smaller markets. They can be a huge asset to a photographer when deciding what equipment to rent for a particular job and allow the photographer to focus on shooting.

In addition to all of these creatives, if the job is big enough, they will often have their own assistants to help with various aspects of their job. When contacting agencies for models and artists, if you have a limited budget, you can ask if there are new models and artists who would work for a lower rate. New models and artists often need to work on getting photos for their portfolios and may be willing to work for a lesser rate.

OPPOSITE **Bright and vibrant**
Bright, colored backgrounds can make gorgeous, vibrant images. We ended up using strobe lighting here because the sun set before we were done shooting.

BELOW (LEFT TO RIGHT) **At work**
A large umbrella provides great light. Once you've set your lights up, a shot including a Gretag Macbeth color chart helps ensure color accuracy. Technicians can act as "voice-controlled" light stands. Finally, a leaf blower is being used to give the model's hair life.

BEHIND THE SCENES

HOW TO CHOOSE YOUR TEAM

"The feeling of creating magic in the lens through collaboration with an amazing team is a huge adrenaline rush and a great experience."

Consider the following when choosing members of your team:

SPECIALTIES

One of the biggest aspects of building your team is figuring out who is the right creative for the job. For instance, when you're choosing your wardrobe stylist, you want to see their portfolio to see what they specialize in. This is so you can find someone who has worked in the style you're after. Some stylists are great doing high fashion, or editorial. Some are better at putting together edgier looks than natural lifestyle. Of course it's always wonderful if you find someone great at everything, but that often is not the case. Some makeup artists are best at avant-garde editorial makeup, while others' speciality is natural. You should always hire the makeup artist who fits the style of imagery the client is after.

PERSONALITIES

What is also paramount in all of this is personalities. When putting a team together, personalities are crucial, among your crew as well as the talent. By building a dream team, you're building a team people want to be a part of and a client wants to work with. These are people with whom you want to spend your day or week (or however long the job goes on for). When a client hires you, they're hiring you initially perhaps because of the work that you've done. How you get hired again by that same client is not only the images you give them but also the experience they have on the shoot. Often that can be even more important. When it gets down to it, it's about who you want to spend your time with.

RENTAL HOUSES

I have often found crew members through local photography studio rental houses. The rental houses usually have these contacts for you. When I travel and do shoots outside my area, I've found rental houses to be a great resource for finding additional crew members.

THE EXPERIENCE

When you have this huge group of people on set, it is a balancing act to make your shots happen while pleasing the client and people involved. Just keep in mind that you are there to do what you do best and the crew is there to help you succeed. There will be some shoots where you have more creative freedom than others, but ultimately the feeling of creating magic in the lens through collaboration with an amazing team is a huge adrenaline rush and a great experience. There is nothing quite like it!

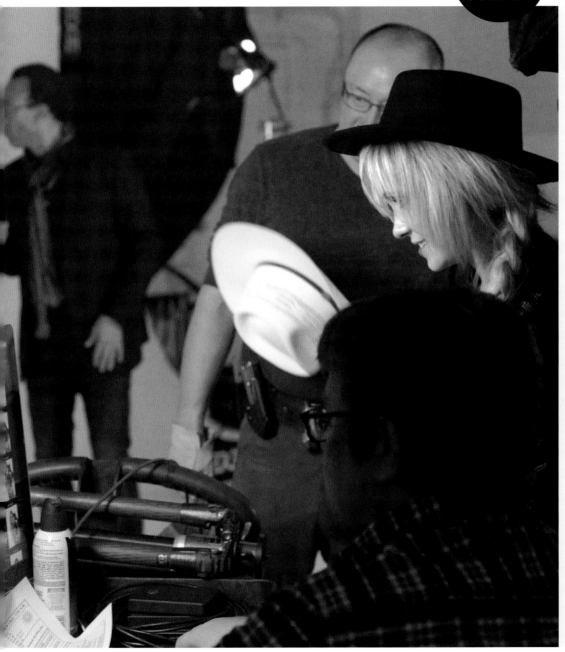

BEHIND THE SCENES

TEAM BUILDING

A few important things to consider when developing your team:

1. **Creating a team takes time, so be patient**—You have to work with lots of different people to find the right people. This is why shooting lots of personal projects when you're starting out is useful.

2. **Hire good problem-solvers**—The team you choose to help you pursue your vision can truly make or break a shoot. When on an actual job, you want to be sure that you've hired a team that can produce results, no matter what happens.

3. **Personality is key**—The people you hire for each job should inspire you creatively and your personalities must complement each other.

4. **Talent is a given**—You want to make sure that each person you hire has the talent to pull off a certain job. Every job is different so it's helpful to know lots of makeup artists and wardrobe stylists who specialize in certain styles. For instance, I have a go-to makeup artist for the natural look and a go-to wardrobe stylist for high-fashion looks.

5. **Networking is powerful**—The more creatives you know, the better—each and every person you meet on jobs or during networking events has the power to introduce you to other creatives in the industry, so always be enthusiastic and open to new opportunities.

HOW TO BUILD YOUR DREAM TEAM

STARTING OUT

So how does a photographer begin to build his or her team in the beginning? The key is to start small. Most of us begin with only our vision, our camera, and our subject, and it's during this time that you master your gear and find your shooting style.

When I started out in college, I had only one camera and lens—the Nikon D70s and a NIKKOR 50mm ƒ/1.8 lens. This challenged me to make great pictures using the simplest of gear. I was shooting personal work constantly and would find subjects on campus and ask them to pose for my pictures. I would do their hair and makeup and put together a wardrobe by combining our closets, so to speak.

The time spent shooting personal work is an important step in your career because that is when you will define your style and goals. You will also begin to realize that in order to take your images to the next level, you will need to be able to focus on the photography, while allowing other creatives who specialize in their crafts to collaborate on the end result image.

I began sending my subjects to the MAC makeup counter to get their makeup done before the shoot. This saved me a ton of time on set as well as in the retouching.

NETWORKING & COLLABORATION

After a while, I started to notice that I really needed a hair and makeup person on set during my shoots to touch up the subject, especially when on location. This is when I discovered a website called modelmayhem.com. It is a networking site for the fashion industry where new photographers, models, makeup artists, hairstylists, designers, and wardrobe stylists can post a profile, begin networking, and set up shoots with other creatives. I would come up with ideas and concepts, pitch them to creatives on the site whose work I appreciated, and we would go shoot.

Facebook is also a great tool to find other creatives in the industry, as well as source props. When I need a certain location or a big prop such as a car or an airplane, I will post the need on Facebook to see who might be able to help. This is the nature of networking today and creative possibilities are endless, given the tools of social media.

OPPOSITE **Perfect sunshine** Sometimes you are lucky enough to have perfect clouds and lighting on a shoot day, and this was one of those days; I used only natural daylight here. When we scouted this spot, it was very overcast and the colors looked much more muted. The sunlight brought out the colors.

"Most of us begin with only our vision, our camera, and our subject, and it's during this time that you master your gear and find your shooting style."

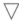

TRADING SKILLS

Many people think that you need a big budget to get other people involved in your shoots, but most creatives who are just starting out want to build their portfolios and are willing to work for free in trade for images. The industry term for this is "TFP" or "TFCD," meaning "Test for Prints" or "Test for CD." So in trade for the makeup artist's time and skills during the shoot, they will receive images to use in their book. Now, most people prefer digital files to prints, as they like to share them online via their website and social media pages.

When you have started building a portfolio of personal work, you can begin approaching modeling agencies. Agency models have the power to take your images to the next level. A little-known fact is that modeling agencies always need new images of their models, and if they like your work, much of the time they will let photographers shoot them for free. All you have to do is call or email an agency and ask to meet with them to show them your portfolio. During the meeting, ask if they have any models that need to build their portfolios. Usually they have new faces that need images and some agencies have makeup artists and hairstylists that might be willing to work with you as well. The more agencies you build a solid relationship with in the beginning, the easier it will be for you to source talent when you book actual gigs.

APPROACHING CLIENTS

Once you have a strong portfolio and a great team, it is time to approach actual brands, magazines, and ad agencies you would like to shoot for. Your best bet is to find the contact information for the art director or creative director within a company, because they are usually the people that actually hire the photographers. And if you can set up a meeting with them to show them your portfolio, you are well on your way to booking actual gigs. It is important even after you have developed a strong portfolio to keep testing and shooting personal work. The commercial and fashion industry is ever-changing, so you have to keep your images current and your style ever-evolving.

ALL Rapport building
Magdelene is one of my all-time favorite models and I've worked with her on many shoots. I always make it a point to hire people I loved working with on other jobs, since we've already built up a good rapport, which makes shooting effortless.

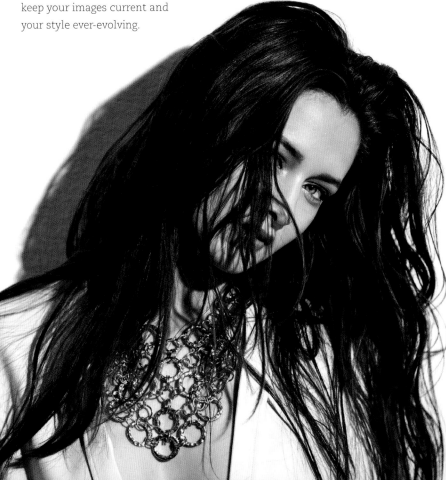

"A lot of people think you need a degree in photography in order to make a career out of it, but the truth is you don't. In my opinion, getting experience in the field is a lot more important and useful. I have a business degree in entrepreneurship, but when I go into interviews with potential clients, what do they ask for? Not my business resume—they ask for my portfolio. Your portfolio is gold in this industry."

WORKING WITH MODELS

A key part of working as part of a commercial fashion team is working with your subjects. Ultimately my connection with my subject is what drives my work. If you are missing that connection, your photographs won't sing. I am a huge believer in creating the right mood and making your subjects as comfortable as possible. I believe this is the reason I get the images I get. If your subject is feeling uncomfortable it's going to show. If they feel comfortable there are endless possibilities to what you can create.

To help your subjects feel comfortable, remember the following:

1. Music—Always have music playing; it puts your subjects at ease.

2. Research—Find out the music they enjoy listening to so you can have it playing when they walk in, and what their interests are so you can build a rapport with them.

3. Food—People can get very grumpy when they are hungry; I do, especially.

4. Don't over-direct—I do very little posing. I may give my subject a basic idea and stance, but then I let them do their thing. If they aren't looking exactly right, I never yell or tell them they're doing something wrong. This creates negative energy and your subject will lose confidence. You need to build confidence, one compliment at a time.

ALL **Secondary focus**
I wanted the model and the lingerie to be the main focus here, so I used a long lens to blur out the background and and have it as a secondary element within the frame.

"I do very little posing. I may give my subject a basic idea and stance, but then I let them do their thing."

▽

"When you are patient and conscious of your subject's comfort, they will feel like they can fully express themselves."

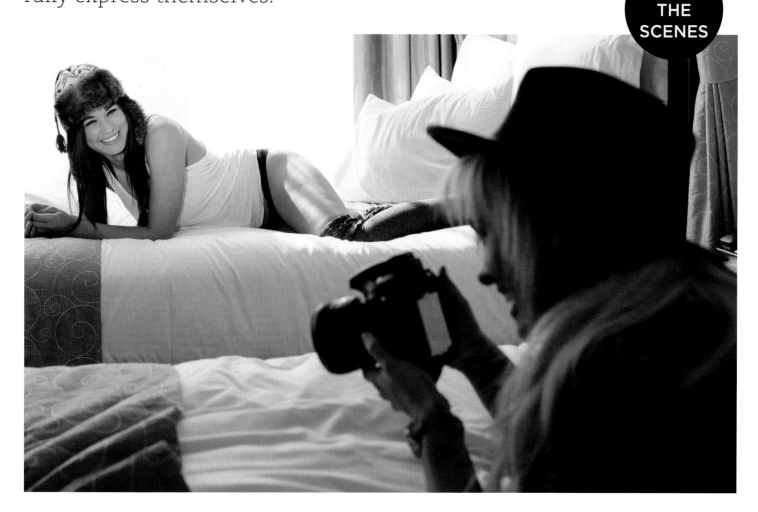

BEHIND THE SCENES

When people see me shoot, they often say to me that it looks like I'm not doing anything. I don't direct a lot and I rarely say anything but "great" or "that's beautiful." You wouldn't believe how much it shocks people but it's a very conscious thing that I've been trying to perfect for a while. My belief is that every time you ask your subject to change something, you make them question whether they are doing a good job, and once that sets in, it will show in the pictures. When you give less direction and stay positive, your subject will eventually give you what you want. The bonus of this is that when you are patient and conscious of your subject's comfort, they will feel like they can fully express themselves and sometimes give you something even better than you expected.

ALL **Getting the shot**
I always continue shooting even after I've gotten the shot, because sometimes I get the best shots when the models think we are finished and they fully relax.

147

7 THE COMMERCIAL PHOTO SHOOT FROM START TO FINISH

THE JOB

THE ESTIMATE

MOOD BOARDS

PRE-PRODUCTION

LOCATION

CASE STUDY:
POO-POURI CAMPAIGN

CASTING

SHOOT DAY

CASE STUDY: A MAGICAL SHOOT

CASE STUDY: EUROSTORM

CONCLUDING THE SHOOT

POST-PRODUCTION

THE JOB

A commercial photography gig deeply contrasts with wedding and portrait work. With weddings and portraits, you are locked into the client's schedule and timeline, while commercial photography allows you to plan and control every aspect of the shoot.

This chapter is a look at how a commercial photography job happens, from start to finish. Keep in mind that every job is different. Some clients and ad agencies prefer that the photographer handles all aspects of the production, while some prefer to do a lot of the heavy lifting for you, which allows you to focus on the shooting aspect.

It is important to be prepared for each scenario that presents itself. The size of the campaign or photoshoot will determine the number of folks on set. If you are working with an ad agency, you will usually have a few creatives from their agency involved, as well as a few people from the client's side. If you are working with a client directly, there are usually fewer people involved. With any job, it is your role as the photographer to work with the art director to achieve their vision.

"With any job, it is your role as the photographer to work with the art director to achieve their vision."

RIGHT **Controlled environments**
When shooting images for advertising, it is often best to rent a studio for a more controlled environment. This is especially true for hair shoots; you don't want to have to deal with bad weather and humidity, so the studio is essential.

THE ESTIMATE

When an advertising agency or client gets in touch about a job or campaign they have coming up, they will ask if you are available and interested in submitting a bid for it. This is your opportunity to ask a lot of important questions. The more details you get in this preliminary call or email, the better equipped you will be to give an estimate for the job. Some agencies and clients will get bids or estimates from a few different photographers before making a decision.

Be sure to ask when they would like the estimate. Much of the time, they need it quickly! Try not to give a ballpark amount over the phone, tell them you will consider all elements and get back to them on the numbers once you've had time to work on it. Sometimes you will go back and forth with the client about rates. Negotiating is part of the process.

HIRING AN ESTIMATING CONSULTANT

Putting together an estimate can seem like one of the most daunting tasks of the job, but it doesn't have to be. When I switched from being a portrait photographer to a commercial photographer, I had no idea how to price a job because the pricing structures for these two genres of photography is so different. One of the best choices I made was to reach out to a company called Agency Access (www.agencyaccess.com). They referred me to a great consultant who helps photographers with estimating and bidding jobs. These consultants charge an hourly rate. It usually takes just a couple of hours to accurately estimate a job and it's well worth the cost!

I utilized this particular consultant a ton throughout my first year of shooting commercially. This process educated me on how to estimate, ask the right questions, and use estimating software effectively. I learned that the best software for estimating and invoicing is called BlinkBid. The reason I find it so helpful is that it has built-in templates for commercial photographers as well as going rates for usage. You can customize the estimate to look beautiful and professional and add your logo as well.

ABOVE **My desk**
This is my home workspace that I had specially built. The focal point, my moose "Homer Dixon," is named after my great grandfather who was a photographer. This is as clean as you'll ever see my workspace. I love having a home office so I can keep my overhead low, which allows me to travel often.

"Sometimes you will go back and forth with the client about rates. Negotiating is part of the process."

Here are some questions you should ask of the client or agency to help you come up with an estimate and flesh out the brief. (These are based on guidelines from the Agency Access Blog.)

The brief:
- What is the concept for the shoot?
- What is the target demographic?

The images:
- How many are needed? (Later you will need a detailed shot list.)
- What look and feel are you hoping to achieve?
- What format? (I.e., portrait or landscape, TIFF or other, on hard drives or transferred?)
- What dimensions? (I.e., size and resolution.)
- Are there any layout requirements? Do you need to leave space for text?
- Will you be doing the retouching and post-processing?

The shoot:
- Will it be in a studio or on location? (If on location, you may need to factor in travel costs.)
- Do they have a location in mind or will the job involve location scouting?

- Catering: How many people from the agency and client side will be attending? Are there any special dietary requirements?

The team:
- Will they require you to put together your own team? (Including stylists and assistants.)

The talent:
- What are the talent specs? (Includes sex, race, age, budget, agency, non-agency, or "real life.")
- What type of casting? In person or online?

The budget:
- You will need to consider whether the client is an ad agency, a brand, an editorial client, or a consumer client (i.e., an individual or small business).
- Ask if there is a set budget or if they want you to estimate the job first.

The timeframe:
- What is the proposed production date?
- When do they need the estimate?

Image usage:
- How will the image(s) be used? Consumer ad, trade ad, packaging, direct mail, billboards, catalogs, and will this be single use or multiple use?
- What is the area of circulation: Local, state, regional, national, international?
- What is the size of the print run?
- What is the duration of license?

Before working out your estimate, also consider what the job will mean for you.
- How difficult will it be? What challenges will there be?
- Do they want you for your particular style or vision?
- How did they hear about you? Word of mouth, online search, a specific campaign?
- What type of credit and ownership do you require? Think about credit lines and copyright. Depending on what licensing options you agree to, you may be restricted in how you can use the images.

MOOD BOARDS

Once you've landed the job, it is extremely important to make sure you and the art director or creative director are on the same page. Some clients ask for a mood board from the photographer before awarding the job, some clients will ask the photographer for a mood board to see the photographer's vision of the creative elements--from the lighting, to the overall mood, the direction for the hair, makeup and styling and suggestions for models.

Whether the client asks for this or not, it is a great way to make sure you and the creatives have a consistent vision. I utilize Pinterest a lot to create vision boards and will bring them to set printed out as well. I always prefer to over-prepare so that I am able to relax on set.

Remember that no one is a mind reader in this business, so don't try to be one! Always ask your client for examples of their vision. This could be tear sheets from magazines or any photos that showcase the style of imagery they're after. This will be very helpful to your client if they don't already have a clear vision of what they're looking for, and will ensure that everyone is on the same page.

So why is it so important? A mood board communicates the end goal of the shoot in a visually inspiring way, and helps your whole team get involved in the process. Once we have come up with an initial idea, I browse magazines and do image searches on Google, Pinterest, and online editorials to look for images that

showcase different aspects of the idea that I am after or the client wants, from hair and makeup to wardrobe and lighting. The combination of these separate elements creates my own vision that I can then communicate to my team. Usually, I will send the vision board online to everyone before the shoot, then print it out and post it on a large corkboard to bring to the set on the day(s) of the shoot. The truth is, creating a vision board is one of the most powerful mind exercises there is in bringing your images to life.

RIGHT **Inspiration boards**
I post tear sheets on a corkboard for my inspiration boards. This is essentially an "old school" version of Pinterest.

"A mood board communicates the end goal of the shoot in a visually inspiring way, and helps your whole team get involved in the process."

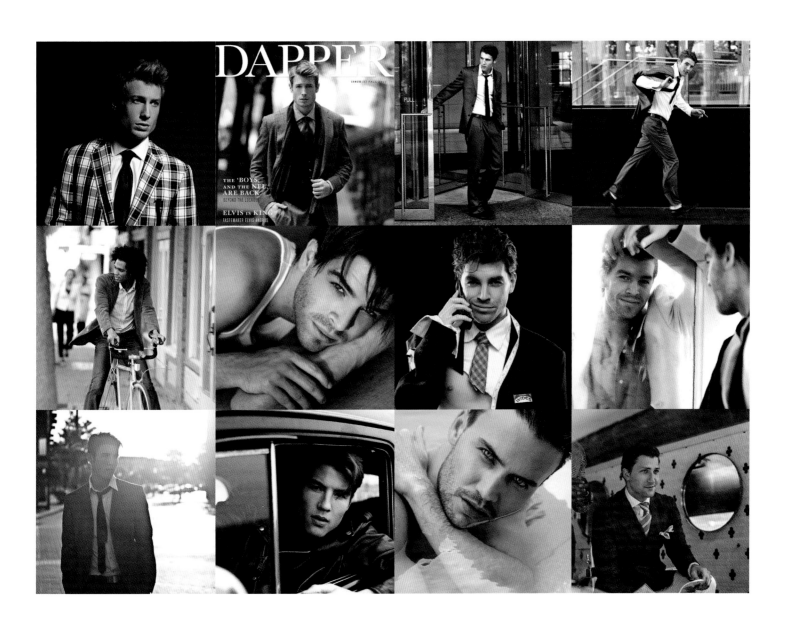

PRE-PRODUCTION

"The more time you spend in pre-production fine tuning all of the details, the less stress you will experience the day of the shoot. Choosing the right team and equipment is extremely important."

Pre-production is the most important aspect of creating a shoot that runs smoothly. The more time you spend in pre-production fine tuning all of the details, the less stress you will experience the day of the shoot. Choosing the right team and equipment is extremely important.

I like to include my team in pre-production meetings so we can work through all of the logistics and each team member can ask questions that pertain to their part of the shoot. The call sheet brings the team and schedule all together before we arrive on set.

THE COMMERCIAL PHOTOGRAPHY TEAM

When I am contacted about a job, my producer or I reach out to my favorite crew and put them on hold for the dates the client has in mind. When the job is confirmed, we will confirm them for the days needed and release the other days. I have a favorite team that I work with on a regular basis, and these are the folks I always reach out to first.

PRE-PRODUCTION MEETINGS

Depending on how logistically challenging the shoot is, you and your team may be involved in lots of conference calls and meetings before the shoot.

If the client is out of town, the meetings will often be Skype conference calls. It can be helpful to get your entire crew on the call to go over details such as wardrobe, lighting, and the creative direction so that everyone is on the same page. Always ask questions if you are unsure of something.

EQUIPMENT RENTALS

Before the job, it's a great idea to go through each shot and make a list of all the equipment needed. I work with my lighting tech on this but you can also work on it with a photo assistant. Be sure to reserve any equipment needed from a photography rental company. I tend to use local rental houses but you can also rent from online companies like borrowlenses.com.

PRODUCTION BOOK/CALL SHEET

The production book/call sheet includes all aspects of the shoot:
- The names and phone numbers for the key people, i.e. the client, ad agency, photographer, and crew members
- Concept/mood boards
- Shot list
- Travel instructions
- Schedule

231 likes 36w

iamdixiedixon Day 1... Absolutely loved everything about today 🎥 🤠 #dreamteam #director #production #MPS #griptruck @nickutter.dp @ericjangphoto @samryanfilms @nanfran12

126 likes 91w

iamdixiedixon Such good times on set today!!!! 😊📷😊 #setLife #dreamteam #grateful #thankyou

ABOVE **Sharing the adventure**
Share your adventures online, and update your social media regularly with relevant content.

156

SHOOT	Title	DATE	2-9-17	START	08:30	DAYS	DAY 1 of 1	CLIENT

SHOOT DAY CALL SHEET

CREW	NAME	PHONE/EMAIL	CALL TIME	WRAP
Photographer	Dixie Dixon		08:30	18:00
Producer	Becky Thomas		08:30	18:30
BTS Video	Chris Benson		08:30	18:00

CAMERA GRIP	NAME	PHONE/EMAIL	CALL TIME	WRAP
1st Photo Assitant	Veronica Wu		08:30	18:00
2nd Photo Assitant	Jack Simmons		08:30	18:30
Digital Tech	Kathy Liang		08:30	18:00
Video Assistant	Simon Jones		08:30	18:00

STYLING	NAME	PHONE/EMAIL	CALL TIME	WRAP
Hair Stylist	Ben Cole		08:30	18:00
Hair Stylist Assistant	Roly Allen		08:30	18:30
Wardrobe Stylist	Ken Li		08:30	18:00
Wardrobe Assistant	Vish Amlani			
Make-Up Artist	Jackie Chase			

PRODUCTION	NAME	PHONE/EMAIL	CALL TIME	WRAP
Production Assistant	Jessica Smith		08:30	18:00
Camera/EQ	Dom Marsh		08:30	18:30
Catering	Nutrition Co.		08:30	18:00

CLIENT	TITLE	CALL	OUT
Frank Gallaugher	CEO	09:00	17:30
Sean Adams	VP of Marketing	09:00	17:30
John Chan	VP of Education	09:00	17:30
Sue Bouchard	Dir of Brand	09:00	17:30
Maria Diaz	Art Director	09:00	17:30
Rachel Silverlight	Dir of Global Innovation	09:00	17:30
Scott Hughes	Asst Innovation Mgr	09:00	17:30

TALENT	TITLE	CALL	OUT
Francesca Leung		09:00	17:00
Lisa Clark		09:45	17:00
Eric Reyes		11:00	17:00
Ash Singh		14:00	18:00

PRODUCTION NOTES

WEATHER
High:
Low
% precip
Sunrise
Sunset

PRODUCTION SUMMARY

PARKING	On Street

HOSPITAL

MOODBOARD REFS

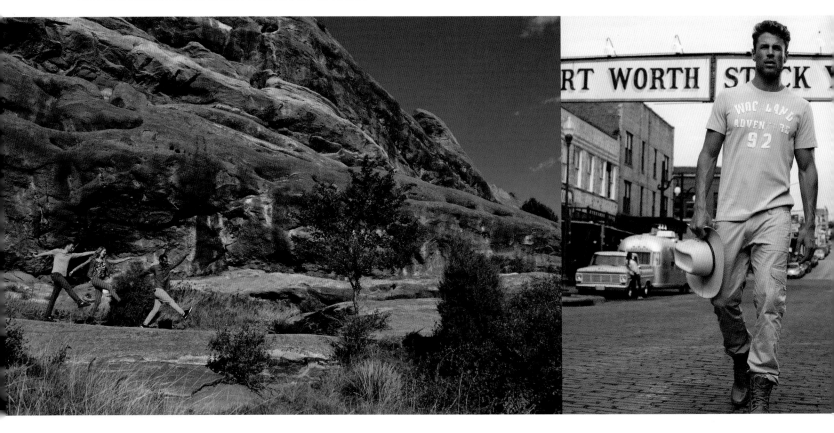

LOCATION

The client will decide to shoot on location or in a studio. You and your producer will want to look at the shot list in detail to determine which studio or location has all of the elements the client is looking for. Most of the time, the client or ad agency will want to help choose and approve the location so you will need to send them your favorite options.

Location: Most cities have commercial photography location rental companies, and you can browse their locations and rentals. I find these companies by googling: "Commercial Photography Location Rentals Miami," for instance. These will usually run $1,200–$3,500 a day. Look at the shot list and find a location that fits the vision best.

Studio: Studios are sometimes slightly less expensive, starting at $600 per day. Keep in mind that the kind of studio you should rent depends on your client's vision. Are they looking for shots with natural light? Then you'll want to rent a space with lots of windows and natural light.

Scouting: Sometimes the client will want to scout their favorite locations before choosing, and most location rental companies will allow this. When scouting the locations, check that there are sufficient outlets. If not, you will need to bring a generator or battery-powered lights. I always bring my camera and shoot the different areas where certain shots can take place.

ABOVE (ALL) **Scouting for sunshine**
We always use the SunSeeker app when scouting locations to see where exactly the light is going to be during a certain time of day. This allows us to plan the shoot accordingly.

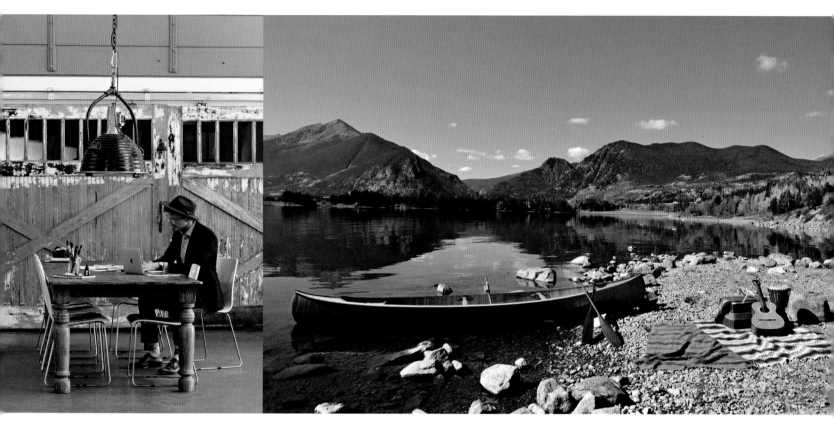

"Look at the shot list and find a location that fits the vision best."

Productions on a budget: If your client has a limited location budget, you or your producer can search sites such as airbnb.com and homeaway.com to find homes that would work for much less money. Sometimes you will need to book these kinds of locations for two nights in order to shoot there all day. Be sure to let the owner know that you plan to shoot in their location before you book it. Most are excited and happy to be a part of it.

Permits: Always check with the location owner if there are permits required to shoot there. And if you are shooting on public property, it is best to get a permit from the county or area you will be shooting. Your producer should take care of this aspect.

Location Scouts: If you are doing an out-of-town production, sometimes it is best to hire a location scout to find the best options for your shoot. They usually charge a day rate or fee for their services and you will need to include this on the estimate. The other alternative, if time allows, is to do a scouting trip where you go to the area and scout yourself.

RIGHT **Scouting for locations**
When searching for a great location, I use Google, Airbnb, VRBO, and commercial location rental companies.

POO-POURI CAMPAIGN

As a commercial photographer, it is my job to make a product look fun and exciting, no matter what it is. When the client reached out about this shoot, I had already seen a rad commercial that went viral a few years back, so I was pretty stoked about the opportunity to transform the brand in a fashionable way.

The client's vision had us shooting in a natural setting—the bathroom, of course—with a quirky model sitting on or near the toilet, using the toilet spray. This was the first time in my career that I scouted for bathrooms. We found a location rental company that sent us to a few places and I photographed each one. The client wanted a well-lit bathroom with the toilet right next to the tub. This was a bit hard to find—we found

the perfect room and tub, but there wasn't a toilet right next to it. This is where the creativity came in; we hired someone to build a faux wall and the client brought in a toilet from their headquarters to stage next to the bathtub.

The client held the casting for this shoot at their office and one particular model came in who blew them all away. She walked in, I photographed her, and she said, "I want to be the next 'Poo Girl!'" The client loved her fun, quirky personality, and hired her on the spot.

The day of the shoot, we covered the bathroom in toilet paper and aimed to capture a fashionable, sweet vibe in the images.

TOP TIPS

- Don't let reality cramp your style; if it looks real in the photo, it's real enough.

- If you're working with a model a client chose, make sure you know why, and highlight that feature.

ALL **Poo-Pourri**
If you're unsure, Poo-Pourri is a brand of bathroom odor clearer that takes a creative approach to advertising.

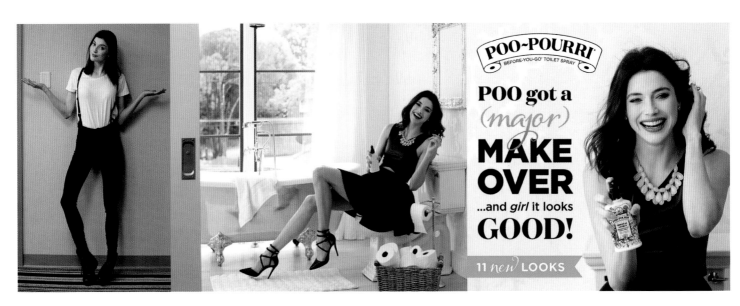

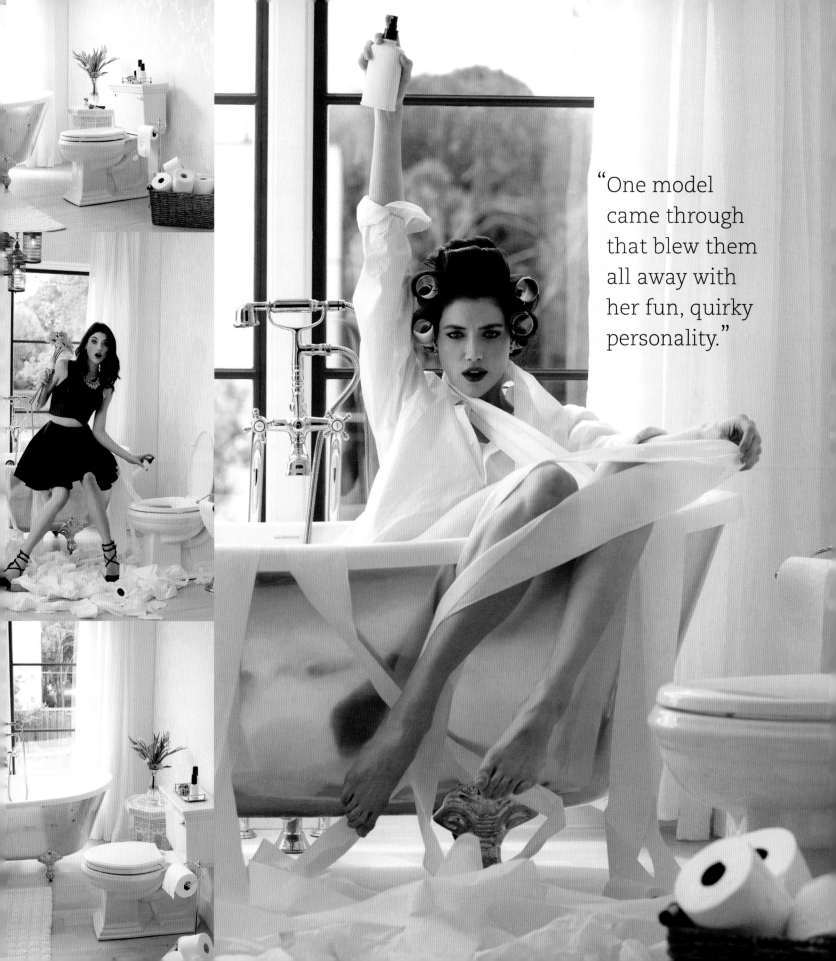

"One model
came through
that blew them
all away with
her fun, quirky
personality."

"Some clients will book from online submissions and some will want to have a casting."

CASTING DAY

Some clients prefer to cast from online images while other clients will want to have a casting where the models or talent come in to interview and have digitals taken. This is a great chance to get to know the talent's attitude and personality that comes through in their images. Your casting director may set this up for you for a fee or your can have your own casting if you have a space to accomplish this. Usually the talent comes in one by one and you ask them a few questions and take a few images of them. I recently did a jewelry campaign and the client wanted all the models' ring sizes so that they would have that information for the shoot.

CASTING

Choosing the right talent or models for the job is by far one of the most important aspects of the commercial shoot. Depending on the client's vision, some clients will book from online submissions and some will want to have a casting. Much of the time, the client will have specifications for the type of models they want for the shoot, including age range, ethnicity, hair color, height, and style (editorial, lifestyle, high fashion).

High fashion editorial models are usually tall—minimum 5'8" for women and 6' for men. Lifestyle and commercial models can be shorter and their body types can vary, depending on the job. Fitness models are obviously strong and athletic.

It is important to get current digitals, which are snapshots or non-professional photos taken with a Polaroid or a phone, as well as headshots and full-length images. For lingerie and swimwear, you will need to see them in lingerie or swimwear from different angles. For some jobs, such as jewelry ads, you will also need photos of their hands. For beauty jobs, some clients may even ask for current digitals of the model without makeup on to see their skin texture.

Agency Talent: When using talent from an agency, you or your producer will reach out to the model agencies with the client's specifications for the model. The agencies will send you a gallery of different models who are available and fit the specifications. You should choose your favorites from the bunch and send those on to the client. Sometimes a client will give you the final say on the model and sometimes they will want to choose.

Regarding talent rates, it is important to know that agencies add a 20 percent agency fee on top of a talent's rate. So, if a model's day rate is $2,000, you will be charged $2,400 for that model. This is especially important to remember when creating your estimate.

Non-Agency "Real People" Talent: If your client requests "real people," it is usually best to hire a local casting director to compile a large group of people to choose from.

OPPOSITE **Creative shooting**
When working in small spaces like a sailboat, you can try creative ways of shooting, such as shooting through things like the steering wheel, which has framed the model here.

BELOW **Comp cards**
It is always important to meet them in person or get current digitals on them, as well, to know their current hair, complexion and size.

SHOOT DAY

The shoot day should be well-planned from start to finish. I like to have the crew arrive 30 minutes to an hour before the client. The day begins with a "look-see" with the team to craft the lighting and set while the model is in hair and makeup. I always give the hair and makeup artist and the models "go-bys" for the looks, which are inspiration images that showcase the style I want them to create. About an hour into makeup, the model will come on set so that we can test the lighting on her and then make adjustments. The model then finishes hair and makeup and tries on wardrobe.

Before we begin shooting, everything is approved by the client and photographer. As the photographer it is important to mention if there is anything about the hair, makeup, and/or wardrobe that isn't working, as changes will need to be made before shooting.

When the model is ready, we begin shooting the first look. When we have the shots we want, the model is styled for the next look and we start on the second shot.

We break for lunch sometime in the middle of the day, which is either catered or, if we are on location, we have someone pick up meals.

When you finish for the day, it is important that all of the data is backed up onto three hard drives—this is the digital tech's job. While this is being done, the crew can work on cleaning up and putting everything back into place.

CREATING AN EXPERIENCE

Your interactions with your clients are a huge part of your brand. From your phone calls and emails to the energy on set—your personality should shine through. How you make your clients feel during the shoot will determine if they come back next time or not.

If you want return clients, you've got to keep the positive energy flowing. That is how the best pictures are made. I am a huge believer in creating the right mood and making your subjects and clients as comfortable as possible. If your subject or client is feeling uncomfortable, it's going to show through. If they feel comfortable, it's endless what you can create. So focus on creating a place where the magic can happen!

> "If you want return clients, you've got to keep the positive energy flowing."

OPPOSITE **Dreamy light**
This is my favorite kind of light; the model is backlit by the sun and a reflector has been placed in front. It creates a dreamy fashion feel. In this particular shoot we were going for the "bedhead" look—soft and sexy.

RELEASE FORMS

You must get model releases signed from your talent and location releases signed from the location rep. These are extremely important. There is a smart phone app available called "Easy Release" where you can create your own release on your phone or tablet.

TOP TIPS

- Always have food and beverages on set: people get very grumpy when they're "hangry."

- Music should always be streaming unless you're filming video and sound.

- Sandwich any criticism: When you're working with other creatives you have to find a way to communicate your vision kindly and in a collaborative manner. The criticism sandwich starts with a compliment followed by what you think needs fixing, followed by another positive statement. I've found this to be extremely helpful in working with people.

"I always give the hair, makeup artist and the models 'go-bys' for the looks that showcase the style I want them to create."

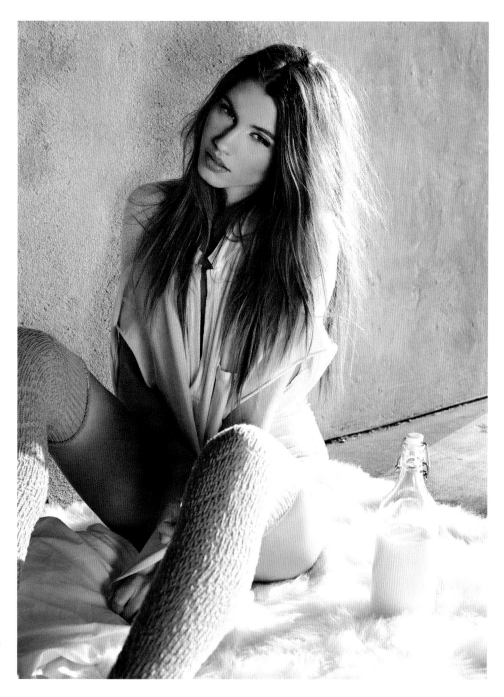

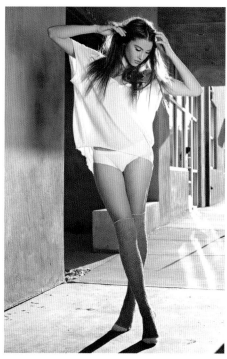

A MAGICAL SHOOT

CASE STUDY

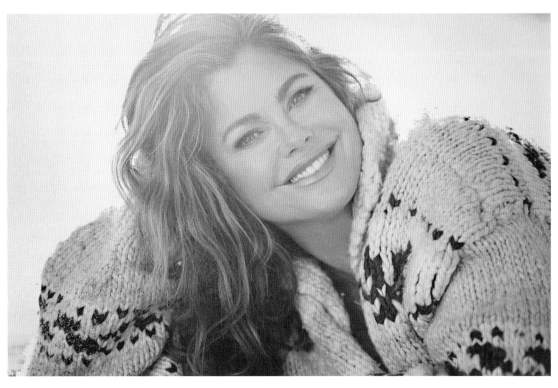

ALL **Capturing personality**
Kathy Ireland was an absolute dream to work with and her beautiful humble energy shines through in her photographs. I work really hard to get to know everyone I photograph so I can capture their essence in their photographs.

For these images, I wanted a natural feel so we opted for soft light and hair and makeup. This sweater, which Kathy owns, added nice texture to the portrait.

One of the biggest, most recent honors of my career thus far was having the opportunity to photograph the iconic Kathy Ireland. She is a powerhouse in business who has literally gone from being on the cover of *Sports Illustrated Swimsuit* to the cover of *Forbes* magazine. I have always been greatly inspired by her and her career. After meeting this beautiful soul in person, I came up with the concept for a shoot that was inspired by the iconic images of Marilyn Monroe that Bert Stern took with the original Nikon F. We also captured images that honored Elizabeth Taylor, Kathy's mentor and inspiration, for World Aids Day.

We spent two glorious days in Los Angeles, shooting in studio and on location in Venice Beach. I chose to shoot with the Nikon D5 and the new NIKKOR 105mm f/1.4 lens, which is one of my favorite combinations. On the beach, we shot a ton of backlit images. It can be challenging to maintain focus in these situations, but that is where the D5 really excels. The NIKKOR 105mm lens created a gorgeous creamy background, and gorgeous skin tones, as well as sharpness. They have been a game-changer in my arsenal. We also used a silver reflector to bounce light back in, while still keeping it very natural.

For this project, we put together an amazing team to create the imagery. I loved working with Kathy's renowned creative director, Jon Carrasco, because of his beautiful and unique vision. The shoot was one of those magical moments where Kathy and I were able to bond as soul sisters. She is one of those rare people whose energy and humble, genuine presence are instantly felt; qualities that come to life in her images. Words cannot even begin to express the gratitude, love, and respect I have for her, but hopefully the images do.

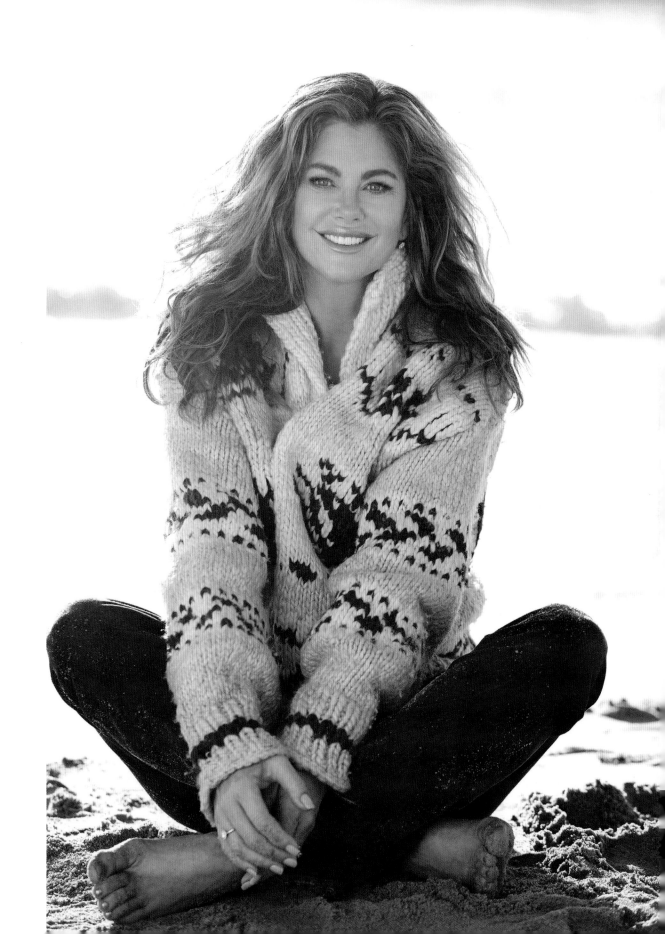

EUROSTORM

CASE STUDY

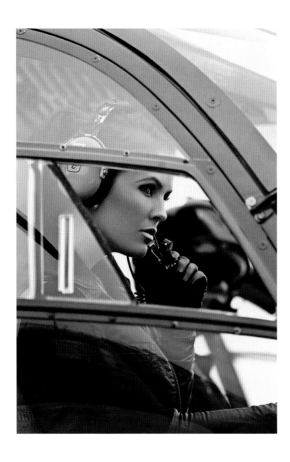

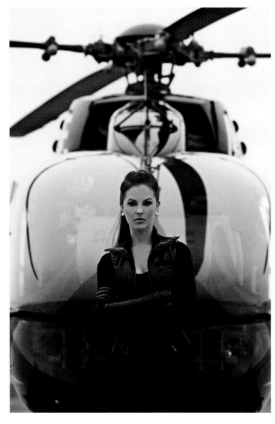

LEFT **Background stories**
I like to give the talent the background story behind an image. This helps them act out the part.

OPPOSITE **True to life**
Many people think that the second helicopter was photoshopped into the frame, but I prefer to shoot as accurately in-camera as possible. So everything pictured here is as it was shot. It was a challenge to position the helicopter between the two blades to make the best composition.

Experiences are priceless. When bestselling author Payne Harrison wanted to turn his bestselling book into a movie, he hired me to pick out and recreate iconic scenes from the book. One of the scenes I chose was an exciting moment in the book where the protagonist is jumping off of the helicopter to parachute while another helicopter is chasing them.

We had 15 minutes to get the shot, and two helicopters to work with. Using a headset I had to direct the second helicopter into the frame in between the blades of the grounded helicopter. It was a crazy adrenaline rush, and it's shoots like this that remind me why I wanted to be a photographer.

I remember the look on the author's face during the shoot—it was priceless. He got to see his entire book come to life in the pictures, and he loved it. This a key reason for his company subsequently hiring me to do more shoots.

TOP TIP

- When you are capturing fast moving subjects and you have minimal time to shoot, try using the continuous setting so you can shoot 6-14 frames per second so you are sure to capture the shot.

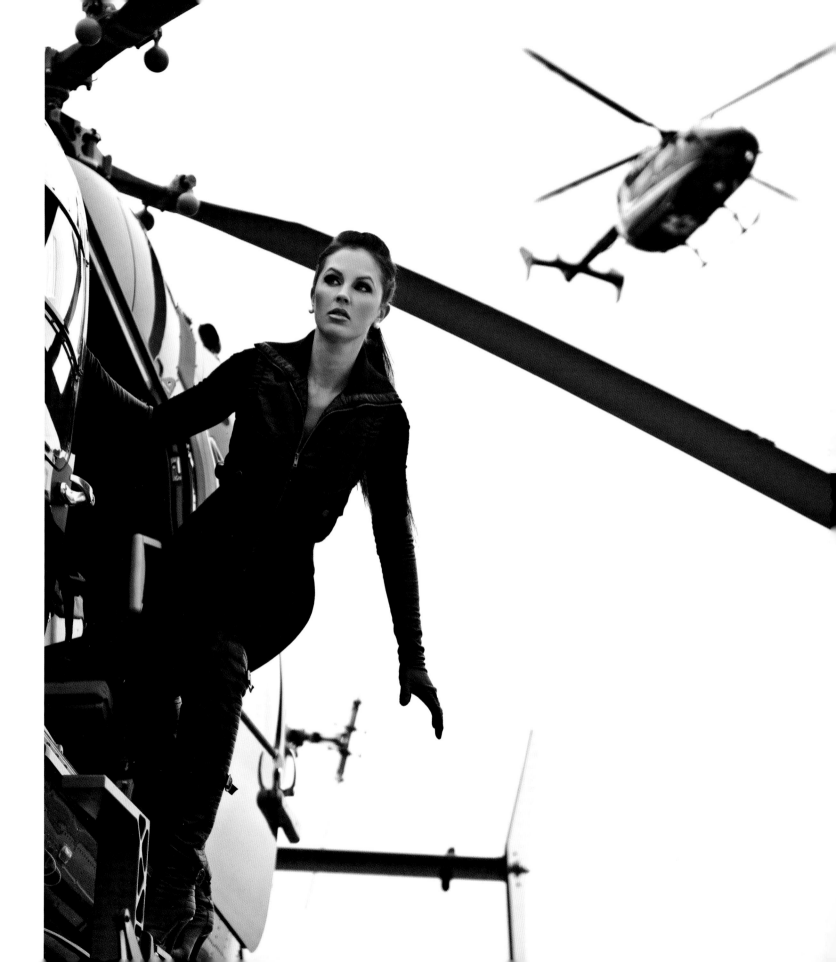

CONCLUDING THE SHOOT

Upon conclusion of the shoot, it is important to backup your imagery as well as celebrate with the client and crew. The shoot may be over, but your job as a commercial photographer is only half-finished.

"When clients are spending thousands of dollars on the creation of their imagery, it becomes incredibly important to back up those images effectively!"

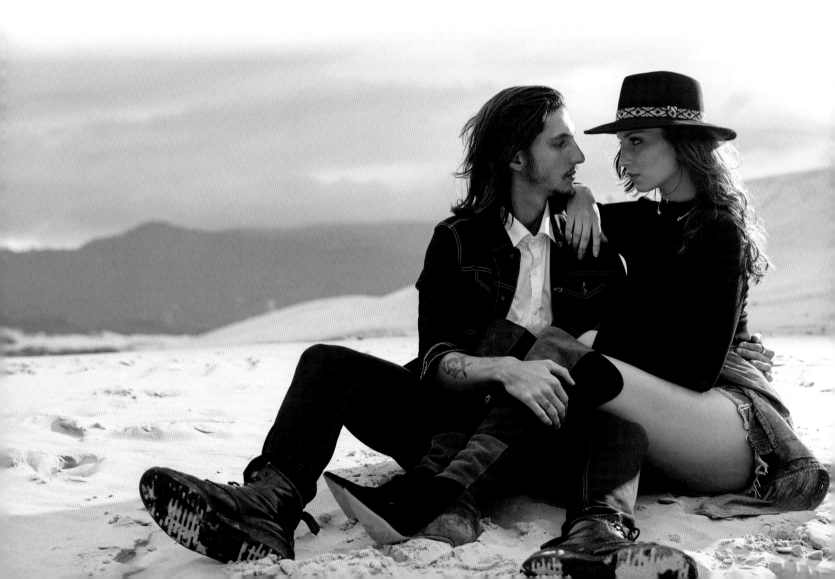

BEHIND THE SCENES

iamdixiedixon

415 likes
iamdixiedixon Yay!!!! Lots and lots of editing
and back up this week- my favorite!!!
@gtechnology

OPPOSITE **Brazil**
Captured just before a rainstorm,
the moody sky soon led to a soaked
crew. Always bring plastic bags on
set to cover equipment!

FAR LEFT **Backups**
Bring multiple hard drives to the set
so you can back up your images
immediately after the shoot.

LEFT **Inclusion**
Don't forget to include your
followers in every step of the work.

BACKUPS/STORAGE

When clients are spending thousands of dollars
on the creation of their imagery, it becomes
incredibly important to back up those images
effectively! Have three duplicate backups of all
the images, with one of those backups at a separate
location. This gives you and the client peace of
mind. On the day of the job, I always bring a few
hard drives to the set and give them to my digital
tech to back up from his laptop, as well.

THE WRAP DINNER

At the conclusion of most shoots, we schedule
a wrap dinner where the client, ad agency, and
crew meet and talk about the shoot. This is great
for relationship-building and keeping the client.
Always remember this: people may not remember
what you did or what you said, but they will always
remember the way you make them feel. The wrap
dinner is a way of thanking the client and creating
a fun experience.

POST-PRODUCTION

PROOFING

The day after the shoot, I go through all the images, take out the bad ones, and narrow the selection down to a set of proofs. This could be a small selection of images, around 20 or so, to a larger amount, depending on the job. I then do basic color-correction on these and save them as web-size files. Web-sized files are JPEGs sized 1,000 pixels on the longest side of the image at 72 dpi.

You can include a watermark on the proofs if you like. I then upload them to a proofing gallery for the client to view and select their favorites from. It is a good idea to send them your favorites as well so they can see your vision.

RETOUCHING

Once the client chooses their images, it is time to begin the retouching. Sometimes I outsource the retouching, especially for beauty jobs. Beauty photography is very detailed and the retouching takes hours upon hours. However, I always make the finishing touches to color myself when I get the images back from the retoucher.

FILE DELIVERY

Most clients prefer TIFF files of the final imagery, since these are of the highest resolution. This always allows them to open the images in any editing program to start their design process.

YOUR PORTFOLIO

Once the campaign has been released, you should always reach out to the client to get the final high-resolution artwork to keep for your portfolio. Then send this out, as well as the high-resolution images, to your team so they can also use them in their portfolio. I always post the campaign on social media and tag my team.

BELOW **Beach denim**
We were aiming for a desaturated look to make the denim appear high end.

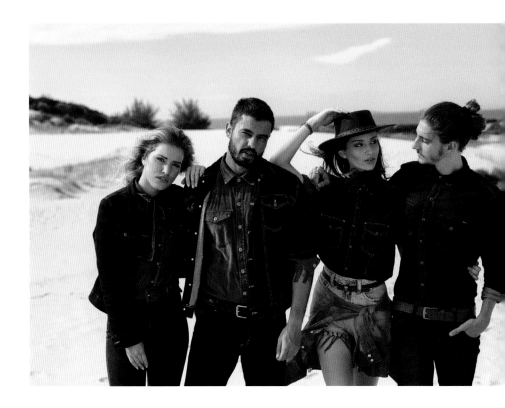

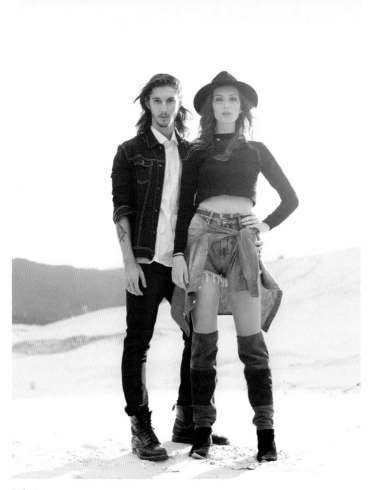

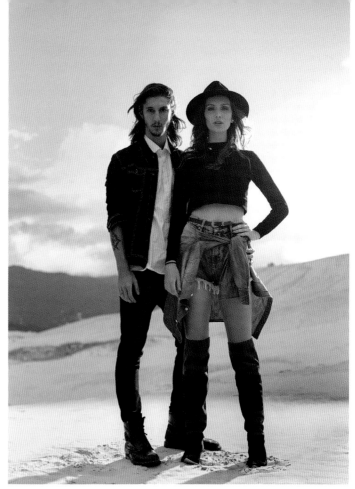

Before

After

Before

After

ABOVE LEFT **Raw**
In this instance you can see how useful Raw is; I was shooting quickly because of the approaching storm and accidentally overexposed, but was able to bring out all the detail needed in post.

LEFT **Desaturation**
Again, a desaturated look was what we preferred in the end.

RIGHT **Color toning**
My retoucher, Pratik Naik, a
renowned retoucher, did some
beautiful color toning on this shot
to bring this image to life. The
shadows are slightly purple, the
highlights are warm, and there is
more detail in the water. He has
also minimized the unwanted flare
from the light I needed behind
the tree branch.

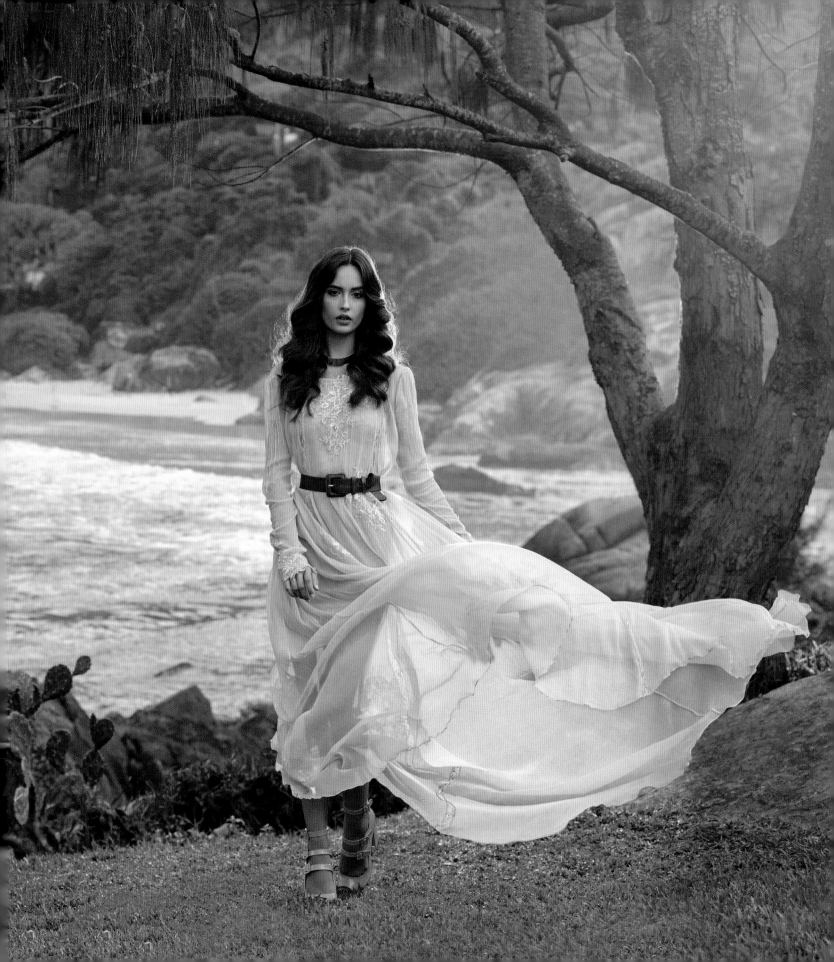

8 BUILDING YOUR BRAND

WORD OF MOUTH

CREATE A COHESIVE BRAND

BEHIND-THE-SCENES VIDEOS

SOCIAL MEDIA

WORD OF MOUTH

It's been my experience that my best clients are referred to me through word of mouth. When you can successfully inspire clients to talk you up to their colleagues, you're well on your way to making a name for yourself. This obviously takes time and is built up shoot by shoot.

Keep in mind the following:
- This industry is a very small world, so approach everyone with kindness and respect. This can go a long way.
- If you create a great experience on set, clients remember that they not only ended up with some great images for their brand, they also had fun. That is a huge part of photography.
- I have found it extremely helpful to join trade organizations in order to meet other creatives in the industry, as this is a great place to network.

This all helps build word-of-mouth advertising!

NETWORK

ABOVE **Ambassadorship**
Speaking on the Nikon stage at The Photography Show, UK, at NEC, Birmingham.

OPPOSITE, LEFT **Working with animals**
Animals make for great props but they can also be a challenge to work with. The beautiful chicken, Gladys, actually pooped on Roxanne during the shoot, so I had to photoshop that out of her jean shorts.

"Clients remember that they not only got some great shots,
they also had fun. That is a huge part of photography."

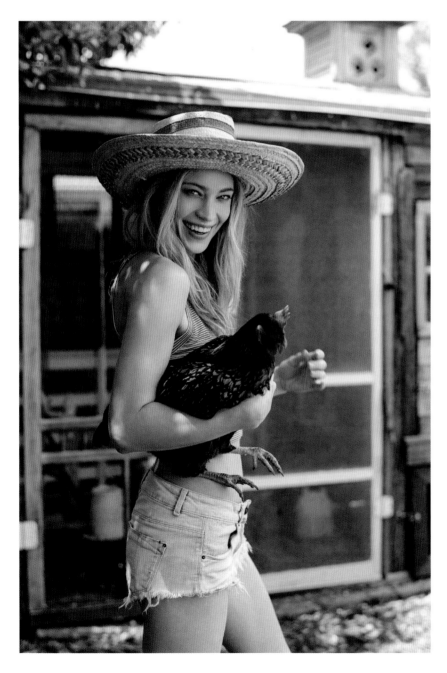

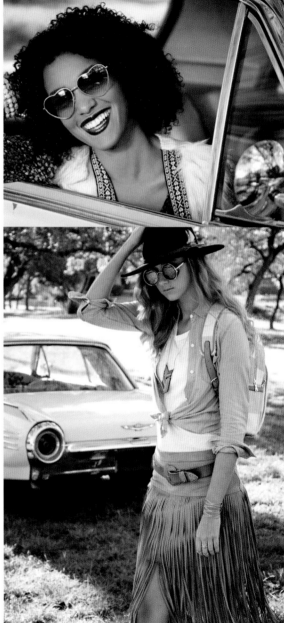

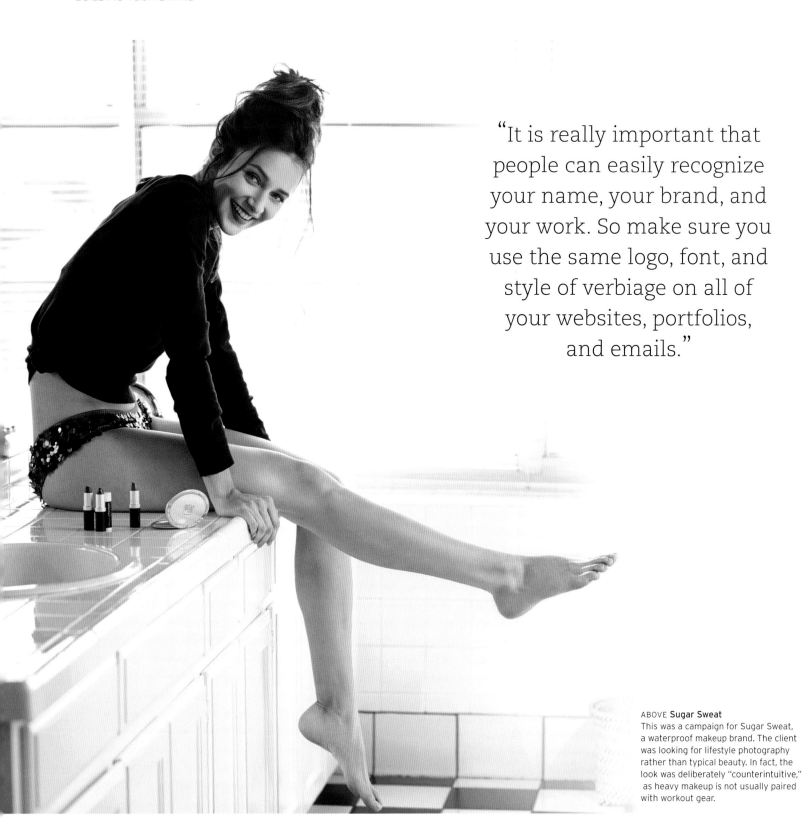

"It is really important that people can easily recognize your name, your brand, and your work. So make sure you use the same logo, font, and style of verbiage on all of your websites, portfolios, and emails."

ABOVE **Sugar Sweat**
This was a campaign for Sugar Sweat, a waterproof makeup brand. The client was looking for lifestyle photography rather than typical beauty. In fact, the look was deliberately "counterintuitive," as heavy makeup is not usually paired with workout gear.

CREATE A COHESIVE BRAND

Let's talk a bit about cohesiveness, because your photographic style and branding must be cohesive. Whether you believe it or not, your photography brand has a personality. Think of the Geico Lizard, Starbucks, or Coca Cola. These iconic brands have a voice that is communicated by their logo, their ads, typeface, colors, and web pages, all of which are cohesive and match. This cohesiveness is the glue that holds your brand together. So if you take a look at my website, portfolio, and marketing materials, the logos, colors, and font are the same on everything. It is really important that people can easily recognize your name, your brand, and your work. So make sure you use the same logo, font, and style of verbiage on all of your websites, portfolios, emails, and so on. This is crucial for building your business.

+ PORTFOLIOS + MOTION + BIO CONTACT

BEHIND-THE-SCENES VIDEOS

A promotional strategy I often use to drive traffic to my brand is sharing behind-the-scenes (BTS) videos on social media. BTS videos are an extremely effective marketing tool. They drive traffic to your website, engage potential clients-- giving them peace of mind when hiring you— and greatly increase word-of-mouth advertising. BTS videos are a popular marketing tool that many commercial clients, as well as others, desire as part of a photo shoot. These days, in addition to the still imagery I create, nearly all of my commercial clients ask for a BTS video for them to use on their websites.

Since I'm primarily a still photographer, I'll hire a cinematographer to film my shoots, as well as edit the video afterward. If you don't have the budget to hire a cinematographer and/or editor, you can check with local colleges to see if there are students looking to build their reels, or you can have an assistant do the filming. You may even find a wedding videographer open to collaborating in

exchange for using your images on their website or promos.

To create a great BTS video, certain elements should be included:

1. Still images—Include the final images from your shoot in the actual video, as this shows the end result and showcases your work. I usually have the editor put the images in at the end of the video.

2. Interesting footage—The more footage the better. Include all aspects of the shoot, including hair and makeup, wardrobe, the gear, you at work, and your interactions with the models or subject. It's great to have a variety of clips from wide to close-up, and make sure your editor chooses clips that have the most emotion. The worst thing you can do is show a video of your shoot that looks boring. The footage should communicate the story and showcase you as an artist. The more footage that's shot, the more you have to work with when editing the final video.

3. Music—Make sure you use licensed background music. There are sites that sell royalty-free music at

Post videos
Getting videos out there on social media (assuming the client agrees) is a great idea.

"Once the campaign has been released, you should always reach out to the client to get the final high-resolution artwork to keep for your portfolio."

affordable prices. The song you choose is important because it sets the tone of your video.

4. Time-lapse—Time-lapse is great tool and many of the Nikon cameras will do time-lapses right in-camera. Put a camera on a tripod before you start setting up the shoot and allow the camera to capture a time-lapse of the process. You can put the footage to music and make a great promo video out of just that. It also makes for interesting footage for your editor to add into the final video.

5. Graphics—Make sure you include your logo somewhere in the video. In some videos, I'll give the editor a list of credits as well.

6. Voiceover/audio—Recording audio isn't going to make or break your video, but it does add an extra dimension if you want to talk about your vision or interview your client on set.

EDITING THE VIDEO

When everything is filmed, your cinematographer will be able to start on the edit. I always supply them with the final retouched images and the music

before they start the editing process. I'll let them know how long the final video should be as well. The shorter the better—usually from one to four minutes in length is ideal. Lastly, make sure you tell your editor to choose clips that best express your personality.

You can also choose to edit the video yourself. I recommend using Adobe Premier as it is currently the best editing software out there. You can also use Final Cut Pro.

PROMOTE YOUR VIDEO AND BRAND

Post your video on your website as well as the social media platforms you use. Adding keywords to the video with your website, name, and the team involved will help it show up on search engines.

Ultimately, your BTS video will serve as a way to showcase your brand in an interesting and interactive way, which will help attract new clients and take your brand and business to the next level.

SOCIAL MEDIA

Currently I utilize social media a ton in my business. It allows me to connect with current clients on a more personal level, attract new clients, showcase new projects, and ultimately drive traffic to my website. It's a great way to grow your photography brand and business. Here are ten useful tips on how to use social media effectively to grow your business from the start.

1. Share your best work—In the beginning of my career, I wasn't very picky about what I shared online. Any new image I shot, I posted it. But now that my business is established, I only show my very best work online. It's important to only show the type of work that you actually want to get hired for. So for instance, if your dream is to specialize in shooting senior portraits but you are still shooting wedding work to pay the bills, only post your senior portrait work online because those are the clients you want to attract.

2. Always put a watermark on your images—You never know where your images could end up online, so it's helpful to have your name and website on each image. You wouldn't believe how many people have told me they saw my work online somewhere.

3. Put social media links on your website and vice versa—When people are considering hiring you, they like to get an idea of who you are on a more personal level and social media allows them to do that. So having those links on your website is important. Just as important is having your website URL on your social media sites as well to drive traffic to your website.

4. Share your adventures—People love to know what you're up to and social media gives you an outlet to share your adventures with people all over the world. I find it effective to post not only my images but also a story behind the image, tagging the people involved, and the lighting and Nikon cameras/lenses I used. People love to know how you got the shot and sharing that information shows potential clients you know what you're doing.

5. Engage with your clients online by responding to their posts—The key to social media really is engagement. You can have millions of followers online but it doesn't do much good unless people engage with you and your brand. I've found it best to let everything grow organically and respond to people online who post on my images. It keeps it fresh.

BELOW & OPPOSITE **The talent** For this shoot, we were shooting both stills and video, so I wanted to cast an actual musician. I ended up finding this beautiful model and talented musician, Chantell Moody, through The Digital Wild on Facebook. She was perfect!

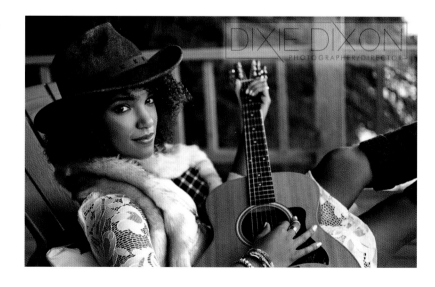

SHARE
ONLINE

iamdixiedixon

178 likes

iamdixiedixon Absolutely loved working on this
project with the Dreamteam :)) and the
stunning and talented @kickinitcurly Repost
@nikonusa · · ·
#NikonAmbassador and fashion photographer

iamdixiedixon

nikonusa

1,877 views

iamdixiedixon 🤠 📷 💃 #Repost @nikonusa
with @repostapp.

iamdixiedixon

nikonusa

1,717 views

iamdixiedixon 🤠 📷 💃 #Repost @nikonusa
with @repostapp.

"People love to know
how you got the shot
and sharing that
shows potential
clients that you know
what you're doing."

185

6. How do you determine which sites are appropriate for your business?—The truth is, the more social sites you're on the better. But if you have limited time and you want to focus on just one or two social media sites, it's important to consider your potential clients—what sites are they checking regularly?

7. What times of day are best for posting?—It's important to consider your ideal customer and think about when they're online. Do they work 9–5 jobs? If so, it might be best to post early in the morning or at lunchtime, because that's when they might be on social media.

8. Keep it professional—There is a balancing act to sharing enough to give people a glimpse into your world, but not over-sharing so much that people

grow tired of seeing you. I like to keep my social media a little mysterious and overall professional, but not void of personality.

9. Create a consistent brand experience—Social media enables us to communicate our brand and it is important to keep it consistent. In my posts, I try to express my own personality in the language that I use, which is consistent throughout my website, emails, and social media. I also tend to use the same logos on everything so that people can recognize my work and brand.

10. Make your social media presence as unique as you are—Your images are an outward expression of who you are and so is your social media presence! Make it as unique as you are and you will be connecting with a captivated audience before you know it.

BELOW **Social media platforms** From left: Twitter, Instagram, and Facebook.

OPPOSITE **Soft & directional** I originally photographed this gorgeous model, Sindy Perez, for the TV Show *Get Out* and I have since hired her for other jobs. I captured this image in Puerto Rico and the sun had moved behind a cloud, so the light was soft yet directional.

"Your images are an outward expression of who
you are and so is your social media presence!
Make it as unique as you are."

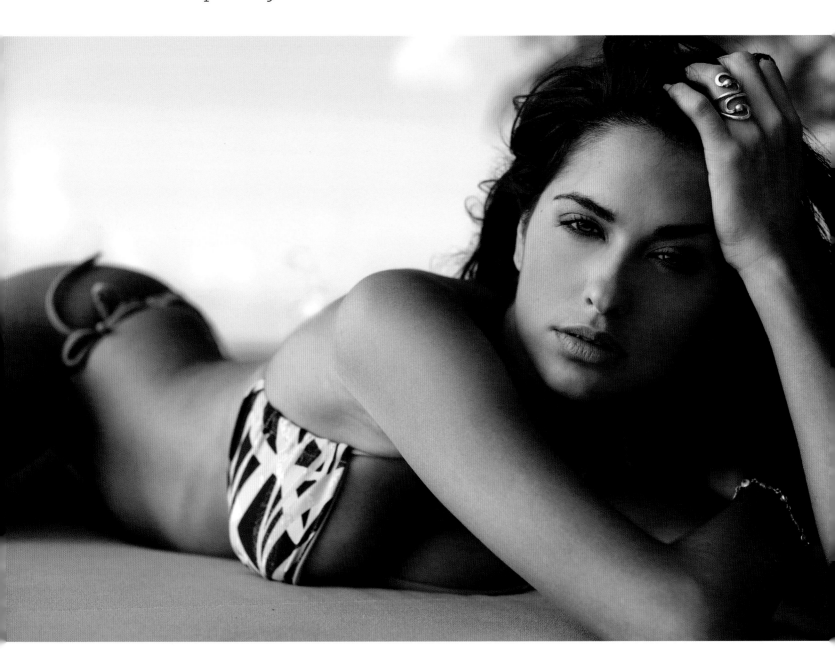

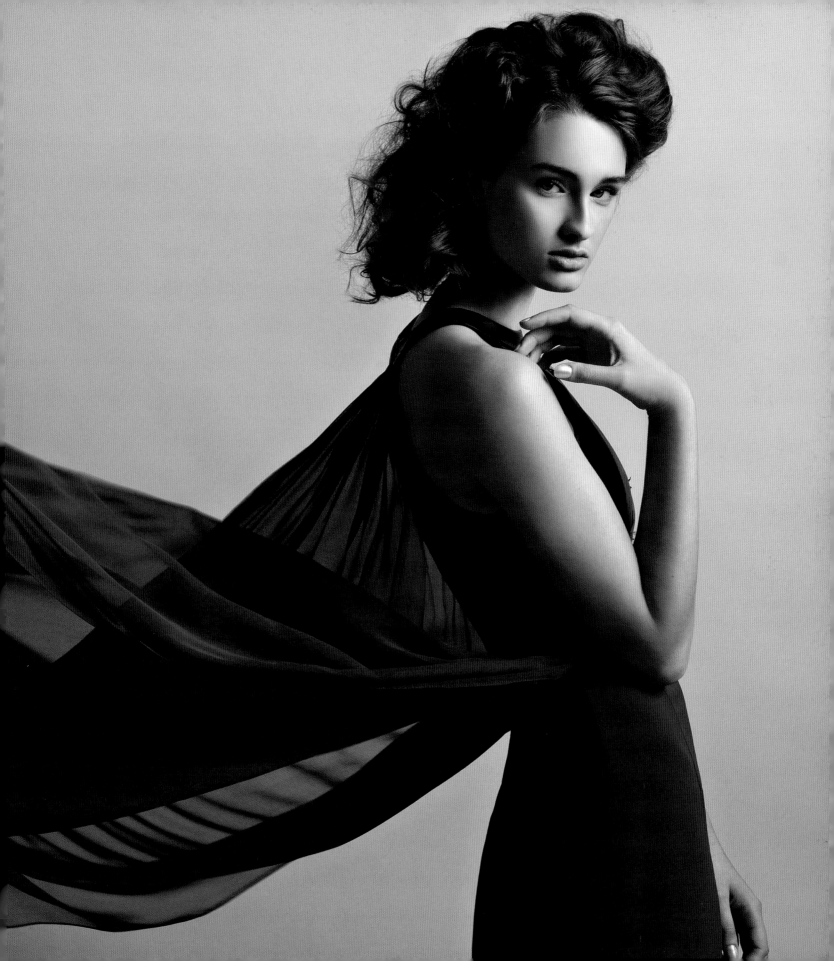

INDEX

A
Active Backpacks 40–41
Adobe Premier 183
advertising 24, 62, 103, 107–111, 114, 130, 150, 152, 160, 182
agencyaccess.com 152
airbnb.com 159
ambient light 76, 82, 107, 116, 120
analogous colors 56–57
APA 14
aperture 44–45, 80, 87, 94, 111, 125
Arri M18 84
art directors 104, 114, 122, 126, 130, 142, 148, 150, 154
artificial light 76, 117
ASMP 14, 17
audio 183
Auto Modes 48
AXS Television 16

B
backing up 164, 170–171
backlighting 65, 70, 74–75, 166
backup plans 122–123
barn doors 82
batteries 18, 80, 87, 125, 158
beauty dishes 19, 62–63, 88, 107, 118
beauty images 103, 108–109, 172
Bennett, Robert 16
black-and-white images 62, 108, 116, 118–119, 122–123
BlinkBid 152
bokeh 39, 98
borrowlenses.com 31
bounced lighting 92–93, 166
brands 102–109, 114, 122, 142, 160, 176–189
Branson, Richard 114
briefs 153
Brixton Hooligans 41

BTS videos 182–183
budgets 94, 112, 130, 132, 135, 137, 142, 153, 159, 163, 182
Burton, Kauwuane 87

C
calendars 126–127
call sheets 156–157
camera settings 44, 65, 87
Capture One 137
career-building 128–147
Carrasco, Jon 166
case studies 18, 58, 127, 160–161, 166–169
casting 108, 112, 114, 133, 160, 162–163
Clapp, Erik 122
clients 53, 62, 66, 94, 102, 107–115, 119, 123, 126–127, 130–138, 142, 148–175, 182–183
Cohen, Arlene 14
Cohen, Skip 14
cohesiveness 181
collaboration 140, 164, 182
color 54–59
color balance 40, 82, 85, 87, 116, 137
color correction 172
color harmonies 56
color profiles 40
color wheel 56–57, 59
commercial images 100–127
commercial photo-shoots 148–175
comp cards 163
compact DSLRs 33
compact lighting 80–83
complementary colors 56–57, 59
composition 50–53
confidence-building 144–147
consistency 186
constant light 76–83
contests 14

continuous artificial light 69
Continuous Focus Mode 48
copyright 153
credit lines 153
crystals 98

D
Dapper Magazine 119
dappled light 66
daylight 69, 92
depth of field 44–45, 87, 98
digital technicians 137, 164, 171
direct light 70
distance 65
Diva-Lite 82
double complementary colors 56–57
dpi (dots per inch) 172
dream teams 94, 126–127, 130–147, 154, 156, 164, 166, 172, 183
DSLRs 33–34, 110
DX sensors 33–34

E
Easy Release 164
edge light 75
editorial images 25, 66, 102–103, 107, 116–120, 130, 138, 153–154, 163
estimates 152–153, 159, 163
estimating consultants 152
experiences 138, 164, 168, 171, 178
exposure triangle 44

F
Facebook 140, 184, 186
fashion images 102–107, 130, 163
favorites 24
file delivery 172
file size 33
Final Cut Pro 183

flash 69
focus modes 48–49
food 144, 164, 171
framing 53
Franks, Nancy 126
FX lenses 33–34

G
G-Technology 40–41
Garcia, Bill 16
gear 28–41, 123, 140, 156
genres 102–103, 152
Get Out 16
go-bys 164–165
gold reflectors 74
golden hour 66, 70–71
Google 154, 158–159
Graphistudio 41
Gretag Macbeth 137

H
hair light 75, 80, 87
hair stylists 134, 140, 142, 164–165
halo effect 68–69
Harrison, Payne 168
hats 41
Hepburn, Audrey 116
High Speed Sync 87
high-key lighting 90
HMI lights 76, 78–79, 82, 84–85, 122
homeaway.com 159

I
image quality 33
In Touch 122
industry 14, 17, 100–127, 139–140, 142–143, 178
Instagram 186
interesting footage 182–183
Ireland, Kathy 166
ISO 44, 46, 87

J
James Avery Jewelry 112–113
Jang, Eric 132
JPEG files 172

K
Khanh, Nha 97
King, Calvin 15
Kino Flo 82

L
leading lines 50–51, 58, 78
Leibowitz, Annie 26
lens flare 62, 94, 114–115
lenses 34–39, 94, 111, 140, 166, 184
lensrentals.com 31
Licata, Jeff 13
licensing 153
lifestyle images 103, 110–119, 163
light shapers 88–89
lighting 24, 60–99, 108, 120, 125, 154, 164
lighting technicians 137
lingerie images 103, 122–125, 163
Living Magazine 116
locations 158–160
logistics 156
lookbooks 103, 106–107
low light 35–36, 46, 116
low-key lighting 90
Lowel GL-1 Power LED 80

M
Macademia Professional 108–109
McNally, Joe 62
magazines 24, 53, 66, 96, 103, 116, 119–120, 122, 142, 154, 166
magic hour 70–72
makeup/makeup artists 116, 124–125, 130, 132–134, 138–140, 142, 164–165
Manfrotto 40
Manual Focus Mode 48
Mason, Doc 13
meetings 156
memory cards 40
midday sunlight 72
Minor, David 14

modelmayhem.com 130, 140
models/model agencies 133–135, 137, 140, 142, 144–147, 154, 160–164
Mola Setti 88
Monroe, Marilyn 166
mood 45, 55, 58, 62, 66, 69, 71, 74, 80–81, 88, 94, 103, 118, 122, 144, 164, 171
mood boards 154–156
Moody, Chantell 184
moonlight 69
moving subjects 87, 168
multiple-source lighting 93
music 144, 164, 182–183

N
Naik, Pratik 174
Natural Hair Oil campaign 108–109
natural light 69–72, 75, 110, 116–117, 119–120, 122
negative space 50–53, 58, 107
networking 139–140, 178
NIKKOR lenses 36–39, 48, 94, 140, 166
Nikon cameras 12, 30–33, 59, 94, 110–111, 116, 140, 166, 178, 183–184

O
Octa 89
overcast light 71

P
Panhandle Slim 104
Para 177 108
parabolics 65, 89
Perez, Sindy 186
permits 159
personal work 33, 94, 139–140, 142
personality 138–139, 162, 166, 181, 183, 186
photo assistants 136

Photoshop 59, 96–97, 108, 111, 114, 168, 178
Pinterest 154
Piper's Perfumery 122–123
Poo-Pourri 160
Porcelli, Adrianne 16
portfolios 14, 16–17, 22, 33, 41, 47, 87, 108, 119, 130, 133, 137–138, 142–143, 172, 181, 183
poses 118, 120, 144–145
post-production 172–173
PPA 14
pre-production 156
print runs 153
producers 132
production assistants 136
production books 156
Profoto 87, 93–94, 108, 118–119, 125
proofing 172
props 112, 140, 178

R
rapport 142, 144
rate ranges 132–137, 152, 159, 163
Raw files 173
reflectors 72, 74–75, 120, 166
release forms 164
Rembrandt lighting 66
Rent the Runway 97
rental houses 138
research 104, 107–109, 116, 144
resolution 172, 183
retouching 172, 174, 183
Rich, Corey 59
rim lighting 75, 89
Rock & Roll Denim 104
Rule of Thirds 50–51
Ryan, Sam 111

S
S-curves 50, 58, 502
scouting 158–159

seamless backgrounds 90
search engines 183
shade 72, 74–75
shoot days 156–157, 164–165
shot lists 111, 153, 156, 158–159
shutterspeed 44, 46, 86–87, 94, 111
side-lighting 70, 105
silver reflectors 74, 166
Single Shot Mode 48
skin tones 32, 40, 59, 74, 89, 108, 120, 166
SLATE Denim & Co 104–107
Smith, Matthew Jordan 15
social media 140, 142, 172, 183–187
soft light 65, 69
softboxes 62, 78, 89
special effects 94–95, 98–99
specialities 138
SPS 14
square colors 56–57
Stern, Bert 166
still images 182
storage 40–41, 171
striking light 66–67
strobes 69, 76, 86–87, 92, 105, 114, 120, 125
studios 158
style 22–23, 26, 102, 133, 138–140, 142, 153–154, 164–165, 181
stylists 112, 130, 134–135, 138–140
SunSeeker 158
swimwear images 103, 120–121, 163
Syracuse University 13

T
tagging 172, 184
Taylor, Elizabeth 166
team-building 130–147
technique 42–59

tetradic colors 56–57
texture 65, 70, 89, 105, 107–108
TFCD 142
TFP 142
Thunderbolt 40
TIFF files 172
Tiffen filters 94, 96
time-lapses 183
timeframes 153
tips 17, 58, 87, 107–108, 110, 112, 115–116, 118, 123, 160, 164, 168
trade associations/shows 14–15, 17, 178
travel 17–19, 40–41, 82, 126, 152, 156
triadic colors 56–57
triangles 50
tungsten lights 116–117
Twitter 186

U
umbrellas 88, 97

V
V-Flats 108
Varanakis, George 14
Vaseline 96, 114
video 76, 111, 122, 164, 182–183
Vielma, Rocio 116
Virgin Pulse 114–115
vision 20–27, 30–31, 45, 59, 62, 65, 102, 107–111, 122–123, 127, 132, 135, 140, 150, 153–154, 158–160, 163–164, 166, 172, 183
visual vocabulary 26
voiceovers 183
VRBO 159

W
wardrobe styling assistants 135
wardrobe stylists 134–135, 138–139
watermarks 172, 184

weather 112, 122–123, 127, 150
websites 15, 142, 180–184, 186
Westcott Ice Light 2 82
Westmoor Mfg 104
WHCC 41
window light 71, 76, 116–117, 119
Wirtz, Kiley 126
word of mouth 178–179, 182
workflow 137
WPPI 14, 17

XYZ
X-Rite 40, 400
YouTube 116

ACKNOWLEDGMENTS

As with all worthwhile creative endeavors, it takes a dreamtime to bring a book to life, and it has been my honor to have the opportunity to work side by side with such amazing creatives throughout this whole journey!

To my incredible family, you are my rock, my inspiration, and my absolute love. Mama Bear, words cannot express all that you have done throughout writing this book, from shooting my cover to coming up with so many amazing ideas. You are incredible. You and Papa Bear have made the biggest impact on my life and are the reason I am able to pursue my dreams. Papa Bear, thank you for lighting up my world and for supporting me in everything I do! And to Grandpa Tuttle Bear for being my biggest fan in photography, and to my Roobs, Lynnard, Amy, Meme, Grandpa Dixon, Doug, Richard, Raleigh Page, Courtney Donica, my best friend who nicknamed me Dixie, Christine Penny, my soul sister and creative guru. Mike Corrado Bear, who has made such a huge impact in my life. Benny Migs, talented photographer, incredible friend, and rockstar. You all continually light up my world and inspire me! Nancy Franks, my incredible producer, who worked side by side with throughout the writing and editing of this entire book. Eric Jang, my amazing crew chief and lighting ninja who I am so insanely lucky to get to work with closely on every single shoot and who I can always count on to make the vision all come together. Kiley Wirtz, my exceptional art director, makeup artist, and inspiration who originally brought all of us together for our first Magpul shoot. Joe Rockstar Paglia, for being the best dose of heart, kindness and inspiration in my photography journey. Mike Hanline, with WHCC Lab who has been an incredible mentor and friend throughout this journey. My new mentor, Lee Shaw, who has brought so many amazing new opportunities and friends my way. My rockstar Digitech Nikola Simic, who always saves the day, and my renowned retoucher, Pratik Naik with Solstice Retouching, who has brought to life a lot of the gorgeous retouching throughout the book. Big thanks to the awesome cinematographers who I work with on a regular basis: Eric Clapp, Chris Gomez, Jameson Brooks, Adrianne and Aytek Porcelli, Nick Utter, Sam Ryan, Ross Craig, Lorenzo Wallace. You guys are incredible! A huge thank you to my epic Nikon family, including: Mike Corrado, Lindsey Silverman, Mark Soares, Kasuke Kawaura, Erika Hill, Barbara Heineman, Marie McKinley, Melissa DiBartolo, Diane Berkenfeld, Kristine Bosworth, Masahiro Horie, Judith Paul, Kenji Suzuki, Mark Suban, Trudy Moleski, Angie Salazar, Jillian Cutrone, Emily Georgalas, Carmelina McGuire, Brein Aho, Dave Edelstein, Diane Bachman, Isao Takahashi, Brian Hettrich, Bill Giordano, Lisa Baxt, JC Carey, Mike Lopez, Lee Lisa, Gen Umei, Shusuke Nakano, Sachie Yamane, Geoff Coalter, and all of my fellow Nikon Ambassadors. So much love and gratitude to you all! The phenomenal Kathy Ireland Worldwide team including the one and only Kathy Ireland, Miles Robinson, Jon Carrasco, Jason Winters, and Brittany Duncan. Sincerest gratitude to my industry partners including Nikon, G-Technology, Lexar, Profoto, WHCC, Tiffen, X-Rite, Manfrotto, Graphistudio, and Viewsonic.

Big thank you to my awesome industry friends and colleagues who have helped me tremendously on this photography adventure: Jeff Licata, Doc Mason, Arlene Evans, George Varanakis, Skip Cohen, Andre Phillipe, Joe Chavez, Matthew Jordan Smith, Joe Mcnally, Alicia Connor, Tina Gill, Jeff Erwine, Russel Dennis, Lucas Gilman, Corey Rich, Kauwuane Burton, Jeanette Chivvis, Nelly Adham, Ron Magill, David and Luke Edmonson, Roberto Valenzuela, Dave Black, Amanda Mahommed, Robert Bennett, Bill Garcia, Aimee Davis, John Cole, Mark Rezzonico, Sara Strid, Cliff Hausner, Andy Rah, Roberto Garcia, Rob Grimm, Gary Martin, and Sinh with RGG EDU, Linda Castro, My Phung, Tom Henry, Greg Crosby, Ken Higgins, Gino Belmonte, Jeff Snyder, Maureen Neises, Dario Righetto, Lisa Larkin, Rod Cooper, Evan Fogelman, Brandon Alcorn, Andy and Brian Marcus, Mark Mclanahan, Roxanne Redfoot, Magdelene Groves, Zandria Theis, Khris Kessling, Dawn Shields, Bambi Cantrell, Jerry Ghionis, Linda Castro, Nathan Winston, Lukas Moffet, Justin Lee, Jay Wegner, Rocio Vielma, Nancy Campbell, Mackensie Ferris, Steve Jones, The Browns, Tri Vo, Kelly Whaley, Ian Andes, Fort Worth Camera, Scott Kelby, Sindy Perez, Kelly Gray, Krystle Hagenlocher, Wallflower Agency, Campbell Agency, Kim Dawson Agency, Patricia Mora, David Minor, Calvin King, Bob Akin, Jeff Cable, Joey Lopez, Mark Lewis, and so many more.

To the whole team at Octopus/Ilex: you all have been so incredible to work with, thank you for bringing my vision to life: Adam Juniper who is the reason this book is now out there in the world. Thank you for your patience throughout all of my many edits and crazy ideas, you have always remained excited and helpful throughout the whole process. Ellie Wilson, for reading all of the words I wrote and making them sound so much better and beautiful and to the entire amazing team at ilex; Frank Gallaugher, the editors, the designers, and production staff who helped make this book a reality.

Words barely express the gratitude I feel in my heart for you all as well as everyone who has made such an impact on my career not mentioned here. Thank you!